Winslow Homer in London

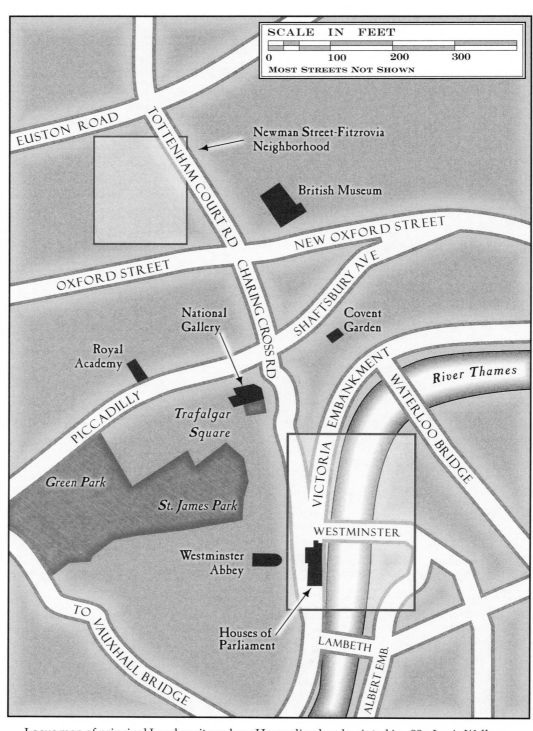

Locus map of principal London sites where Homer lived and painted in 1881. Lucie Wellner, cartographer.

Winslow Homer in London

A New York Artist Abroad

David Tatham

Syracuse University Press

∞ The paper used in this publication meets the minimum requirements
of the American National Standard for Information Sciences—Permanence
of Paper for Printed Library Materials, ANSI Z39.48-1992.

For a listing of books published and distributed by Syracuse University Press,
visit our Web site at SyracuseUniversityPress.syr.edu.

ISBN: 978-0-8156-0953-7

Library of Congress Cataloging-in-Publication Data

Tatham, David.

Winslow Homer in London : a New York artist abroad / David Tatham. — 1st ed.

p. cm.

Includes bibliographical references and index.

ISBN 978-0-8156-0953-7 (cloth : alk. paper)

1. Homer, Winslow, 1836–1910—Criticism and interpretation.

2. Homer, Winslow, 1836–1910—Travel—England—London. I. Title.

N6537.H58T37 2010

759.13—dc22 2010027120

Manufactured in the United States of America

In memory and life
to
Barbara Tatham Johnson and Beverly Tatham Orr

DONORS

*Publication of this book is made possible
through the generous support of:*

Furthermore: a program of the J.M. Kaplan Fund

The Gladys Krieble Delmas Foundation

The Rosamond Gifford Charitable Corporation

DAVID TATHAM was born in Wellesley, Massachusetts, and educated at the University of Massachusetts, Amherst, and Syracuse University. In 1962, he joined the faculty of Syracuse University's Department of Fine Arts (now the Department of Art and Music Histories), attaining in 2002 the rank of professor emeritus. He is the author of books, exhibition catalogues, and many scholarly articles concerning painting, sculpture, and the graphic arts in nineteenth- and twentieth-century North America. His numerous studies of the life and work of Winslow Homer include three earlier volumes published by Syracuse University Press: *Winslow Homer and the Illustrated Book* (1992), *Winslow Homer in the Adirondacks* (1996), and *Winslow Homer and the Pictorial Press* (2003).

Contents

LIST OF ILLUSTRATIONS | *xi*

LIST OF MAPS | *xiii*

PREFACE | *xv*

ACKNOWLEDGMENTS | *xix*

1. Prout's Neck, 1903: *The Painter in His Prime* | *1*

2. New York, 1876–1880: *The Discontented Artist* | *8*

3. New York and London, 1880–1881: *London Envisioned and Found* | *18*

4. London, 1881: *The Neighborhood* | *29*

5. London, 1881–1882: *Art and Artists* | *57*

6. London, 1881: *The Houses of Parliament* | *67*

7. New York and Maine, 1882–1890: *The New Painter* | *78*

8. Prout's Neck, 1905–1910: *Edging Toward the Pantheon* | *90*

NOTES | *99*

BIBLIOGRAPHY | *115*

INDEX | *119*

Illustrations

COLOR PLATES

(following page 40)

1. Homer, *Early Morning after a Storm at Sea,* 1902

2. Homer, *Snap-the-Whip,* 1873

3. Homer, *The Tent (Summer by the Sea),* 1874

4. Homer, *Girl and Daisies,* 1878

5. Homer, *Shepherdesses Resting,* 1879

6. No. 80 Newman Street, photograph, 2008

7. Entrance to No. 80 Newman Street, photograph, 2008

8. Homer, *Mending the Tears,* 1888

9. Homer, *Hark! The Lark,* 1882

10. Homer, *The Houses of Parliament,* 1881

11. The Houses of Parliament, London, photograph, 2008

12. *Scene on the River at Westminster,* 1867

13. Roberts, *The Houses of Parliament from Millbank,* 1861

14. Homer, *Four Fishwives,* 1881

15. Homer, *An Afterglow,* 1883

16. Homer, *The Life Line,* 1884

FIGURES

1. Doré, *Westminster Stairs—Steamers Leaving,* 1872 | 24

2. Doré, *The Workmen's Train,* 1872 | 25

3. The Elgin Gallery of the British Museum | 61

4. View of the Lambeth riverside lined with cranes, 1860 | 75

Maps

Locus map of Homer's London sites *Frontispiece*

1. Newman Street, St. Marylebone, and environs | *31*

2. Map of the site from which in 1881 Homer painted
 The Houses of Parliament | *71*

Preface

This book examines Winslow Homer's metamorphosis at the midpoint of his career from a New York artist of great promise to a master of international standing. It considers the central and decisive role that London played in that change, while affirming that wherever Homer worked or resided, New York City remained the center of his world of art.

Homer had first crossed the Atlantic at age thirty in 1866, when, newly established as a leading figure in the younger generation of painters in New York, he sailed to France. The ten months he spent in and around Paris broadened and deepened his knowledge of the art of the past. They also sharpened his understanding of the painting styles of his own time. But his months in Paris led to no major changes in his style or his choice of subjects.

His second crossing occurred fifteen years later when he journeyed to Great Britain. Firmly established by then as an American fine artist, he arrived in England nonetheless dissatisfied with his status. The changes in his work that came so rapidly during his first months in England were of a kind that left little doubt that they were products of a brief but intense period of study during his first weeks there, which he spent in London. After his return to New York in November 1882 and during his later years in Maine, the sequence of oil paintings that came from his brush owed much in the most fundamental ways to a willed transformation begun in London.

Until the first decade of the twenty-first century, close to nothing was known of Homer's association with the great British metropolis. Not until 2006 did evidence appear to confirm that after reaching Liverpool (the usual port of entry for transatlantic voyagers to England), he had taken himself directly to London and spent at least three weeks in that city. For the next year and a half, he lived and worked some 270 miles north of London in the Northumberland fishing village of Cullercoats, close to Tynemouth and not far from the city of Newcastle-upon-Tyne. Though settled in the Northeast, he now and again traveled by rail down the east coast of England to rejoin metropolitan life.[1]

During his year and a half in England, Homer's style became both stronger and more subtle. He gained a new and impressive mastery of figure drawing. The natural world ceased to be a quiescent component of his compositions and took on a more active, even dominant, role. On his return to America, the scope of his subjects as a painter in oils became less local and topical, more universal and timeless. When he worked in transparent

watercolors, his technique became more recognizably British. Within a year and a half of his return to New York from England, critics and others set aside earlier reservations to acclaim him an American master of the first rank.

Homer's stay in Cullercoats has over the years attracted much scholarly attention. Indeed, articles, exhibitions, and monographs have documented his time in the village and its environs as well as along the coast with rather more thoroughness than many other vital moments in his career. Homer in Cullercoats has been documented far more fully than, say, Homer in Virginia in the 1870s or in the Bahamas in the 1880s. Knowledge of Homer in London, however, remained until 2006 almost a blank. The only significant document to endure from his time in the city seemed to be a pictorial one, a single painting in watercolors of a London subject, the Houses of Parliament. The task of constructing even a summary account of his presence in London had always been hampered by the fact that, so far as was known, nothing had survived of correspondence or other documents concerning his plans for a visit to the city.[2]

That I have been able to construct a preliminary sketch of his initial visit to London owes much to archival discoveries generously reported to me by two others. The first source was the late Tony Harrison of the United Kingdom (the historian of Homer in Cullercoats rather than the poet-playwright of the same name). The second, a year later, was Judith Walsh, professor of art conservation at Buffalo State College of the State University of New York and an authority on Homer's watercolors.[3] As discussed at greater length in later chapters, both discoveries have strengthened the belief that Homer's weeks in London played a decisive role in transforming his aims as an artist and in setting him in a direction that led to the major works of his maturity.

These reports, made initially in conversation, proved timely, for in 2005 I had begun to sort out research notes for a monographic article concerning Homer's sole painting of a London subject—his watercolor *The Houses of Parliament* (fig. 13). This work held more than ordinary interest on several counts. One was, as we have seen, that it had long been the most substantial piece of evidence confirming that the artist spent any time in London during his year and half in England. Another singularity was that only in this instance had he given a major work of architecture pride of place in a painting.

Tony Harrison had managed to locate Homer's place of residence in London during the early spring of 1881. He could now confirm the long-held assumption that Homer had indeed gone to London directly following his arrival in Liverpool. What Harrison found opened the way to his further discoveries, including (as discussed in chapter 3) the identities of the two artists, husband and wife, in whose lodging house Homer stayed and from whom he rented studio space. When I met with Harrison in London in February 2006 during the run of the exhibition Winslow Homer: Poet of the Sea at the Dulwich Picture Gallery, he shared with me a copy of the 1881 census report that established Homer's location in London. He told me that he had also determined the duration of Homer's visit to have

been at least three weeks, but added that until he completed his research into the source of that finding, he preferred to defer sharing its details with others. Some months later Harrison became seriously ill. He died the following year without having brought to publication an article in which he had planned to report his discoveries. Searches undertaken by his family have found neither drafts of his article nor notes relating to it.

In 2007, news arrived of a different discovery, this time by Professor Walsh. She had embarked on an investigation of the visitors books that had survived in London art institutions from the period when she assumed (correctly) that Homer had initially been in the city. She hoped that any such records still extant might document his museum visits. Most of the ledgerlike volumes in which museum staff recorded the names of visitors to certain galleries by date (a nineteenth-century practice) have not been preserved, but a volume for the year 1881 remains intact for the British Museum's Department of Prints and Drawings. In it, Professor Walsh found Homer's name and the date of his visit to an exhibition of drawings. Her discovery established for the first time that Homer, as she suspected, had spent some of his hours examining works of art in London. As she has pointed out, the implications of his visit to a museum to study drawings, perhaps some by Old Masters, are multiple. I am most grateful for her generosity in having shared with me details of her discovery prior to their publication as part of her essay on Homer's English work in the catalogue of the Art Institute of Chicago's exhibition Watercolors by Winslow Homer: The Color of Light (2008).[4] My own research has augmented Harrison's and Walsh's reports while pursuing other aspects of Homer in London.

The reader seeking a general historical introduction to Homer and his work might well begin with Lloyd Goodrich's biography *Winslow Homer* of 1944.[5] Despite its age, its lack of color reproductions, and a few errors of fact, it remains unsurpassed in its concision, in the clarity of its thought and prose, and in its author's felt response to Homer's paintings— Goodrich had himself trained as a painter. Since the 1960s, several other biographies have appeared, each with its own strengths and each to some degree clarifying, amplifying, and augmenting aspects of Goodrich's seminal study.

Goodrich devoted an insightful chapter to Homer's Cullercoats/Tynemouth work, but made no mention of Homer in London. More recent scholars who have examined Homer's English work and touched on London at least in passing include Helen Cooper in her *Winslow Homer Watercolors* (1986); Franklin Kelly in his chapter "A Process of Change" in the exhibition catalogue he coauthored with Nicolai Cikovsky Jr. for the National Gallery of Art, *Winslow Homer* (1995); as well Judith Walsh in her essay "More Skillful, More Refined, More Delicate" of 2008.[6]

An extensive listing of the large body of specialized Homer literature that accrued from his lifetime to the mid-1990s in the form of books, reviews, articles, and catalogue essays is readily available in the National Gallery exhibition catalogue noted previously, an exhibition shown also at the Museum of Fine Arts, Boston, and the Metropolitan Museum of

Art, New York. That volume contains a generous quantity of color reproductions.[7] A fuller bibliography, current through 2003, appears in Lloyd Goodrich and Abigail Booth Gerdts, *Record of Works by Winslow Homer*, vol. 1: *1846–1866*.[8] Less widely available, this work is the first of five projected volumes. Three had reached publication by the autumn of 2008.

My account of Homer's relationship to London is a preliminary one in many respects. It amounts to a small sketch of a large subject or, more accurately, several sketches of parts of a complex subject. I offer the study in the hope that as further documents may come to light, other scholars will be ready to render more fully the details of Homer's brief but crucially important life in London.

Acknowledgments

It is a pleasure to record my very great thanks to the American Philosophical Society for the award of a Franklin Research Grant, which enabled me to spend the autumn months of 2008 examining in London institutions a broad range of archival and other materials pertaining to Homer's time in that city. The results of my searches during those months illuminate much of the discussion in the chapters that follow. I am deeply grateful as well to the Gladys Krieble Delmas Foundation, the Rosamond Gifford Charitable Corporation, and Furthermore: a program of the J. M. Kaplan Fund for grants toward the costs of the volume's publication.

For sharing with me their important findings about Homer's time in London, I am most happy to express again my gratitude to Judith Walsh and the late Tony Harrison. I am pleased as well to acknowledge with thanks the expert and ever-helpful assistance given by the staffs of the institutions of specialized research I visited in 2007 and 2008: the Caird Library of the National Maritime Museum; the Maps Division, Rare Books and Music Division, Science Division, and Prints and Drawings Division of the British Library; the Camden Borough Archives; the City of Westminster Archives; the Guildhall Library of the City of London; the Lambeth Borough Archives; the Kensington and Chelsea Archives (Local Studies); the London Metropolitan Archives; the Marylebone Library; the Museum of London; the National Art Library; the National Meteorological Archives; the Palace of Westminster Collection of Works of Art; and the Worshipful Company of Goldsmiths.

For permission to quote from Ann Cox-Johnson's preface to her *Handlist of Painters, Sculptors, and Architects Associated with the Borough of St Marylebone, 1760–1960,* I thank the Westminster Archives, London. The *Handlist,* an invaluable resource for my project, was an early work of the distinguished historian of London architecture, topography, and culture Ann Saunders (née Cox-Johnson). For permission to quote from Pamela Taylor's essay on Fitzrovia in the Godfrey edition of *Old Ordnance Survey Maps,* I am much obliged to both Dr. Taylor and Alan Godfrey.

From the inception of this London-oriented study to its completion, much help has come from American sources. I am happy to express my appreciation to Kerry Brougher and members of the staff at the Smithsonian Institution's Hirshhorn Museum and Sculpture Gardens for sharing with me information from the museum's object file for Homer's

watercolor *The Houses of Parliament*. Thanks also go to colleagues and others who have encouraged this project from its inception—among them, Georgia Barnhill, Randall Bond, Sarah Burns, Peter Hornby, Patricia Junker, James O'Gorman, Edward Green, and Judith Walsh. At the Syracuse University Library, Edward Alan Gokey remained an invaluable and ever reliable source of needed information. Colleen Truax found time within her graduate studies to search British pictorial publications for images pertinent to Homer's time in London and to attend to other matters of research. Ellen Croisier skillfully managed the final preparation of illustrations and captions. At Syracuse University, Ann Skiold, Linda Straub, and Mary Selden Evans merit my great thanks for their helpfulness. David Prince of the Syracuse University Art Galleries deserves a medal for his patience when my work on Homer in London trimmed the time available for my involvement in an exhibition at the Galleries of works by Homer painted and drawn at Houghton Farm and elsewhere in New York State. Closer to home, Heila Martin-Person brought her expertise in graphic design to bear in the preparation of some of the photographic illustrations. Annie Barva has been a superb copy editor.

In closely examining two present-day localities in London that Homer knew well, one a stretch of Lambeth riverside now much changed and the other a neighborhood in Marylebone still to some small degree intact, I affirmed the old military adage that no reconnaissance well made is ever a waste of time. My discussions of these places have been enhanced by the clarity and good sense of Lucie Wellner's cartographic designs. Her schematic maps tell much about two urban environments that were of vital importance to Homer as a working artist.

For hospitality over many years in London and elsewhere in England, my wife and I owe heartfelt thanks to the late Felicity Ashbee, Bridget and John Cherry, Diana and Jerry Cinamon, Alan Crawford, Avril and Michael Denton, Norma and Chad Doveton, the late Bernhardt Friesen and his wife, Dorry, Eleanor and the late Tom Greeves, Patricia and Carl Heath, Tony Herbert and Cathy Huggins, Diana and Malcolm Whitaker, and the late Judy Whitaker. At the Syracuse University London Centre, my thanks for unfailing helpfulness go to Peter Leuner, Meredith Hyde, and their staff.

Looking to the past, I have not forgotten the expert assistance of George Lisle, who in 1966, on the occasion of my first visit to Cullercoats, led me on a sunny afternoon to several sites associated with Homer. When I returned there in 1984, Tony Harrison guided me to other Homer sites, introduced me to his fellow local historian John Boon, and arranged for a memorable conversation with the elderly Cud Simpson, whose well-remembered forebears included fishwives who had posed for Homer.

As I prepared this manuscript, it helped immeasurably that Cleota Reed, as so often before, took time from her own scholarly work to read and critique her husband's. For a book about London, whose myriad countenances she and I have examined together annually for more than a third of a century, her sharp eye and keen observations have counted

a very great deal. Back in America, where drafts and notes were sorted out and some of the text prepared, the most local of our grandchildren, Lucy and Zachary Person, found time to brighten the author's spirits even while they wondered what kept him so long at his laptop.

London
March 2009

Winslow Homer in London

1

Prout's Neck, 1903

The Painter in His Prime

In February 1903, Winslow Homer reached his sixty-seventh birthday. By then, he had lived and worked for nearly twenty years in a trim cottage overlooking the sea at Prout's Neck on the coast of Maine. For part of each winter, he tended to slip away to islands in the Caribbean or rivers in Florida. In warmer months, he went for a few weeks or more to forests and lakes in the Adirondacks or Quebec. Though he journeyed to these places to fish—he was a keen angler—he went also to paint, mostly in watercolors and mostly with results widely admired then and ever since. When he returned home to work on his oil paintings and to finish his watercolors, the Atlantic lapped and occasionally pounded not far from his doorstep.

Before settling in Maine, he had resided and maintained a studio in New York for nearly a quarter of a century. Though a Bostonian by birth, upbringing, and temperament, he had by the end of the Civil War become very much a New York artist. From the mid-1860s through the 1870s, he held a prominent place within the Manhattan milieu of painters and illustrators. When he moved to Maine in the spring of 1884, he distanced himself from most of his New York colleagues. He did so not only in miles, but also in personal relationships.

He reappeared in New York now and again, most often briefly, to visit relatives and to confer with his dealers. His new works regularly appeared on the walls of the city's exhibition spaces and in dealer's galleries. In this way, Homer remained a vital, if not often seen, presence in New York's art community.

A lifelong bachelor, he lived alone at Prout's, though often in the midst of others. Each summer his two brothers and their wives, his two nephews, and for many years his father arrived to occupy neighboring cottages. As the years passed, an ever-growing community of summer residents descended on Prout's in June and stayed into September. During the off-season, Homer had the occasional company of the locality's few year-round residents—farmers and fishermen and their families.

Four miles from his cottage by road stood the Boston and Maine Railroad's Scarboro Station. Southbound trains took him through southern Maine and a tip of New

Hampshire into Massachusetts and his native Boston, a city he still knew well. His younger brother Arthur resided near Boston in his later years. From Boston, Homer often continued on to New York to visit his older brother Charles and sister-in-law Martha (Mattie) and perhaps also to discuss business with a dealer or to dine at his club, the Century Association.

Scarboro's northbound trains took him to Portland in a matter of minutes—the city was all of ten miles distant. There he now and again lunched with fellow members at the Cumberland Club. One of his Prout's Neck oils, *A Summer Night* (1890, Musée D'Orsay, Paris) resided on loan in the clubhouse for nearly a decade. Homer connected himself quietly to the life of this bustling corner of New England. Back at his cottage, the hours and days of solitude, about which he made no complaint, gave him time to get his work done.

Throughout his years at Prout's Neck, critics and journalists in New York and Boston occasionally referred to him as a recluse. They found it difficult to explain why a prominent, successful, and still active artist should choose to abandon the center of the American art world to become, as the press occasionally described him, a kind of hermit-by-the-sea.[1] Yet the image of Homer as hermit scarcely suited him. Though he lived quietly in Maine, he had certainly not detached himself from either his New York interests or the greater world. He oversaw property matters for himself and his family as they developed Prout's Neck into a select summer compound. He kept an eye on prices current in the art world and constantly pressed his dealers to do better by him. In addition to his twice-a-year (or more) excursions to warmer or cooler climates, he traveled occasionally not only to Boston and New York, but also to Chicago, Philadelphia, Montreal, and other cities. When away on fishing expeditions, he stayed at select clubs and good hotels.

He could easily enough have refuted the press's image of him as a solitary soul living apart from society, but he made no effort to do so. Indeed, he reinforced the image of himself as a recluse by brusquely declining interviews with journalists and discouraging visits to Maine from longtime friends and former colleagues. He was not so much a hermit at Prout's Neck as a painter disaffected from many aspects of the world of American art. He had separated himself from nearly all fellow artists and members of the art press. He maintained connections in that world chiefly to those persons essential to the exhibition and sale of his work.

He had always been a person of some austerity and reserve. These traits had been evident even in his early years in New York. At that time, his aloofness had been ameliorated by the collegiality of fellow New York artists, whose studios, including his own, clustered together in the New York University Building on Washington Square or, later, at the Tenth Street Studio Building. Homer in the 1860s and 1870s may have seemed more taciturn than most of his colleagues, but as a purebred Bostonian he was perhaps half-expected to embody the stereotypically Yankee hallmark of economy in all things, including words and personal expressiveness. Even in those early years, however, his colleagues must have

been willing to accept him just as he was in consideration of his talents, so impressively promising and so markedly individual.

It was a rare occasion, then, when years later, in September 1903, Homer cordially and generously played host at Prout's for some days to John Beatty, director of the Department of Fine Arts at Pittsburgh's Carnegie Institute. Homer and Beatty had been acquainted for half-a-dozen years. Through Beatty's good efforts, the Carnegie in 1896 had acquired for a handsome price the painter's oil *The Wreck*.[2] Then, in 1897 at Beatty's request, Homer served on the jury of the Carnegie's international exhibition of contemporary art.[3] He would do so again in 1901.

As reserved and even brittle as Homer tended to be in his later years with many people in his profession, he unbuckled a bit when Beatty visited Prout's. The two men fished and painted together, enjoyed a clambake with "Neckers" (local residents), and joined Charles and Mattie for evening repasts at the Ark—the Homer family's large seaside summer house next to the artist's cottage.[4] Years later Beatty described Homer's friends among the locals as "plain, common-sense men . . . [whose] conversation was practical, earnest, and intelligent."[5] This observation reinforces a conclusion that Homer's disagreeableness as a social animal in all but the last of his years occurred mainly in the presence of persons, Beatty and few others excepted, involved one way or another with the world of art.[6]

In observing Homer during these days at Prout's and on a later visit, Beatty tried to identify those aspects of the man that explained his work.

> The chief qualities that made up Homer's character were, I think, simplicity, earnestness, absolute honesty, concentration on his art, and a straightforward manner of thinking and acting. These qualities account for the direct and forceful character of his paintings. . . . [But] another side of his character was that of almost childlike simplicity. . . . I have long since had the opinion that Homer is possessed of a [great] deal of native shrewdness and business sense, and I still have this opinion; but he has another side, and it is that of a child. He seems to be a simple child of nature.[7]

Though the notion of Homer as a child of nature seems odd in the case of a man of middle-class propriety who invariably attired himself in meticulous good taste, Beatty's comments constitute perhaps the fullest and most considered contemporary assessment of Homer's character and manner.[8]

It is easy to wish that during his visit Beatty had managed to pose questions about several points in Homer's career that have ever since seemed crucial to his development. What, for instance, did Homer believe had enabled him in midcareer to leap beyond his reputation as a distinctly original artist of much promise to become, with great rapidity, nothing less than a figure of major achievement, an American painter of the highest rank?

Indeed, in the minds of some of his contemporaries, Beatty among them, Homer in the 1880s became with some suddenness the preeminent American artist of his time.

Even in Homer's lifetime, it was understood that this metamorphosis from promise to realization occurred during the year and a half, in 1881 and 1882, that he had spent in England. Immediately afterward, while he resided in New York for a further year and a half before departing for Maine, critics and other artists praised the new powers so clearly evident in the work he brought home from England. They then acclaimed the increase of these powers in the first oil he painted after his return, *The Life Line* (plate 16) when it went on show in 1884 fresh from his New York studio.

Beatty's account of his visit to Prout's makes no specific reference to Homer's time in England, but it does report conversations that touch indirectly on that episode. Each evening after the two men had dined with Charles and Mattie at the Ark, Beatty joined Homer in his cottage's studio room for a nightcap and chat before he returned to his nearby hotel.[9] In one of these conversations, he gained a glimpse of Homer's critical eye in relation to the work of a notable painter of his era, the American expatriate James Abbott McNeill Whistler. It was a timely discussion, for Whistler had died in London two months before Beatty's visit. Beatty recalled Homer remarking, "I am surprised because he did not leave more works. . . . His mother's portrait and [Thomas] Carlyle are important pictures, but I don't think those symphonies and queer things Ruskin objected to will live any great while."[10]

Homer's bias as a realist painter informed this estimate of the staying power of Whistler's less conventional works (an estimate that, of course, has proven to be off the mark). But his comment suggests a familiarity with Whistler's work, which encourages an assumption that he had seen a great deal of it, some certainly in the spring of 1881 in London art galleries when much of it was on display. Whether Homer met Whistler himself in London is another matter, as we shall see.

More illuminating than Homer's views of the work of another painter is Beatty's account of how Homer saw the trajectory of his own career. The subject arose in the course of a nightcap discussion when a pair of Beatty's questions brought responses that surprised him. He first asked Homer if he kept a record of his oil paintings. Receiving the reply, "Certainly not!" he next suggested that perhaps the total of Homer's oils might amount to some two hundred canvases. The reply came again, "Certainly not," but Homer then followed with a qualification: "I think if you mean my important paintings, probably twenty-five."[11]

This remark seems to have taken Beatty by surprise—he must have expected a considerably greater number. (By 1903, in fact, Homer had painted more than two hundred oils.) But Beatty evidently failed to ask the question that naturally followed: What qualified an oil painting for inclusion in this select group of two dozen or so "important" works?

Homer's answer to that question would almost certainly have mentioned as objective criteria for a painting's importance three things above all: a substantial purchase prize,

a medal awarded in a major exhibition, and a major museum's eagerness to acquire the work.[12] Of these criteria, Homer seems to have valued substantial purchase prizes most highly, or so we may judge from oft-repeated comments throughout his later years to the effect that for him the making of art was first and foremost a business. This was to some extent a natural thing for him to say, for his forebears included generations of Boston merchants who counted their professional success in terms of dollars earned and profits made. Within his home from childhood onward, the significance of financial success or lack of it was ever present. Homer's brother Charles—his lifelong closest friend—profited handsomely from his career as an industrial chemist.[13] Contrariwise, their father, Charles Homer Sr., cultivated a show of bravado to cloak the repeated failures of his business ventures. This family dynamic gave Homer reason to count as important any painting that brought him a substantial amount of money. That few of his paintings had achieved this end until his post-England years had always been a source of annoyance, but it had never deterred him from painting what he chose to paint.

Beatty would probably have understood that the paintings that Homer considered important included only those he had completed since his return from England. Scarcely any of his earlier works met his criteria. He apparently viewed most of his paintings of the 1860s and 1870s as scarcely more than juvenilia, efforts peripheral to a small core of mature works and no longer meriting his interest. Indeed, as much as twenty years earlier he had declared himself "sick" of hearing of his much-praised Civil War oil *Prisoners from the Front* (1866, Metropolitan Museum of Art).[14]

All of the two dozen or so paintings he now held to be important were without question oils. Despite the rising acceptance in America of watercolor as a medium for fine art rather than for utilitarian or amateur applications, an artist's reputation in Homer's generation still rested on his or her achievements as a painter in oils. The oil medium allowed a largeness of scale, richness and permanence of color (some watercolor pigments were notoriously fugitive), depth of surface texture, and other qualities difficult or impossible to achieve in the water-based medium. For Homer's generation, the celebrated masterworks of the past were nearly always oil paintings. Any hope that he had of gaining a reputation as one of his generation's contributors to the Western world's historical inventory of great works of fine art thus depended on his achievements as an artist who painted in oils.

Nonetheless, he found reasons to drive ahead concurrently as a painter in watercolors. His work in the medium often earned more unreserved critical praise than did his oils. His watercolors sold more regularly than did his works on canvas. He painted them more rapidly and in greater quantity. He was at the head of his field as a painter in watercolors in America in the 1880s, as he was not so clearly in oils, and he meant to remain in the forefront. Here, too, England had made him an even more proficient master of the medium. It had opened the way to his quite exceptional post-1884 achievements in the Caribbean, the Adirondacks, Florida, and Quebec.

Homer's time in England became nothing less than the crucial pivot point of his career. It divided his many earlier oil paintings from the relatively few of his long maturity. It shifted his subjects from the depiction of American life of his own times—depictions that he had painted with such quietly original insights throughout the 1860s and 1870s—to themes of a more universal nature. The natural world ceased to serve only as background in his oil paintings and became instead a major subject in itself, often the sole subject. His draughtsmanship showed new strengths. A more dynamic level of energy infused his oils. His brushwork became bolder; his thinking about color more complex. He constrained the literary content of his paintings, giving greater emphasis to design and mediumistic expression.

How did this happen? That he spent most of his long English sojourn facing the North Sea in the Northumberland fishing village of Cullercoats close by Tynemouth has made it essential to look there for clues to help explain his transformation. And, without question, Homer's relationships with both the Cullercoats fisherfolk and the turbulent North Sea counted for much in the reshaping of his thinking and practice as a painter.

But Cullercoats was neither Homer's only stopping point in England nor his first. He began by spending at least three weeks in London immediately after his arrival from America and saw more of that city later. There is no way of knowing with anything approaching exactitude the role that London played in his transformation, but in more general terms the city contributed to the rapid growth of his powers through its museum collections, its proprietary galleries, and its community of working artists. Homer undoubtedly brought to these resources an agenda of things he was determined to learn, things that he felt would propel him forward as a painter in both oils and watercolors. Beyond such particulars, London offered a cultural ethos much richer and more sophisticated than anything that New York could offer, an ethos that encouraged an artist of Homer's drive to believe that he could accomplish what he set out to do.

He lost no time in London in pursuing his goals. Beginning with what must certainly have been intensive study in London's museums, galleries, and perhaps elsewhere, and followed in Cullercoats by an equally intensive putting to use of what he had learned, he remade himself as an artist.[15] Without the outright mimicking of anything in English art or surrendering anything fundamentally distinctive to his own style, he made his great leap. When he returned home, he was, indeed, greeted as a "new" painter.

<p style="text-align:center">∾</p>

BY THE TIME of Beatty's visit in 1903, Homer was in his prime. A decade had passed since *The Life Line* had established him in New York without question as a major American master. The body of oils and watercolors that had followed steadily increased his stature. His honors multiplied. The size of his bank accounts attested to the robust sales of his work.[16] Once-hesitant critics now wrote glowing reviews. Art museums that had as a matter of

policy remained reluctant if not unwilling to acquire works by living artists now actively sought his.

These successes failed, however, to mellow Homer. Consider, for instance, his comments to Beatty in a letter written a few weeks after his friend's visit. During those weeks, Homer had repainted parts of an oil he had finished the previous year, his impressive *Early Morning after a Storm at Sea* (plate 1).

This painting of a wave rolling against the coast at Prout's had been exhibited earlier in 1903 in Chicago and New York. In the former city, it received solid praise, but in the latter it attracted at least two negative reviews. In one of them, the critic wrote that "the foam is not foam but some strange, uncanny shape and color." Another critic said that *Early Morning* represents "a heaving sea of chalk and pink, with waves topped by bunches of wool, and the distant stretches of his ocean are illuminated with milk."[17] These reviews stuck in Homer's craw.

When the painting failed to sell following these showings, Homer elected to send it to Pittsburgh for the Carnegie's annual exhibition. Writing to Beatty for the first time since his friend had visited Prout's, Homer managed in a postscript to be, as was so often the case with friends in his late years, at once amiable and acerbic: "I enjoyed your visit here very much and I have to give you my sincere thanks for the lectures on Art that you unloaded and practiced on me. The result has been wonderful—here is a picture that was laughed at at the Society of American Artists and now in ten days' work changed into this work that I am now sending to your exhibition—and I am proud of it."[18] The astringent mixture of pride and resentment, gratitude and defensiveness, hope and doubt so apparent in this letter had been part of Homer's existence as an artist at least since the late 1870s. It had then begun to complicate his life, even as he prepared to take himself to London.

2

New York, 1876–1880

The Discontented Artist

Homer spent the decade before leaving for London well settled in Manhattan. Since 1859, he had resided at Mrs. Alexander Cushman's highly respectable boarding house on East Sixteenth Street, which placed him within an easy walk of his studio some streets to the south in the New York University Building on Washington Square. In 1872, he moved his easels and brushes to the more select Tenth Street Studio Building and worked there for the rest of the decade. In all these places, he was never very far from the new (1865) Ruskinian Gothic building of the National Academy of Design, an imposing presence at Twenty-third Street and Fourth Avenue (now Park Avenue South).

At the start of the decade, he frequently traveled by train to Boston to visit his parents and various cousins in suburban Belmont, as well as Charles and Mattie farther north in Lawrence. By 1872, however, he journeyed to Boston less often, for his key Massachusetts relatives had moved to New York. Charles and Mattie now resided on Washington Square. His parents had settled in Brooklyn near Mrs. Homer's brother, Arthur Benson, who shared with his nephew an abiding interest in fly-fishing. This was a closely knit family.

As was the case with many artists in New York in the 1870s, Homer annually absented himself from the city from June into October to sketch and paint in cooler, more picturesque, less crowded settings. During the decade, he worked at several locations in New York State, including East Hampton on Long Island (he was among the first artists of note to do so), the Catskills, the Adirondacks, Saratoga, Hurley and Leeds on the Hudson, and Mountainville in Orange County. He could occasionally be found at beaches in Massachusetts and New Jersey. At most of these places, he spent no more than a few weeks before moving on to another location.

This routine of annual summer travels alternating with cooler months in New York City gives a sense of uniformity to Homer's life and work throughout the 1870s. But so far as subjects and style were concerned, the decade was divided at its center. During the first half, he developed and elaborated those things that had brought him success in the years just after the end of the Civil War. These subjects included the newly popular game of croquet, country schools, rural children, mountain bridle paths, and the pleasures of the

seaside. He had treated these subjects with an originality of concept that gained him much praise. His observations were acute, and his sense of timing keen.

The paintings he had made late in the 1860s of genteel croquet matches in the immediate postwar years had succeeded the depictions of army camp life and muddy battlefields that had brought him his early fame. Chief among the latter was his much praised *Prisoners from the Front* (1866, Metropolitan Museum of Art). When he shifted from images of war to those of peace, he left behind an all-male world to paint one occupied by both sexes. In doing so, he became the first painter of note to portray the American "New Woman" in her varied guises. He set her most often on croquet lawns, at beach resorts, and along mountain bridle paths, but not in urban surroundings. She appears young, self-sufficient, unpretentiously stylish, quietly confident, unassociated with the domestic sphere, and without doubt a product of the affluent middle class. The younger generation of New York society was certain to have recognized her as one of its own.[1]

At about the same time, he turned to the countryside, where in a range of rural subjects he depicted most memorably country children at school, at play, and at rest. He was confident enough about his oil *Snap-the-Whip* (1872, Butler Art Institute, Youngstown, Ohio) to create a near replica of it and also a woodblock drawing of it for publication as a wood engraving in *Harper's Weekly* in 1873 (plate 2). He less often took as his subject farmers and their wives. As he did in his depictions of the New Woman, he placed his rustic figures in a world of sunshine and fair weather. Some critics and much of the public found in these idealizations of American rural life a transcendent quality of "truth," a quality then (as now) believed to be difficult to define but easy to feel. This assessment brushed aside any concerns about the disjuncture between the reality of that life and Homer's portrayal of it.

At the seaside, he again concerned himself with women rather than with men as subjects. In *The Tent (Summer by the Sea)* painted at East Hampton probably in 1874 (plate 3), women make use of a spacious, well-furnished, open-ended sun shade. What little we see of the comfortable furnishings of this interior and its casually seated figure relieves the objective, almost documentary directness of the image. This realism was harder and stronger here than in most of his other works of these years. Nevertheless, his paintings of this first half of the 1870s projected a remarkable consistency of vision and confidence of manner. They support the belief that the first half of the decade was in many respects a time when Homer was reasonably content with both his production and, despite occasional critical carpings, its reception.

In the decade's second half, however, he found himself needing to respond to a growing number of troubling circumstances in New York's art world. These changes had begun even before mid-decade with the Panic of 1873. That collapse of the nation's financial world brought on an economic recession that depressed the art market severely. There was no quick recovery. Three years later, in 1876, Homer commented to the *New-York Tribune* on

"the dull market for pictures."[2] He might well have repeated the remark annually to the end of the decade.

To make matters worse, by the mid-1870s the National Academy of Design, for many years an institution of great stability and one in whose affairs Homer had been a loyal participant, found itself beset by internal dissentions. The Society of American Artists formed as a rival organization. Invited to join the society, Homer demurred, but he also lessened his once close association with the academy.

A souring of the national mood presented further challenges for painters of American life. As scandals in high places became increasingly endemic throughout the 1870s in the worlds of government, business, and private life, the postwar optimism, even innocence, of Homer's croquet scenes of the late 1860s and his country children of the early 1870s seemed no longer apropos. In New York City, the exposure of the Tweed Ring's patterns of graft and outright theft in the early 1870s marked the beginning of a long and disheartening sequence of scandals in government that eventually tainted even President Grant's reputation. By mid-decade, the all too evident failure of Reconstruction added to a sense of national malaise. The freshness of Homer's pre-1876 paintings of American life must have soon seemed to recall a past era.

A new mood now arose in New York's art world, one that welcomed an increasingly cosmopolitan outlook. From Europe came new developments in style along with the intellectual currents that sustained them. These new ways of thinking about art unsettled the old order of taste and patronage that had reigned in New York throughout Homer's earlier career as a painter. The arrivals included inklings—and often more than that—of the Aesthetic Movement, the Arts and Crafts Movement, Japonisme, impressionism, symbolism, and more. The exhibition of international contemporary art at the Centennial Exposition at Philadelphia in 1876 had broadened and sharpened the American art community's knowledge of these new departures in taste, practice, and modes of thought. Not all the new movements and styles were well understood, had yet gained standard names, or yet made an immediate or lasting impact in America in the 1870s. But varied as they were, they held one thing in common: a negation of the primacy or even the worth of realism.

Realist painters in America, such as Homer, who had met with praise over the years for their distinctly national subjects and the "truth" of their depictions now had reason to fear that they would seem not only geographically provincial in relation to European art, but bound also to a waning set of beliefs at home about art as mimesis.

And then there was the ever more pertinent question of what constituted American subjects. Did it make sense in an era of growing urbanization, immigration, industrialization, and technological advance in transportation, communication, and other fields to continue to produce images of an idealized agrarian society, as Homer had done throughout the first half of the 1870s? Were the American qualities sometimes attributed to his style likely to carry much weight in an era of diminishing interest in a fine art that addressed

only a national audience? Homer's directness of pictorial statement, his Emersonian self-reliance, his seemingly plainspoken evocation of democratic culture—all these had earlier appeared to be strongly positive attributes of his style. Now, in the midst of rapidly arriving international art movements, his "American" qualities seemed increasingly irrelevant.[3]

This downgrading of American subjects, however slight, helps to explain the tone of some reviews of Homer's work in New York at mid-decade—especially a review by Henry James in the July 1875 number of the New York literary monthly *The Galaxy.* At thirty-two, James was seven years younger than Homer. He had already traveled much in Europe and was soon to settle in London as an expatriate. In 1876 after a stay in France, he established his residence on Bolton Street, off Piccadilly, across from Green Park.[4] He was still some years from attaining his reputation in the literary world as the Master.

Reviewing art exhibitions was not James's specialty. His *Galaxy* review was a one-off for a writer already committed to fiction. Here, for a change, he surveyed New York's recently ended season of fine-art exhibitions. In passages much quoted since, he complained elegantly about Homer's rustic subjects and the manner in which he had treated them, while admitting, almost grudgingly, the strength and originality of the artist's work. Homer's response, if any, to James's essay as expressed to colleagues and family is unknown, but the review appeared at a key moment in his career, when he was ready to alter the course of his development. Whether James's review can be held to any degree accountable for the direction of change that soon occurred is doubtful, but it may well have spurred Homer to leave behind what he had been doing.

James wrote:

> The most striking pictures in the [National Academy] exhibition were perhaps those of Mr. Homer. . . . Before Mr. Homer's little barefoot urchins and little girls in calico sunbonnets, straddling beneath a cloudless sky upon the national rail fence, the whole effort of the critic is instinctively to contract himself, to double himself up, as it were, so that he can creep into the problem and examine it humbly and patiently, if a trifle wonderingly. Mr. Homer's pictures, in other words, imply no explanatory sonnets; the artist turns his back squarely and frankly upon literature. . . . Mr. Homer goes in, as the phrase is, for perfect realism, and cares not a jot for such fantastic hairsplitting as the distinction between beauty and ugliness. He is a genuine painter; that is, to see, and to reproduce what he sees, is his only care; to think, to imagine, to select, to refine, to compose, to drop into any of the intellectual tricks with which other people sometimes try to eke out the dull pictorial vision—all this Mr. Homer triumphantly avoids. He not only has no imagination, but he contrives to elevate this rather blighting negative into a blooming and honorable positive. He is almost barbarously simple, and, to our eye, he is horribly ugly, but there is nevertheless something one likes about him. What is it? For ourselves, it is not his subjects. . . . He has chosen the least pictorial features of the least pictorial range of scenery and civilization; he has resolutely treated them as if they *were* pictorial, as if they were every inch as good as Capri or

Tangiers; and, to reward his audacity, he has incontestably succeeded. . . . Mr. Homer has the great merit, moreover, that he naturally sees everything with its envelope of light and air. . . . He sees not in lines, but in masses. . . . If his masses were only a trifle more broken, and his brush a good deal richer—if he had a good deal more secrets and mysteries and coquetries, he would be, with his vigorous way of looking and seeing . . . an almost distinguished painter.[5]

Biographers have described James's review as a "devastating" one, but its effect was hardly anything so simple as that.[6] It seems likely that Homer was not much pleased by it, but he may have been to some degree prepared for it, as we will see. James's primary motive in his essay needs in any event to be seen not so much as an assault on Homer as an advertisement of his own imposing literary skills. It is a display piece, a show of splendid prose fashioned to outshine and upstage the reviews of other New York critics. The essay needs also to be seen as James's means of complaining about what seemed to pass for high culture in America by conferring a degree of qualified importance on Homer as perhaps the best that his immature society had been able to produce. James, despite his reservations, specified Homer's paintings as "the most striking pictures in the exhibition" before presenting his sequence of deflating reservations.

James's reserved praise amounted to an expression of his growing aversion to American culture in general. That culture offered, as he said in his review, the "least pictorial range of scenery and civilization." To describe American scenery as pictorially inferior was to send the Hudson River School packing, and in this approach he echoed his generation's fading interest in the works of Thomas Cole, Frederic Church, Asher B. Durand, and their many followers. Homer from the start had dismissed the conventions of that style. But for James to say more generally that American civilization in itself was unpictorial was to damn the culture as a whole. It implied that the nation's society was unworthy of a serious artist's talents.

The more that Homer's paintings seemed to embody James's vision of a still-unrefined American civilization, the more difficult it would be for James to find much that was agreeable in Homer's work. The "lack of finish" in his paintings—that critics often remarked upon during the first half of the 1870s—offered James an opportunity to find an unhappy correspondence between an artist and a society that together struck him as roughly hewn. Homer's apparent lack of interest in the intellectual or imaginative realms of art, at least in his offerings of the 1875 season, gave James a chance to assume that the materialism of American society had blighted the work of an artist of unusual promise.

Throughout his long career, James maintained an interest in art and artists both in life and in his work, though not as a professional reviewer of exhibitions. Among the best known of his literary treatments of the world of art is his story "The Real Thing" (1892) with its interplay of social class, money, models, and an artist's need to sort reality from

illusion.[7] Much earlier, however, seven years before his *Galaxy* review of New York's 1875 exhibition season, James had published a short story that revealed even at this very early point in his career—he was all of twenty-four at the time—a critical stance that would echo in his 1875 essay. "The Story of a Masterpiece," his sixth published tale, appeared in the January and February 1868 numbers of *The Galaxy*. In one passage, a wealthy connoisseur examines a not-yet-finished portrait he has commissioned of his fiancée and says to the young painter,

> "I'm sure it's the best picture you've painted."
>
> "I honestly believe it is. Some parts of it . . . are excellent."
>
> "It's obvious." "But either those parts or others are singularly disagreeable. . . . They are too hard, too strong, of too frank a reality. In a word, your picture frightens me. . . ."
>
> "I'm sorry for what's disagreeable; but I meant it all to be real. I go in for reality; you must have seen that."
>
> "I approve you. I can't too much admire the broad and firm methods you've taken for reaching the same reality. But you can be real without being brutal—without attempting, as one may say, to be *actual*."[8]

Later, in his review of the 1875 art season, James would resurrect this question of taste when he referred doubtfully to Homer's "perfect realism."

Homer well might have read this story in *The Galaxy* when it appeared in 1868, for he was then already at work preparing illustrations that would be published in the same magazine a few months later.[9] If he had remembered its key moments, he would have known of its author's antipathy to realism, which might have softened the blow when the 1875 review arrived. Both Homer and James appeared in the pages of *The Galaxy* occasionally over the next few years.[10]

The complaints about critics' reviews that Homer and other New York artists must have aired among themselves in the 1870s had some validity. The profession of criticism in America had not yet moved very far beyond the old practice of prescriptive or legislative criticism. In this approach, a reviewer considered the ways in which a given work was (or was not) in accord with academy teachings. James built his review in part on just such an expectation that "good" subject paintings should have a literary program and that a painting's formal qualities should adhere to the academic standards of the day. Some critics went further, as James did to a degree, and attempted to practice a kind of aesthetic criticism in which they considered the nature of an artist's creative act and described the viewer's (i.e., the critic's) felt response.[11] The intrinsic originality of Homer's paintings, the continuing development of his style, his shift from one group of subjects to another every year or so, his proficiency in more than one medium—all this required critics of the 1870s to look and think freshly about his work. Most of them found this challenge difficult to meet.

More worrisome for Homer, perhaps, was the New York critics and collectors' growing interest in a new wave of younger American painters. These artists' arrival on the scene posed an implicit challenge to his status. Some of the new breed had returned from study in Europe—from Munich and Paris in particular. Others were home-grown products. The work of some of these newer artists, a few of whom had no special interest in American subject matter, met with enough acclaim to make Homer feel that others were edging him aside within New York's relatively small art world.

This development was unsettling. A decade earlier Homer had been greeted as perhaps the most promising painter of his generation. As recently as 1876, when he reached age forty, his new *Breezing Up* (National Gallery of Art) had, like his *Prisoners from the Front* a decade earlier, gained much praise from critics. By the next year, however, the press busied itself welcoming younger painters in terms Homer had once heard used about himself. He had reason to suppose that his reputation was slipping into shadows cast by such new arrivals as William Merritt Chase and Frank Duveneck, each of whom was still in his twenties. Both had recently returned to America from study in Munich, bringing with them a European outlook in subject and style that gained gratifyingly warm reviews from the press.

Especially galling for Homer must have been the praise heaped on young American-trained artists whose subjects, like his, dealt with American life. An account survives of his dismay in 1877 on reading reviews of the annual exhibition of the American Watercolor Society. The account comes from the unpublished memoirs of the sculptor James Edward Kelly, who years later recalled the morning on which the first newspaper reviews of the exhibition arrived. Kelly, then age twenty-one, was a junior member of the Harper Brothers' art department. He worked with Edwin Austin Abbey, who, three years older, was a Harper staff artist with a fast-rising reputation as a book illustrator. Both young men admired Homer as an artist and respected him as a person. They had met him when, as a freelance illustrator, he had delivered drawings to the Harper firm's art room.[12]

In the weeks leading to the Watercolor Society's exhibition, Abbey had posed for Kelly, who was making a drawing to illustrate Walt Whitman's Civil War poem "Vigil Strange." Kelly had returned the favor by posing for the coachman in Abbey's watercolor painting *The Stage Office*. The Watercolor Society accepted Abbey's watercolor for its annual exhibition. Homer had five watercolors in the show; they received mixed reviews.[13]

Abbey had better luck. On opening night, *The Stage Office* attracted much attention and sold for three hundred dollars. Such a debut was remarkable for a then little-known painter. Kelly recalled what happened the next day in the art room.

> We got the morning's papers and began to read the criticisms. All sounded his [Abbey's] praises. This seemed to rouse him. Notice after notice was read, each proclaiming him the success of the year. He began to laugh like a boy. . . . He would read an article, or I would

read one, and he would then jump up, begin to sing, or dance a walk-around. Some of the papers compared him with Winslow Homer, to Homer's disadvantage. At this he looked serious, then annoyed. "I don't like that. I don't like that," he said and began to pace the room impatiently. Then, putting on his hat, he started round to Homer's. On his return he told me, "Homer seemed cut up over the article, and said, 'All these years they have been calling me a rising young artist, and now in one day they call me an old fossil.'"[14]

Homer saw Abbey occasionally over the next year or two at meetings of the Tile Club.[15] He saw him also at events arranged by the Harper publishing firm prior to Abbey's departure for England late in 1878, on assignment by the publisher. Entranced by London, Abbey quickly became acquainted with many of its artists. He may have provided Homer with useful information prior to the older artist's journey to the city, but no evidence of it seems to have survived. Indeed, in March 1881 Abbey seems to have been unaware of Homer's plans to visit London.

The overall strengthening of virtually every aspect of Homer's work in both oil and watercolor between 1876 and 1880 and his rapid move in those years from subject to subject almost certainly owed something to a freshly perceived need to compete not only with a new wave of artists, but also with himself. Within a year of James's review, he had taken himself to Virginia, apparently for the first time since the war, to paint African American life in the aftermath of Reconstruction. Oils such as *A Visit from the Old Mistress* (1876, Smithsonian American Art Museum), where he arranged the figures to echo those of his *Prisoners from the Front*, made a telling contribution to the year of the nation's centennial. Here was a painting, pace James, with a literary program (admittedly from recent history rather than from poetry or myth) that engaged the intellect and the emotions.

The next year, 1877, Homer veered in a different direction and exhibited several highly finished watercolors of finely attired young women engaged in genteel pastimes. In them, such as *Backgammon* (Fine Arts Museum of San Francisco), he responded in his own ways to the Aesthetic Movement and, more subtly, to the vogue for Japanese design as well. These pleasing figures are at far remove from the American rusticity that James found so dispiriting. Later in 1877 Homer left behind this engagement with quiet beauty and painted a trio of strong oils of figures in the rugged terrain of the Adirondacks. The trio included both *The Two Guides* (Sterling and Francine Clark Art Institute, Williamstown, Massachusetts), with its integration of hearty woodsmen and a wilderness setting, and *In the Mountains* (Brooklyn Museum of Art), with its band of women hikers on a high trail, free of any need for a male guide. With this latter painting, Homer returned to the New Woman, showing her to be even more resourcefully independent than before.

Then in 1878 came Homer's association with his friend and patron Lawson Valentine's new summer residence, Houghton Farm, at Mountainville in New York State's Orange County. From visits extending through spring, summer, and autumn of that year, he

produced a large and quite remarkable body of watercolors. His vision of farm life in these works departed in almost every way from that of his pre-1876 rural subjects. Breaking from his realist mode, he created a near idyllic, sometimes lyric, often intimate, forever youthful pastoral world, a kind of parallel universe to the one Valentine was then in a process of creating.[16]

It is now clear that Homer's long season at Houghton Farm amounted to a laboratory session of sorts in which he worked in alternating sessions of transparent watercolor and gouache (opaque watercolor). He delved more deeply into the properties of both, learning more precisely than ever before the merits and limitations of each. Transparent watercolor had long been associated with British practice; gouache was traditionally French. By the end of the season, he had committed himself to work henceforth almost exclusively in transparent watercolor. Already an American master of the medium, he must now have concluded that he needed to study the work of great British practitioners to advance farther. At some point, presumably after he had completed his 1878 season at the farm, he concluded that a visit to London was in order.

Homer's success with both types of watercolor in 1878 was remarkable. The depth and richness of the surface of his gouache *Girl and Daisies* (plate 4) reinforced the large concept contained within this small work. The girl's bonnet-shaded face expresses touchingly quiet feelings. The diagonal axes of the flowers and the sloping hillside and the crownlike array of tree limbs vitalize the composition. In his transparent watercolor *Shepherdesses Resting* (plate 5), dated 1879 and probably developed from sketches made at the farm the previous summer, the whiteness of the underlying paper invigorates the washes of color.[17] It is a quietly humorous work of the imagination, light in substance but finely composed and captivating in its charm. Compared to *Tent* of five years earlier, it reveals an altogether different hand and mind at work. One wonders how James might have responded to these elegantly composed pastorals.

Critics and the public alike applauded the 1878 watercolors when they reached exhibition in New York early in 1879. In 1880, Homer's summer at Gloucester brought forth another large body of transparent watercolors, different in subject and mood from those produced at Houghton Farm and even more adventurous in technique and effect.

Perhaps the pace of innovation and self-redefinition was too rapid for the critics; their reviews of the late 1870s remained problematic. For this or other reasons, by the end of the decade Homer seems to have become irritated with his life as an artist in New York. His curmudgeonly manner began to assert itself.[18] Despite his accomplishments, he seemed to be a deeply discontented artist. Moreover, he must by then have reached a conclusion that there was nothing more for him to learn from his colleagues in New York.

In the twentieth-century, a few commentators, in print or otherwise, have proposed that personal problems in New York in the late 1870s impelled Homer to flee to England. These conjectural assessments of his mind, emotions, and habits suggest that he absented

himself from the center of the American art world to recover from a failed affair of the heart, to dry out after a prolonged period of immoderate imbibing, and to escape relentless criticism from the art press.[19]

No basis in fact exists for any of these or any other sensational speculations about the motives for Homer's departure for Great Britain. The work he produced in the last half of the 1870s, so varied in subject, so original in concept, and so confident in execution, hardly suggests an emotional impairment. The evidence of what he did in London and Culler-coats and what he did on his return to New York make it abundantly clear that his mental and physical health were sound enough on arrival in England to allow him to work his way systematically through an agenda of art-related study and practice, one based in good part on a scrutiny of works of art intensive enough to lead to revelations of a "so that's how he did it" sort. There is every reason to suppose that as he set out for London, he believed that, entirely through his own efforts, his time abroad would become a major turning point in his career.

He left behind a body of critics and fellow artists who had not yet come to terms with the shifts, changes, and developments that had occurred so steadily in his work after 1875. Only gradually and not really until he settled in Maine did they comprehend that when this aloof Yankee had been among them, he had already begun to emerge—quietly, steadily, and wholly in his own way—as one of the great adventurers among American artists.

3

New York and London, 1880–1881

London Envisioned and Found

At the early hour of 5:30 A.M. on 16 March 1881, Homer sailed from New York on the Cunard steamship *Parthia*, his destination Liverpool, thence to London.[1] Charles and Mattie, his parents, and perhaps others undoubtedly saw him off the previous evening. In the past, he had attended shipboard seeing-off gatherings for relatives, members of the Tile Club, and others, and he very likely permitted the same amiable event for himself.

He already knew a great deal about his destination. His knowledge of London had come from books, magazines, paintings, and other pictorial matter as well as from hearsay and conversations with people intimately acquainted with the city. Much was available from all these sources, for America was then beset by Anglomania. Virtually anything English, from literature to ladies' fashions to the British ceramic tiles that had inspired the Tile Club, took on enhanced value.[2] The British sympathy for the Confederacy had been forgiven if not forgotten.

Precisely what Homer heard, read, or saw about London is for the most part lost to the historical record, but a few of his sources are certain. Among his earliest significant informants had been his father, the garrulous Charles Savage Homer Sr. The senior Homer had spent part of 1852 and 1853 in London attempting to revitalize his flagging (or worse) Boston-based import hardware business.[3] After his return to his family in Cambridge, probably when Winslow was sixteen, his tales of his time in London, told and retold, must have shaped some of his son's early impressions of the city. Other Homer relatives had mercantile interests in London. It can hardly have seemed an especially exotic place to anyone in the family.

A different range of perceptions of the city emerged beginning in 1857, when Homer launched his career as a freelance graphic artist. His association for a little more than two years with the tabloid Boston weekly magazine *Ballou's Pictorial Drawing Room Companion* placed him among several illustrators and wood engravers who had come to the city from England. He shared studio space next door to the Ballou Building with two London-trained British woodblock artists, the brothers Alfred and William Waud (pronounced Wode).[4] They had come to the United States earlier in the decade, perhaps encouraged to

do so by an Englishman well settled in Boston, John Andrew, who headed the *Pictorial's* wood-engraving operations and may also have acted as its art editor. In this role, he would have suggested subjects to Homer, critiqued his submissions, and generally encouraged him as a bright new talent. After Homer moved to New York in 1859, he met Frank Leslie, another London-trained wood engraver, but one who had moved beyond the woodblock to become a prolific publisher of popular pictorial magazines. Homer supplied him with a few illustrations in the mid-1860s.[5]

Unlike Homer's father, who had seen London with the eyes of a visiting businessman, Leslie, Andrew, and the Waud brothers had observed the city and its life as art workers. Their sensibilities, like Homer's, were distinctly visual. Moreover, having abandoned England to find better opportunities in America, they very likely recalled life in London in more complex and less sanguine terms than did the senior Homer.

In 1866, the master wood engraver William J. Linton arrived in New York from London. He let few forget that in addition to being at the top of his profession, he was a poet, pamphleteer, political activist, constant advocate of social reform, and historian of his craft.[6] In New York, he might recount his involvement as a young man with the Chartist Movement and then, with little transition, analyze competing approaches to the art of wood engraving. He held Homer in high regard as a woodblock artist who drew in facsimile style, and he engraved some of Homer's drawings.[7] Linton periodically returned to London for a spell. After such trips in the mid- and late 1870s, his comments on the current state of the city would have been more timely and sharp-edged than the recollections of persons such as Homer's father, who had not set foot in London since the 1850s. Linton might be heard in conversations at the Century Association or the National Academy or the Tenth Street Studio Building, for he associated with painters at least as much as with fellow wood engravers.

The years between the mid-1850s and late 1870s had brought transformative changes to London. Among the most dramatic was the state of the Thames. In 1852, the senior Homer would have known this tidal river as a broad stream of fetid water, thickened daily by most of central London's raw sewage. At low tide, its mud flats and banks reeked with sun-heated filth. During the hot, dry summer of 1858—the summer of "the Great Stink"—the stench emanating from the cesspool-like Thames closed whole riverside sections of the city for weeks. By 1870, however, the vast, recently built network of local sewers carried much of the city's effluent to cavernous intercepting collectors buried deeply underground at river's edge. The collectors carried the sewage well downstream for discharge.

Excavations for the subterranean riverside collector along the Thames's north bank between Westminster and Blackfriars bridges made room also for a large tube to carry an underground railway line. On new land above this pair of adjacent subterranean passageways, one for sewage and the other for people, the Victoria Embankment came into being. This broad riverside carriageway, pedestrian promenade, and handsomely landscaped ornamental gardens gave Londoners of all classes a public park overlooking the Thames.

By 1881, when Homer depicted the river from the unattractive and largely inaccessible opposite bank in his *The Houses of Parliament* (plate 10), the Thames was a much cleaner and better-smelling body of water than his father had known.[8]

Another major engineering project of the 1860s had also altered life in London. This was the construction of the world's first underground rail lines. They sped passengers under streets jammed with horse-drawn traffic. In January 1863, the Metropolitan Railway opened its initial seven stations, running trains between Paddington Rail Station and Farringdon Street. The rival District Railway soon built an underground rail line closer to the Thames; by 1870, it ran trains from High Street Kensington in West London to Mansion House in the City. When Homer arrived in 1881, the conjoined Metropolitan and District railways operated more than twenty stations, forming a nearly complete subterranean route around central London. Construction of this Inner Circle route (so named until 1947) reached completion soon after Homer left London. (In the twenty-first century, with its tracks, carriages, stations, signals, and air quality improved, the circuit survives as the London Underground's Circle Line.)

Despite clouds of steam and smoke hovering above the platforms and infiltrating the carriages, the underground railway became a grand success. Whether Homer ventured forth on it remains a matter of conjecture, but he would certainly have known about it. It seems reasonable to suppose that he used it, if only to be able to say that he had done so.

Throughout the 1860s and 1870s, American newspapers noted, usually briefly and matter-of-factly, the cleansing of the Thames, the building of the underground railways, and much else that contributed to London's claim to be a modern city as well as a historic one. Homer may have noticed and read some of these items in the print media, but he would probably have found more interest in the scattering of pictorial images of these topics that appeared in American and British pictorial weeklies. These images gave some sense of how recent advances in engineering had begun to gain for London a reputation as a renewed city.

Even so, most of the pages of popular pictorial magazines continued to emphasize historic rather than modern London. They suggested that the essence of the city rested in its grand or quaint older buildings, bridges, monuments, squares, and parks. This promotion of the city's grandeur, spotty though it was, offered some help to first-time visitors, for it enabled them to recognize such key landmarks as Westminster Abbey, St. Paul's Cathedral, the Monument, the National Gallery, and the Houses of Parliament.

The texts accompanying these typically wood-engraved pictures rarely offered any kind of practical information for travelers, however. For facts, figures, directions, and other utilitarian information, the visitor to London turned to that most reassuring of bring-alongs, a guidebook to the city. The several available to Homer included a few of compact size that contained detailed maps as well as concise listings of places of interest, omnibus routes, cab fares, theaters, restaurants, and lodgings. One such was the *Indicator Map of*

London and Visitors Guide, available from the American Exchange offices in both London and New York.[9] Homer made use of the Exchange's London office on the Strand as a forwarding address throughout his stay in England.[10] Before leaving New York, he may have picked up a copy of the firm's guidebook from its Broadway office.

A quite different introduction to the city could have come from a genre of discursive travel books about the city meant for Londoners as much as for visitors. With a more elegant literary tone and greater richness of detail, these books addressed both armchair travelers and strolling tourists, and they were ideal companions for voyagers crossing the Atlantic. Guiding their readers through London's better-known streets, travel books of this kind stopped at notable buildings, historic sites, and picturesque spots. Their authors chatted about architectural style, storied personages, and events great and small. In the most expansive of these travel books, the two-volume *Walks in London* (1878), Augustus J. C. Hare took nearly a thousand pages to amble to, through, and by the places he thought his readers should know about, occasionally pointing out connections to art and literature. Concerning art, he observed in his introduction to volume 1 that

> [a]n artist, after a time, will find London more interesting than any other place, for nowhere are there such atmospheric effects on fine days, and nowhere is the enormous power of blue more felt in the picture; while the soot, which puts all the tones into mourning, makes everything look old. If the fogs are not too thick, an artist will find an additional charm in them, and will remember with pleasure the beautiful effects upon the river, when only the grand features remain, and the ignominious details are blotted out.[11]

Homer would have an opportunity to test the usefulness of fog to an artist by the river in his *Houses of Parliament.*

Like all travel writers who have taken London as a subject, Hare discussed only selected parts of the city and its near environs. Most of London's vastness remained unmentioned. Despite his sophistication in matters of art, Hare found no reason to mention the respectable though visually uninteresting neighborhood in the southeastern corner of St. Marylebone Parish that had once housed many of London's most notable artists. As we will see, three years after Hare's book appeared, Homer took lodgings and a studio in that neighborhood.

Whether Homer knew Hare's *Walks* or not, he certainly knew a very different kind of travel book about the city: *London A Pilgrimage,* a handsomely produced quarto volume with text by Blanchard Jerrold and some 180 wood-engraved illustrations by Gustave Doré.[12] Published in London in 1872 at the height of Doré's international fame as an illustrator, the book sold well despite its hefty price (three and a half pounds) and prior serialization.

In his home city of Paris, Doré commanded the services of a team of wood engravers able to preserve the subtleties of his drawings and washes. He had earlier illustrated for

London publishers English translations of such well-established texts from the Continent as Dante's *Inferno* (1860) and Cervantes's *Don Quijote* (1863). But as the 1860s moved along, his flourishing relationship with London and its publishing industry turned him increasingly to British classics. In that decade, his illustrations graced elegant editions of Shakespeare's *The Tempest,* Milton's *Paradise Lost,* and the English Bible, among other titles.[13]

The French artist was also a painter. One source of his closeness to London in the years leading up to his collaboration with Jerrold, came from the warm welcome given an exhibition of his paintings in a Bond Street gallery in 1867. Consisting mostly of large-scale biblical subjects, they met with greater critical and popular success than his paintings had ever received in Paris. This success led to the establishment of the Doré Gallery in New Bond Street. It was still a thriving enterprise when Homer arrived in London.

London A Pilgrimage came about when Jerrold, a British journalist long associated with Paris, persuaded his friend Doré to do something quite different from his past efforts. Rather than illustrating a well-established work of literature in his grandly romantic style, as he had done so often, why not create a profusion of more or less documentary images to bring to life a newly composed text—Jerrold's observations about present-day London? Jerrold structured his text as a journey along the Thames from east to west with extended excursions into the city's neighborhoods, parks, and historic buildings. His commentaries touched on London life at all social levels. He noted work and play, traditions and oddities, and much more. Unlike the compilers of guidebooks, he gave attention to the poor and to the squalor of their precincts.[14]

Jerrold's text on its own would have caused little stir, but Doré's 180 pictures, a substantial number of which depict London's underclass in much detail, proved a sensation. On page after page, Doré stirred his audience's feelings by pictorializing what Charles Dickens in his novels and Henry Mayhew in his reportorial *London Labour and the London Poor* offered in words about the city's vast poverty-ridden populace. He did so moreover with a Dickensian sympathy for the downtrodden. To a remarkable degree, he individualized the poor. Doré's work for this project, both praised and damned when it appeared, in time became a durable landmark in the annals of nineteenth-century book illustration.[15]

Homer knew these images. They would have been of keen interest to any working illustrator and especially to those who, as Homer did, took contemporary life as a subject. The Harper firm almost certainly placed a copy of the book in its art room to ensure that staff artists and visiting freelancers such as Homer knew and examined it. Doré's shift from the illustration of literature to the observation of contemporary life made him suddenly a rival colleague in the world of pictorial journalism.

But Harper's also made Jerrold's text and Doré's illustrations available to the American public at large. Having purchased the book's American rights, the firm began in April 1872 to serialize *London A Pilgrimage* in monthly episodes in *Harper's Weekly.* Circumstances of

production put the French artist's work at a slight disadvantage, for the *Weekly*'s format squeezed the book's contents into a crowded presentation. Nonetheless, Harper's promoted the project grandly: "The publication of this magnificent Pictorial Serial is commenced in the Supplement sent out without extra charge with this issue of *Harper's Weekly*. Each number . . . will be adorned with many beautiful and interesting illustrations by Doré, the greatest living master of the Picturesque in Art. . . . This splendid work, which is published in London at the price of two dollars a number, or twenty-four dollars for the whole work, will be sent out gratuitously."[16] Probably wary of the cost of duplicating the fine production of the English volume, Harper's shied from bringing out an American edition of the text and illustrations in book form.[17]

The *Weekly*'s number for 6 July 1872 contained illustrations by both Homer and Doré. Their joint appearance consisted of Homer's *Making Hay*, a scene of American farm life.[18] Elsewhere in the issue, in pages identified as the supplement, were the text and Doré's eight illustrations for chapter 5 of *London A Pilgrimage*, "All London at a Boat Race." The two artists' subjects could hardly have been less similar, the one pervaded by the stillness of meadows during haying and the other animated by teeming crowds.

Doré's opening image for the chapter, *Westminster Stairs—Steamers Leaving* (fig. 1), offered an angled view of the Houses of Parliament as seen from a passenger boat on the Thames. It was a distinctive treatment of a subject that Homer addressed in watercolor nine years later from another angle and in quite different terms. By that time, the traffic of passenger steamboats on the Thames had declined owing in part to the loss of hundreds of lives in the disastrous collision of a coal barge with the steamer *Princess Alice* in 1878.

Another installment in the *Weekly* contained Doré's *The Workmen's Train* (fig. 2). Here he depicted two trains at platforms of the Metropolitan Railway's Gower Street Station (renamed Euston Square in 1909). The trains normally accommodated three classes of passengers in separate carriages, but Doré shows one of the early-morning "penny" trains running exclusively for workmen as required by act of Parliament. The workmen, of course, would not have been so uniformly attired as pictured, but as was often the case in this project, Doré illustrated the concept of a London practice more than its particulars. His illustration hardly ranked as the first of the interior of an underground rail station, but his strong draughtsmanship and skills of design may have made it the most memorable Homer had seen.

Assuming that Homer looked with interest at all of Doré's illustrations for *London A Pilgrimage* as they came forth in the *Weekly*—if he had not already studied them in the book itself—he probably gained a richer visual comprehension of London than from any other printed source. Doré's images of London pulse with life. By comparison, most pictures in the guidebooks and pictorial magazines of the time were lifeless.

Homer's stature as a graphic artist had always rested chiefly on his work for pictorial magazines such as *Harper's Weekly*, but he had also turned his attention occasionally to

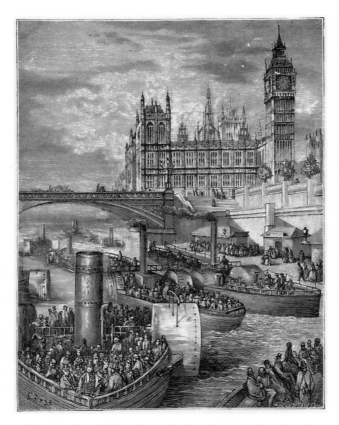

1. Gustave Doré, *Westminster Stairs—Steamers Leaving*, 1872. Wood engraving, 6¼ x 4¾". Illustration for chapter 5, "All London at a Boat Race," in Blanchard Jerrold and Gustave Doré, *London A Pilgrimage* (London: Grant, 1872). Private collection.

the illustration of books, including some for children or adolescents. One such book was *That Good Old Time, or Our Fresh and Salt Tutors* by Clarence Gordon (using the pseudonym "Vieux Moustache"), published in New York in 1867 by Hurd and Houghton. Homer contributed six illustrations of incidents in the text and a portrait of the author with his dog, an image almost certainly drawn from life.[19] The informality of the portrait strongly suggests an acquaintanceship between artist and author. The book also contained four illustrations by the Dutch-born marine artist Mauritz F. H. de Haas, a colleague of Homer in New York. *That Good Old Time* sold well, enjoying several printings. Homer's illustrations count among his most thoughtful interpretations of a text. It should perhaps be no surprise that a British publisher saw fit to republish Homer's work.

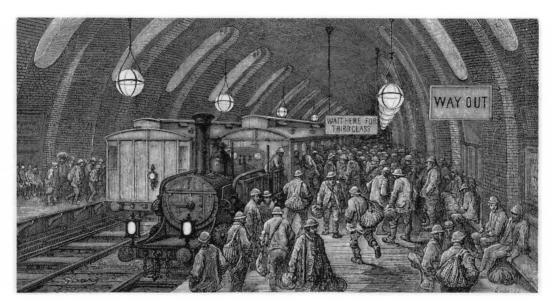

2. Gustave Doré, *The Workmen's Train,* 1872. Wood engraving, 4⅛ x 7¼". Illustration for chapter 14, "Work-a-Day London," in Jerrold and Doré, *London A Pilgrimage.* Private collection. The station shown is Gower Street (now Euston Square in London).

In 1869, the London firm of Sampson, Low and Son brought out an extensively rewritten version of Gordon's text, now addressed to British rather than American readers. The author was given as William H. G. Kingston (Gordon goes unmentioned by either name or pseudonym), and the book's title was shortened to *Our Fresh and Salt Tutors.*[20] Homer's six text illustrations remained unchanged, presumably printed from electrotypes obtained from Hurd and Houghton. Sampson, Low omitted de Haas's work. Whether Homer knew about this English publication is anybody's guess. Despite its relatively minor place within his oeuvre, this set of wood-engraved illustrations as republished in London stands as his earliest-known appearance as an artist in England.

Then, in 1870 in New York, one of Homer's six illustrations from Gordon's book *The Boat Race* was put to use serving a different text when it appeared on the front page of the March number of *Young Sportsman,* a monthly paper for boys published in New York.[21] Homer may have encountered the illustration on a newsstand, or one or another of his colleagues may have called it to his attention. He had nothing to do with this republication of his work, nor would he have earned anything from its new life. Nevertheless, its reuse was a compliment of sorts.

In 1875, Homer at last set aside his activity as an illustrator and determined to be a painter only. He had always been alert to what other painters of his time were doing

in Europe (insofar as examples found their way to New York and Boston) as well as in America. His interest, however, was not accompanied by any inclination to emulate what he saw. He studied other painters' uses of the mental tools of art, as they were sometimes called, to enlarge his own facility and to overcome what he lacked in academic training. He did so always in support of his highly discerning visual intellect. Before he left for London, he is certain to have known much about what was current and most discussed in the work of contemporary British painters. Specimens of that work occasionally found its way to exhibitions and collections in New York. Pictorial weeklies such as *The Graphic* and the *Illustrated London News* now and then published black-and-white wood-engraved reproductions of new British paintings. More important would have been comments about new British art by fellow painters in the Tenth Street Studio Building who had recently returned from London.

What he learned in New York about the London art world must have set it in sharp contrast to what he remembered of his time in Paris. During his ten months in the French capital nearly a decade and a half earlier, the provocative realism of Courbet and Manet was still fresh enough to upset the French art establishment. The disasters of the Franco-Prussian War and Commune had followed Homer's Parisian stay, and not long after them came the rise of impressionism, further unsettling academic tradition. Across the English Channel in all these years, a greater stability continued to rule in the art world and in society generally. Anecdotal realists in London, such as William Powell Frith, descended from the precepts of the Pre-Raphaelite Brotherhood, had themselves been succeeded by the Aesthetic Movement idealists. By 1881, the paintings of Lawrence Alma-Tadema, Frederic Leighton, Edward Burne-Jones, and their followers in the movement held the center of attention. Around them in galleries and collections one could also find recent work in the spirit of the Aesthetic Movement from the Netherlands, France, and elsewhere on the Continent (but rarely from America).

Nearly all the American artists who preceded Homer to London in the late 1870s, Abbey included, had gone there not seeking what was adventurous or controversial in new art, but hoping, rather, to work within the comfort of tradition. French art would prove to be the wellspring of innovation for the foreseeable future, but British art of the 1870s and 1880s would remain largely untouched by these excitements. London would play no significant role in the rise of the modern movement, a movement even then gathering momentum. In choosing London, Homer seems to have been unconcerned about this bifurcation between the art cultures of the two cities. His interest was less that of altering his style than of strengthening his already remarkable powers.

The evidence of his work in the years directly after his return to New York leaves no doubt that he went to London to become a greater master of watercolor, to increase his skills in figure drawing, and to broaden his already distinctive approach to composition. There can be little doubt that he accomplished these goals in good part through study in

London's rich collections of historical and contemporary watercolors, master drawings, and oil paintings. As he strove to become an ever more powerful artist, his teachers would now be masters from the past as well as the present.

<center>⚭</center>

IN PLANNING for his time in London and needing to book lodgings and studio space, Homer may well have sought the advice of fellow New York artists who had recently returned from the city. The more prosperous of them had perhaps resided in a hotel, for the era of that newer kind of accommodation had opened grandly in London's St. Marylebone Parish with the construction of the luxurious Langham. It stood at the point where an arc of roadway transformed Regent Street into Portland Place. These streets formed an axis dividing St. Marylebone Parish into two, east and west.

To the east, visitors to London, even as late as the 1880s, could find agreeable, modestly priced accommodations at boarding- or lodging houses. As a general rule, the former provided dinner as well as breakfast, the latter breakfast only. Some boardinghouses welcomed lodgers. Satisfactory lodgings in the eastern end of St. Marylebone could be found for as little as a pound or a guinea a week, sometimes including a sitting room as well as a bedroom. Guidebooks listed accommodations of this sort by locality.[22]

Over the years, at least a few of Homer's colleagues had made good use of lodgings and studio space on or around Newman Street in the southeast corner of Marylebone, a corner known since the eighteenth century as an artists' neighborhood. One of Homer's fellow painters in New York, Edward Lamson Henry, had resided at No. 76 Newman for a while in 1879. In the same year, the painter and illustrator William James Hennessey had left New York to live abroad, giving his address until 1881 on Langham Place, a ten-minute walk from Newman Street. In 1880, Alfred Parsons, an American expatriate artist who returned to New York on occasion and was, like Homer, a member of the Tile Club, had lodged on Newman Street before moving around the corner to Mortimer. Homer knew these artists through the National Academy, the Tenth Street Studio Building, the Tile Club, and the Harper's art room, but nothing has come to light to indicate that any of them directed him to Newman Street, although he settled in this street on arrival in London.[23]

A stronger case can be made that Homer's younger colleague Abbey recommended not only the Newman Street neighborhood, but also a lodging house located at No. 80. Two and a half years earlier, on 20 November 1878, Homer had attended a Tile Club dinner at the Westminster Hotel in New York arranged as a send-off for Abbey.[24] Abbey sailed to England the following month, his first visit to the land that in time would become his home. Once in England, he went directly to Stratford-upon-Avon on assignment from Harper's and then, early in 1879, traveled onward to London. When an attic room in Bloomsbury proved less than satisfactory, he moved to No. 80 Newman Street.[25] He did so following the

advice of Ernest Parton, an American expatriate landscape painter who had made London his home since 1873.[26]

Parton had resided at No. 76 Newman between 1875 and 1879.[27] He or Parsons may have been the source of Abbey's observation that Newman Street in the early years of the nineteenth century was the "very centre" of artistic London.[28] Two implications of this statement were clear enough: the street was past its glory days, but some of its historic reputation lingered in community memory. The street in fact contained a residue of the studios that had once been part of many—perhaps most—of the terrace houses that lined both sides of the street.

Homer presumably went to No. 80 Newman without delay. After disembarking from the *Parthia* at Liverpool on Monday, 28 March, he traveled by train to London, undoubtedly on the London and Northwestern Railway to Euston Station.[29] He was settled in his accommodations by no later than 30 March. Tony Harrison established this date, the location of Homer's lodgings, the identities of the boardinghouse proprietors, and the duration of his initial stay in the city. It is to be hoped that Harrison's account of his discoveries, prepared in the months before his death in 2007, will yet reach publication, but it suffices to say for the present that he located Homer as a lodger at 80 Newman in the boardinghouse run by William Rimer (b. ca. 1825) and his wife, Louisa Serena Rimer (b. ca. 1827). The Rimers' rooms and studio occupied one or more of No. 80's upper stories. Both Rimers were accomplished professional artists whose paintings appeared occasionally in Royal Academy of Arts summer exhibitions, but they were by no means members of the upper echelons of London's art world.[30]

Harrison discovered that, by a remarkable coincidence, Homer had settled into his lodgings at No. 80 Newman in time to have his presence recorded on 3 April in the United Kingdom's once-a-decade national census. Homer may have been elsewhere in London on 3 April when the census taker arrived at No. 80, which would perhaps explain the misspelling of his name in the census records. Perhaps one of the Rimers provided his details. Through a misreading of someone's handwriting—Homer's, the Rimers', or the census taker's—Homer's name entered the record as "Winslow Hosmer."[31] The census details of his age (forty-five), city of birth (Boston), and profession (artist) leave no doubt about the lodger's identity. This was certainly not the first time that his name had been misspelled in published records.[32]

Homer was now settled not only in London, but in a neighborhood once the "very centre" of the London art world. It was still a place where artists lived, worked, and learned.

4

London, 1881

The Neighborhood

At No. 80 Newman Street (plate 6), Homer became the latest in a long line of American painters to reside on this thoroughfare or close by it. The line had begun with Benjamin West in 1774. It came to an end within a few years of Homer's visit. West spent forty-six years on the street; Homer, less than a month (though he may have returned later during his year and a half in England). In a sense, Homer and all his American predecessors in the neighborhood were beneficiaries of West's efforts throughout his career to foster the rise of the fine art of painting in his native land. The Americans he encouraged to cross the Atlantic returned home to tell younger countrymen of a London locality where they would find ready acceptance as artists. Their successors did the same. And so the line continued.

West had arrived in England from Pennsylvania (via Rome) as a young man in 1763. By 1768, he ranked high enough among London painters to become a founding member of the Royal Academy of Arts—he later succeeded Sir Joshua Reynolds as the academy's president. West flourished for decades as a painter of both portraits and subjects from history–ancient, biblical, and modern. In 1772, he received a pension of a thousand pounds a year from George III, his patron and friend—a friend, that is, insofar as a commoner might be invited to converse about matters of art with a monarch. In 1774, he built his new home and studio at No. 14 Newman, adding to the street's fast-growing population of eminent artists. He remained there, active and honored, until his death in 1820. When Homer emerged from the front entrance of No. 80 each day (plate 7), No. 14 faced him across the street.

Colleagues in New York had probably told him something of the neighborhood's historical significance, for beginning in West's era and for a few decades thereafter Newman and the streets close by had constituted London's primary artists' quarter. In addition to its resident population of British artists, the street had sustained a nearly steady stream of visiting American painters even as Rome, Dusseldorf, Amsterdam, Paris, Munich, and other European centers of art training and art production surpassed London in popularity as a place for an artist from the United States to study and work. The Americans who found their way to the neighborhood tended to stay for a few weeks or a season or perhaps a year

or two, but few of them failed to return home. They rarely numbered more than a hand-ful at any given time, and in a few years there may have been none. By the time Homer made his appearance, even the number of British artists in the neighborhood had thinned considerably. Visiting Americans were often the street's most distinguished professionals. That was certainly the case when Homer lodged at No. 80.

Historical accounts of American art have taken scant notice—usually none at all—of this century-long association of British and American artists within a single neighbor-hood. Published narratives of British art have rarely given more than fleeting attention to the street and even less to the Americans who made appearances there. Yet the interplay in the neighborhood between artists of two English-speaking cultures once meant much to Americans. Homer surely knew this history, at least in a summary way. More important, he contributed to it.[1]

Newman runs north from Oxford Street, the third turning (after Hanway Street and Rathbone Place) west of Tottenham Court Road (see map 1). Toward its end, it angles slightly to the northwest and soon meets the east–west cross streets Mortimer (formerly Charles) and Goodge. When the street was laid out, this angle reflected a need to keep it within the St. Marylebone Parish boundary. East of the line sat a splinter of Camden with its different jurisdictions. By the beginning of the nineteenth century, Newman's angled axis had been extended well northward to the New Road (later renamed the Euston Road). This long northerly extension, originally known as Buckingham Place, gained its present name, Cleveland Street, in the 1860s.[2]

In the mid-1750s, early in the construction of the neighborhood, Middlesex Hospital rose catercorner to the end of the still-building Newman Street.[3] The hospital's three tall stories plus attic loomed over a locality that had previously consisted of a scattering of small buildings among fields and marshes. As was the case with the other major London hospitals built in the eighteenth century, Middlesex had been situated outside the popu-lated center to minimize the spread of contagion.[4] With the draining of the marshes, how-ever, a network of streets lined with brick-faced houses and shops, Newman among them, soon sprang up around the hospital. When Homer arrived in 1881, the hospital, much rebuilt and enlarged, remained the neighborhood's anchoring edifice.[5]

The hospital's founding mission had been to serve "the lame and sick of Soho and St. Giles."[6] The first of these adjacent parishes was still famed for its brothels and unsa-vory taverns when Homer visited London. The second, a dense network of squalid streets and decaying alleyways infested with crime—William Hogarth had set his *Gin Lane* in St. Giles—had been only partly swept away with new construction in the 1840s. Throughout much of the eighteenth century, Oxford Street had amounted to little more than a muddy toll road, but it acted nonetheless as a kind of transparent barrier, separating Newman Street and its propriety from the distinctly less reputable communities just to the south and southeast.

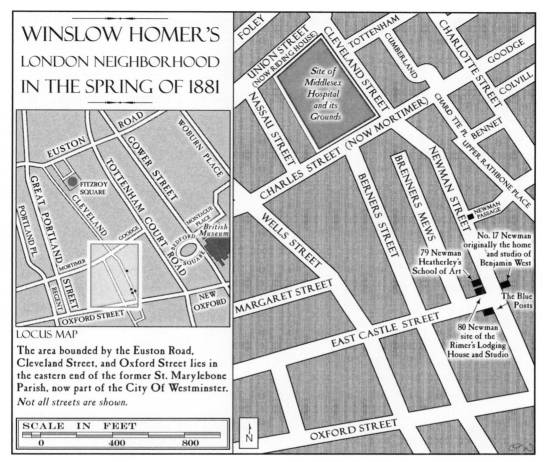

Map 1. Newman Street and environs, St. Marylebone Parish, London. Winslow Homer's neighborhood in early spring of 1881. Lucie Wellner, cartographer.

By the time West had arrived on Newman in 1774, the street and those close to it had already begun to crowd with painters, sculptors, architects, engravers, frame makers, colormen, teachers of art, art students, art dealers, retailers of art supplies, and others associated with the fine arts.[7] The architect Sir William Chambers was among the earliest to arrive. He built his house and studio on Berners Street, just to the west of Newman. When Chambers gained the choice commission to design Somerset House on the Strand, he included in his plans rooms for the Royal Academy. Other architects who lived and practiced near Newman included Charles Heathcote Tatham on Charles Street and Charles Barry (the architect, along with Augustus W. N. Pugin, of the Houses of Parliament) on Foley Place.[8]

Among the several sculptors who came to the neighborhood in its early decades and spent some or most of their careers there were Thomas Banks, John Bacon, John Flaxman,

and John Nollekens. The painters included, along with many others, James Barry, John Constable, John Sell Cotman, Arthur Devis, Henry Fuseli, Nathaniel Hone, John Opie, Thomas Stothard, Francis Wheatley, Richard Wilson, and, of central importance to two generations of American artists, their expatriate countryman West.[9]

This early settlement of artists on Newman and adjoining streets shifted London's center of high-level fine-art production away from Leicester Fields (i.e., Leicester Square), where Sir Joshua Reynolds and, until his death in 1764, William Hogarth maintained their residences and studios, with lesser figures nearby. John Singleton Copley had maintained his studio at Leicester Fields before relocating to Hanover Square in Mayfair, presumably making a point of remaining a comfortable distance from West, his fellow expatriate and rival as a painter of history.

Ann Cox-Johnson has summarized the neighborhood's appeals during its first few decades and the changes that occurred as the nineteenth century moved along:

> [By the middle of the eighteenth century at] the eastern boundary of the parish, Newman Street was being built and this was to be the artists' area for another generation. . . . [The street offered] space for workshops, light and clean air for studios, and [immediately to the north] farmlands for pleasant exercise stretching unbroken to the heights of Hampstead and Highgate. . . . Artists were here in force. . . . Any painter, sculptor, or architect who could afford a house—or a room—squeezed himself and his family into Newman Street or the network of streets around it—Berners, Great Titchfield, Mortimer, Rathbone Place, Union. . . . [But by the early decades of] the new century more and more houses were let out in rooms and studios. By the time a Newman Street address had become a step on the road to fame, the really famous had moved out. The woodworkers, the gilders, the painter-stainers—in short the craftsmen—had begun to move in. [But these were always] streets of solid respectability.[10]

The Americans arrived on Newman Street in three sequences. The first consisted of those artists or artists-to-be who traveled to London to study with West at No. 14 beginning in the 1770s.[11] The more able became his studio assistants. West's influence at the Royal Academy and his connections elsewhere in London's world of fine art gave the more able of this sequence a great boost. Most returned to America to become significant (or at least notable) figures in the new nation's cultural growth.

It was a storied procession. A few of West's earliest students, including Ralph Earl, Charles Willson Peale, and Matthew Pratt, had come to London to study with him even before he had situated himself on Newman. Then, in the 1770s and 1780s, first Gilbert Stuart and next John Trumbull lived and worked at No. 14 as members of West's household. Stuart later set himself up elsewhere on Newman. Other American students in these years included William Dunlap, Charles Bird King, Henry Sargent, and Thomas Sully. Just after the turn of the century, Rembrandt Peale, following his father Charles's example, arrived to

study with West. Others among the later students were Washington Allston, Samuel F. B. Morse, and Charles Robert Leslie. Leslie was one of the few to remain in London to make a career in England.[12]

In 1803, Allston lived on Great Titchfield Street before returning to America. In 1811, when he traveled again to London, he shared a house and studio with Morse on Newman's northerly extension, Buckingham Place.[13] A blue plaque installed in 1962 on the building at No. 141 (now Cleveland Street) marks the site of Morse's residence. It commemorates his work as a developer of the electric telegraph more than his achievements as a painter, but it makes no mention of Allston.

Homer probably had scant knowledge of most of West's students and little interest in their work. As painters of portraits and historical subjects, they stood at some remove from his realist instincts and practice. Nonetheless, as a Bostonian acquainted as early as the 1850s with the art collections of the Boston Athenaeum, he would certainly have known about Allston, revered in that city as a great artist for a generation after his death in 1843. Homer probably met the aged Morse in New York at the National Academy of Design well before this founding member and former academy president died in 1872.

The second sequence of Americans—at first a trickle more than a wave—reached Newman Street by the early 1830s and lasted until the onset of the American Civil War. Because West's students had described themselves as such when they returned to America, we know who they were. The American painters who arrived in London later did not come to study with a master—most of them had already established themselves as artists. The identities of some are known through the ease with which they entered their work in London exhibitions that required participating artists to supply London addresses. The preservation of these exhibition records complete with artists' addresses has established the presence of numerous American artists on Newman Street.[14]

Most of these post-West artists had come to London in the 1840s and 1850s for reasons other than any hoped-for association with the upper reaches of London's art establishment. No British artist had supplanted West as an advocate for aspirants from across the Atlantic. Nor, for that matter, did artists in the new nation feel so strongly a need to come to London for training. With the founding of the National Academy of Design in 1825, New York had begun the institutionalization of professional instruction in the fine arts as a viable enterprise in the United States.

The Americans of the second sequence could travel onward to the Continent with an ease that the French Revolution and Napoleonic Wars had denied most of their predecessors. The art collections and ateliers of Europe's great cities were again conveniently accessible from London. In Great Britain itself beginning in the 1840s, the new age of rail travel enabled visiting Americans to move about England and Scotland with a degree of speed and comfort unknown to earlier visitors. It was an advantage especially to landscape painters.

More important, London itself now offered public museums with collections of a breadth and depth not yet envisioned in America. The National Gallery's purpose-designed building on Trafalgar Square opened in 1838. Even earlier, in 1817, the Dulwich Picture Gallery, just south of London, had opened its John Soane–designed building. Both institutions held important collections of Old Master and other paintings. The older (1753) British Museum, having outgrown its original Bloomsbury home in Montague House, opened an imposingly grand classical-revival building stage by stage beginning in the 1830s. By the late 1840s, the building had reached near completion. The splendid Round Reading Room followed in 1857.

The Americans of the second group who resided for a while on Newman Street included John Kensett in 1845, a key figure in the Hudson River School. In 1852, Richard Caton Woodville, still in his twenties and already praised in New York for his American genre subjects, stayed on the street for a while. In 1852–53, the painter Daniel Huntington was there. In New York, he served for many years in New York as president of the National Academy. Two decades earlier he had been Morse's student there. In 1859, Thomas Waterman Wood resided nearby on Foley Street.

Huntington and others who arrived in the neighborhood in the 1850s found streets of aging, soot-darkened buildings. For fully a generation, John Nash's redesign of London's West End as a vast precinct of classically detailed white stucco had made the simpler Georgian red brick terraces of Newman Street and its environs architecturally passé. The British artists who resided or maintained studios in these buildings were now either young, aspiring, and hoping to relocate to more fashionable locales or older, resigned to a lesser status in their profession, and expecting always to remain in the neighborhood. Of the first type were painters such as William Holman Hunt and Ford Madox Brown, who spent the early parts of their careers on Newman Street but moved to more prestigious parts of the city after fortune smiled on them.[15] Most sculptors had left the neighborhood even earlier, some in the 1820s, moving to Maida Vale and other locations where the newly built Regent's Canal eased the transport of stone, clay, and finished works.

As early as midcentury, Charles Dickens alluded to the neighborhood's decline in his *Bleak House* (1853). He located Mr. Turveydrop's Academy of the Dance on Newman, placing it in "a sufficiently dingy house at the corner of an archway. . . . It had been a fine house once. . . . In the same house were also located a drawing-master, a coal-merchant, and a lithographic artist."[16] The drawing master served as a reminder of both the street's illustrious past and its present decline into a place for art instruction rather than for art production. But to locate a coal merchant on a street once occupied almost entirely by persons of refined callings in the arts amounted to an admission of wholesale change. And to place an academy of dance on a street still respected for its academies of art further signaled a fading reputation. Dickens had known the street for years. His mention of an archway may derive from remembrance of the entrance to Newman Passage, even though its portal was lintel bridged rather than arched.[17]

The slow decline of the street as the center of an artists' quarter came not merely from the aging of its buildings and the rise of more fashionable neighborhoods, but also from changes in the business of art. The neighborhood had come into being as a distinctly late-eighteenth-century model of art production as a rational, all-inclusive process. In its first few decades, it had accommodated a flourishing high-level service industry, one sustained by a demand for portraits, subject pictures, painted architectural decoration, and memorial and other kinds of sculpture. Based on the fact that few, if any, significant drawn, painted, or printed views of the street have survived from its heyday, its frontage of terrace houses clearly enough lacked picturesque qualities. Even its most illustrious residents, including West and Chambers, viewed it as a place of industry rather than show.

But the street had also begun to empty itself of fine artists of the first rank by the 1830s in part because forms of patronage had changed. Art dealers' galleries had become increasingly more important than artists' studios as venues for the business of art. So, too, had artists' self-concepts changed. Romanticism's culture of pronounced individuality found little comfort in rows of lookalike brick-faced houses with studios.

Well before Homer had arrived in London, the most distinguished of London painters had begun to live and work in parts of the city well removed from both Newman Street and each other. John Everett Millais had built grandly at Palace Place in Kensington, enjoying his proximity to Kensington Palace. Edward Burne-Jones resided and maintained studios in Fulham and elsewhere. Lawrence Alma-Tadema was to the north, by Regent's Park. Frederic Leighton could be found at his elegant orientalist residence in Holland Park. His neighbors included G. F. Watts, Luke Fildes, Val Prinsep, Marcus Stone, and a few other artists of established standing, but their proximity to one another scarcely constituted anything resembling a true artists' quarter. The neighborhood attracted neither art students nor art teachers. Shopkeepers and artisans of the kind essential to a working community of artists lived and maintained their trades elsewhere. In Chelsea, Holman Hunt and Whistler established themselves handsomely, followed by Sargent and Abbey, each in his own studio-home. As had their fellow artists in Holland Park, these four became separate ornaments of Chelsea rather than components of an art community.

If the Americans who arrived on and around Newman Street in the 1850s and later lacked distinguished neighbors, they nevertheless had at hand a rich assortment of shops ready to answer to the needs of almost any working artist. Winsor and Newton, the leading manufacturer of watercolor paints, had established its business in 1832 on Rathbone Place, just east of Newman. It prospered at this location, among other purveyors of art supplies, for more than a century. The busy historian of London, Edward Walford, writing not long before Homer's visit, observed rather stiffly of Newman Street that "half the shops are devoted to the sale of articles subservient to artistic purposes."[18]

Though the neighborhood had ceased to house London's most eminent fine artists, it remained an important place for art training. Even while West still refined the talents

of his American students, Henry Sass on Charlotte Street had opened his own school to prepare young artists for entrance to the Royal Academy Schools. In 1845, around the time of Sass's death, James Matthews Leigh established his own private school of art at 79 Newman. Contrary to Sass's aims and reflecting a growing resistance within the younger generation to the teaching methods of the Academy Schools as well as to the schools' de facto exclusion of women, Leigh's approach was distinctly reform minded. With his death in 1860, his associate Thomas Heatherley took over, renamed the school after himself, and led it until his retirement in 1887. The many students who gained instruction from Leigh, Heatherley, and their associates—from Edward Burne-Jones to Kate Greenaway—ranged widely in their aims and accomplishments. Homer knew the school. It stood directly next door to his lodgings at the Rimers.[19]

The third sequence of Americans to stay on Newman arrived after the Civil War, peaked in the 1870s, and declined throughout the 1880s. They were the artists of America's Gilded Age. Whistler, newly arrived from Paris, lived on the street in 1870.[20] He and the others found a street gradually renewing itself architecturally. Some of the original buildings had been refaced. New structures had risen to replace eighteenth-century buildings destroyed by fire or pulled down. The newer buildings tended to be taller by one or two stories and dressed with emphatic lintels, pediments, quoins, and entranceways in stone. By 1881, several buildings on the west side of the street had been rebuilt in this way, including No. 80.

Directories of the 1880s give some sense of the street's character during Homer's stay.[21] Only ten persons identified themselves as fine artists, all but one of them located on the west side of the street from Nos. 60 to 80—clustered, that is, by Heatherley's School of Fine Art at No. 79.[22] Though Newman Street could no longer claim a resident group of fine artists of note, its population contained enough craftspersons, graphic artists, teachers of art, decorators, and others to preserve some semblance of identity as an artists' quarter, though one much reduced in reputation.

What the directories do not say is that in 1871, following the suppression of the Commune in Paris, an influx of political and other refugees from France and elsewhere on the Continent settled in the neighborhood. Initially directed to Soho, where inexpensive lodgings were plentiful, but finding the prospect of living cheek by jowl with prostitutes and habitués of lowlife taverns unappealing, they instead crossed Oxford Street to find the least costly available accommodations on Newman and other streets on the eastern edge of Marylebone. A soup kitchen opened in Newman Passage for the most impoverished among these socialists, Communists, and activists of various kinds. The Blue Posts public house at 81 Newman Street (just across Eastcastle Street from Homer's lodgings) contained a "compartment rarely penetrated by Englishmen, where foreign refugees of all nationalities, and their inevitable suites of foreign police spies, indulge in Continental drinks."[23] When Homer arrived at No. 80, a few refugees may have been in the neighborhood still,

settled as expatriates. One or two may have continued to frequent the Blue Posts. To the extent that he knew about this chapter in the district's history, he may have recalled his acquaintanceship in Boston in the late 1850s with several "48-ers," or artists and artisans who had fled France and Germany after the failed revolutions of 1848.[24]

Despite these changes, Newman Street in the 1880s remained the heart of an old but respectable neighborhood. It offered Homer many amenities, not least a choice of public houses other than the close-by Blue Posts.[25] At least seven other pubs stood within a radius of six hundred feet of No. 80. A further advantage of the neighborhood was the availability of horse-drawn public transportation. Hackney and hansom cabs ran up and down Newman and far beyond. Omnibuses moved—more often crawled—along Oxford Street, Tottenham Court Road, and other nearby major thoroughfares, "every five minutes from 8 A.M. to 9 P.M."[26]

If Homer sought to use underground transportation, a walk up Newman and its extension Cleveland Street would have brought him to the busy Euston Road and the Metropolitan Railway's Portland Road (now Great Portland Street) Station. In 1881, trains running "every few minutes" presented him with the possibility of traveling more rapidly than by omnibus to, say, South Kensington Station with its nearby museums. A few stops farther along the line would have taken him to the then-named Charing Cross Station (now Embankment), not far from the National Gallery, the galleries of Old Bond Street, and, just beyond, the Royal Academy. (Since 1867, that institution had made its home at Burlington House on Piccadilly, where it remains.) The line also stopped at Westminster Bridge Station (now Westminster), the closest to the site from which he painted his view of the Houses of Parliament.

But when Homer set out for most of these places, above-ground routes would have been more direct. A pedestrian route down Newman Street to Oxford Street, east to Charing Cross Road, down that thoroughfare to the National Gallery on Trafalgar Square, and then down Whitehall would have taken him to Westminster Bridge, next to the Houses of Parliament. By hansom cab or on foot, the distance covered amounted to less than a mile. The roundabout route by underground was nearly ten miles.

Homer was among the last notable American artists to stay on Newman Street. In 1887, the move of Heatherley's School of Fine Art to Chelsea (where it remains) effectively marked the end of the neighborhood as an artists' quarter.[27] Less than two decades later, another artists' community, altogether different in character, began to take form piecemeal a few streets to the north around Fitzroy Square, just across the parish boundary in Camden. By the early years of the twentieth century and for more than fifty years thereafter, this locality attracted a succession of highly self-conscious artistic groups and individuals, not limited to the visual arts. The development had begun spottily as a few artists established studios on the square and its surrounding streets. As early as 1896, Whistler had a studio on Fitzroy Street, though he lived in Chelsea.

Then, more determinedly, one after another memorably labeled groups made its appearance. On these streets in 1911–12 could be found some of the Camden Town painters, led by Walter Sickert, who had taken a studio on Fitzroy Street as early as 1903. By 1914, Roger Fry and his modernist Omega Workshops had become a presence around the square. In the 1930s, when members of the Euston Road School of modern realists made their quiet impact in the London art scene, most of these painters, like their predecessors, maintained studios near Fitzroy Square but lived elsewhere. It was in the streets around this square that Sickert, Fry, Spencer Gore, Nina Hamnett, Wyndham Lewis, William Coldstream, William Roberts, and a host of others over the years nurtured (or disrupted) their relatively short-lived groups, and by the 1940s the streets had gained the informal name "Fitzrovia."

Along with the name came a reputation as a Bohemian quarter. Over the years, artists as different as Augustus John and Francis Bacon made appearances, as did the sculptor Jacob Epstein and the poet Dylan Thomas. Such names enhanced the area's reputation as a community of intensely idiosyncratic creative spirits. This was so even though more than one celebrated Fitzrovian's association with the area amounted to little more than frequent prolonged audiences conducted at a favored pub—the Fitzroy Tavern on Charlotte Street was the great favorite—with a return at the end of an evening to a residence in Kensington or Chelsea or Hampstead or another more respectable quarter of London. Nothing in the thinking of the protomodernist or modernist groups that loosely constituted Fitzrovia as both a place and an episode in early-twentieth-century arts culture connected it to what had transpired for more than a century three or four few streets to the south, on and around Newman.

Pamela Taylor notes the contrast of this later neighborhood to the former community immediately to its south, on Newman:

> Fitzrovia . . . became synonymous with artists and poets in particular, as well as with "outsiders, down-and-outs, drunks, sensualists, homosexuals and eccentrics," but the first cluster of artists, earlier and securely Establishment-oriented, occurred when Newman Street almost single-handedly made St. Marylebone "the artists' parish." Benjamin West was one of the earliest arrivals . . . acting as such a powerful magnet . . . that in 1810 there were six Royal Academicians in the street. . . . [Later] for less established artists, the area's advantages—cheap central location, British Museum to hand, a plethora of the supporting art trades—did not diminish, and a mid–nineteenth century resurgence was helped by various art schools, among them one at 79 Newman Street . . . which started as Leigh's in 1848 and was Heatherley's from 1860–1887. It counted among its pupils Thackeray, Rossetti, Burne-Jones, and also Kate Greenaway while it was the only London school allowing women to draw from the nude.[28]

In the early decades of the twentieth century, memory of the Newman Street neighborhood as an artists' quarter steadily slipped away. Writing in the mid-1930s but remembering

something of the locality's earlier nature, E. V. Lucas, who knew the history of London and its artists intimately, observed that "between Gower Street and Great Portland Street is a district where foreigners now congregate but which once was thick with artists—especially Newman Street and Charlotte Street (where Constable had his London studio)."[29] A generation later, in 1963, David Piper reflected in his admirable *Companion Guide to London* on the further lessening of the neighborhood's hold on memory. After a look around Fitzrovia—"a region hallowed or pickled more often, perhaps, in the memory of English art"—he placed his reader on Goodge Street heading west from Charlotte and observed merely that as one strolls along, "[one] can glance southward down Newman Street and Berners Street towards Oxford Street. These two roads in the early nineteenth century were also artistic settlements."[30]

As Fitzrovia's reputation grew in the 1930s and 1940s, Newman and the streets around it, which had never possessed a community name and which were now in quiet decay, began to be referred to as "North Soho." This unofficial annexation by its colorful if not altogether reputable neighbor to the south brought with it some of the less savory aspects of Soho's reputation. "North Soho" became known as a place best by petty and even serious crime.[31] Then, in the 1960s, bits of the neighborhood began to disappear. Construction of the Western District Post Office, for example, swept away several houses on Newman Street along with bombed-out properties behind them on Rathbone Place. The site of West's house and studio became a parking lot for postal delivery vehicles.

No. 80 and most of the rest of Newman Street had escaped serious bomb damage during World War II.[32] By the 1960s, however, time itself had hastened the street's decay. Then, in the 1970s, a brighter future began to appear when the more positive side of Soho's reputation—its entertainment industry—moved into the neighborhood. Soho found in its northern extension ample space available for new media-production enterprises. Gradually restored, the street's nineteenth-century buildings began to fill with offices and studios for ventures in recorded music, video, and film. New buildings replaced derelict ones. As the neighborhood began to prosper once again, and its streets became safer, Oxford Street reasserted itself as a transparent barrier. The label "North Soho" fell into disuse. In 1964, the Post Office Tower (later renamed the Telecom Tower) rose just off Cleveland Street to command the skyline of a neighborhood of electronic media. Film, video, advertising, the music industry—these and others flourished on streets once home to painters, sculptors, and architects.

In the last years of the twentieth century, as gentrification of more of Newman Street's buildings advanced, estate agents, publishers of guidebooks, and the press began to identify the old neighborhood informally as part of a greater Fitzrovia. Although Homer had spent his first weeks in London in a district that lacked any distinctive community name, twenty-first-century visitors seeking the site of his residence will find it in an enlarged and gentrified Fitzrovia.[33]

Though No. 80 still stands, it and its surroundings shed little light on Homer's life on the street. He remains a figure barely visible in the neighborhood's history. He may have strolled about, stocked up on art supplies, looked into shops, visited a pub or two, and coped with street traffic, but nothing remains that associates him with any person other than the Rimers. One wonders whether he arranged to contact artists from New York who now resided in London. Alfred Parsons, for example, English by birth, an honorary member of the Tile Club, and Abbey's great friend, still resided at an address on Mortimer Street, around the corner from Newman in 1882. Abbey, himself once a lodger at No. 80, would surely have wanted to contact Homer if he knew Homer were in the city—if, that is, Abbey himself were in London. He traveled a great deal, sketching subjects for his book and magazine illustrations. But because Homer had arrived in London to work, it seems probable that, already known for his social reserve, he would have made little or no effort to contact anyone for social reasons throughout his time in the city.

If during his initial stay in London he developed any sort of sentimental attachment to the city, no evidence of it survives. He seems to have been immune to the charms that two decades earlier had moved Nathaniel Hawthorne to write of London: "I acquired a home-feeling there, as nowhere else in the world—though afterwards I came to have a somewhat similar sentiment in regard to Rome—and as long as either of those two great cities shall exist, the Cities of Past and Present, a man's native soil may crumble beneath his feet without leaving him altogether homeless on earth."[34] Homer's "home-feeling" would grow not in any city, but rather at Prout's Neck.

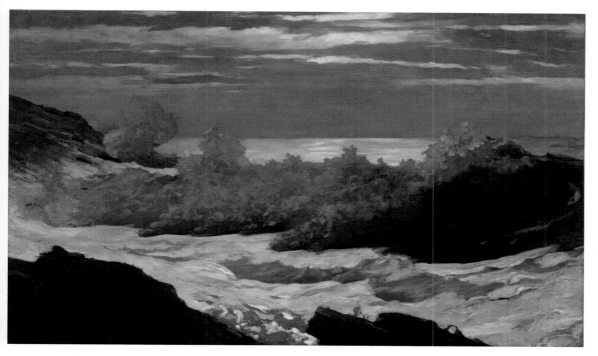

1. Winslow Homer (American, 1836–1910), *Early Morning after a Storm at Sea,* 1902. Oil on canvas, 30¼ x 50″ (76.8 x 127 cm). Cleveland Museum of Art. Gift of J. H. Wade. 1924.195. Dissatisfied with its reception when shown in New York, Homer worked further on the painting in 1903.

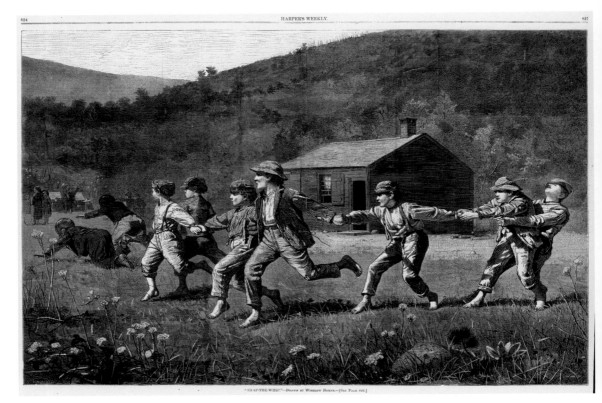

"SNAP-THE-WHIP."—DRAWN BY WINSLOW HOMER.—[SEE PAGE 826.]

2. Winslow Homer, *Snap-the-Whip*, 1873. Wood engraving, 13⁹⁄₁₆ x 20⁹⁄₁₆″, drawn on the woodblock by Homer after his oil painting of the subject and engraved by E. Lagarde. Published in *Harper's Weekly* for 20 September 1873. Courtesy of the Syracuse University Art Collection.

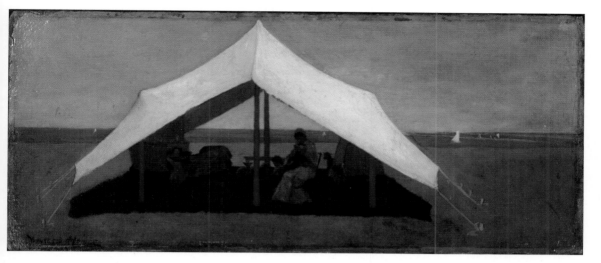

3. Winslow Homer, *The Tent (Summer by the Sea),* 1874. Oil on canvas, 9½ x 22″. The Robert Hull Fleming Museum, University of Vermont. Bequest of Henry Schnakenberg, 1971.2.2.

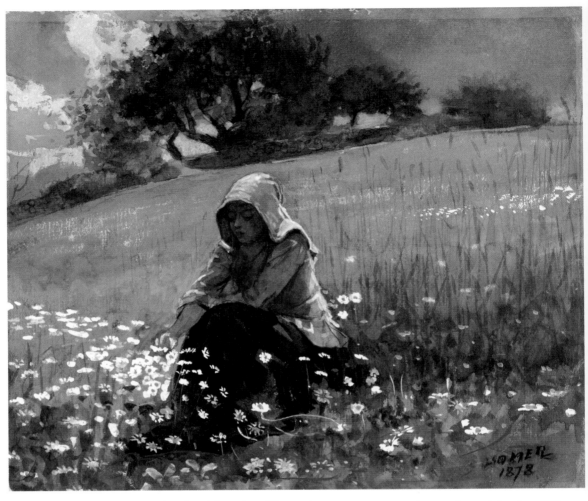

4. Winslow Homer, *Girl and Daisies*, 1878. Watercolor, opaque watercolor, and graphite. 6 x 6⅞". Museum of Art, Rhode Island School of Design. Gift of Isaac C. Bates.

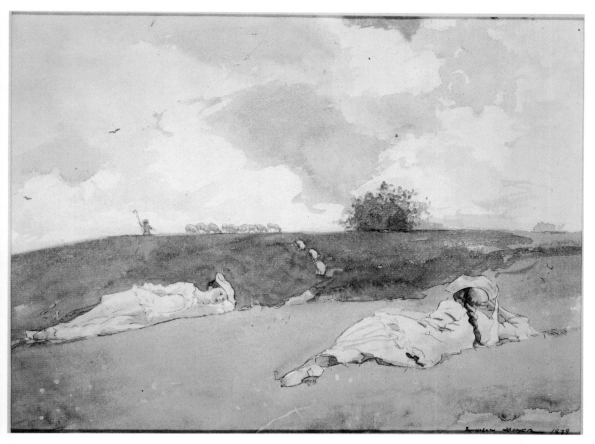

5. Winslow Homer, *Shepherdesses Resting,* 1879. Watercolor, 9 x 12″. Courtesy of the Gerald Peters Gallery, New York.

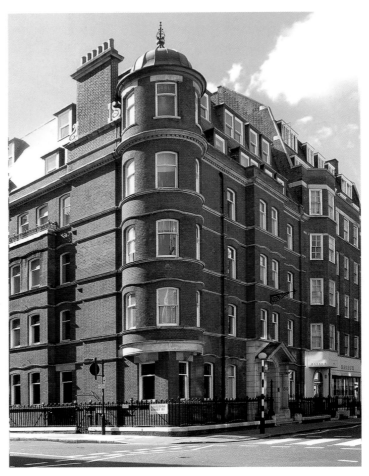

6. No. 80 Newman Street, Marylebone, London. Photograph, 2008, Cleota Reed. Homer took lodgings in this building in late March 1881, presumably on one of the upper floors.

7. Entrance to No. 80 Newman Street, Marylebone, London. Photograph, 2008, Cleota Reed. The building acquired the name "York House" when it became a hotel early in the twentieth century and later housed offices. Several other buildings in central London carry the name "York House."

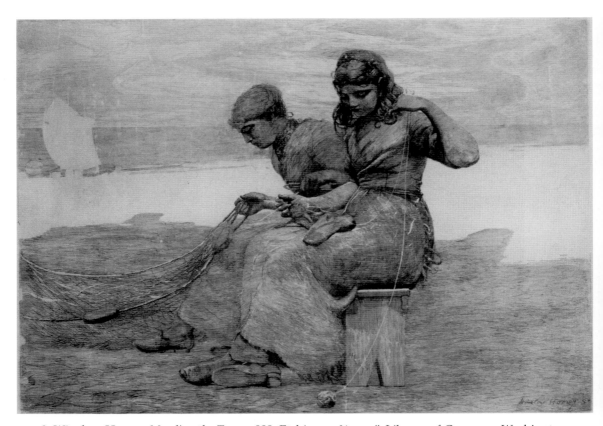

8. Winslow Homer, *Mending the Tears,* 1888. Etching, 17⅜ x 23". Library of Congress, Washington, D.C. Homer first called this etching *Improve the Present Hour,* though most and perhaps all impressions sold carried the now standard title. His initial title came from the English poet William Cowper's translation (1788) from the Latin of Horace: "Improve the present hour, for all beside is a mere feather on a torrent's tide."

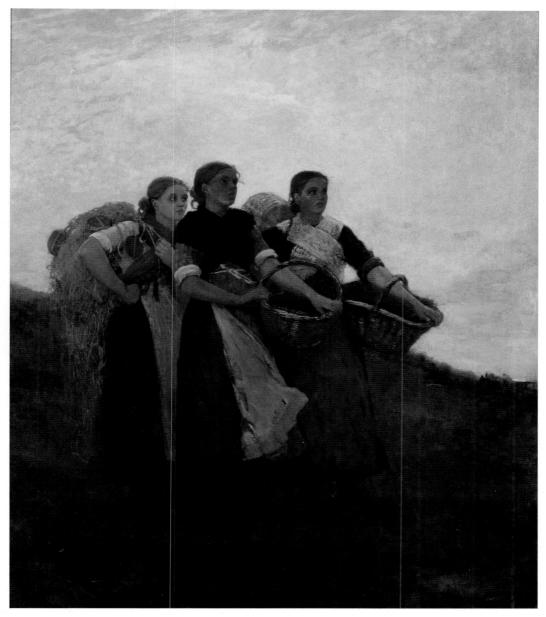

9. Winslow Homer (American, 1836–1910), *Hark! The Lark*, 1882. Oil on canvas, 36⅓ x 31⅓". Milwaukee Art Museum, Layton Art Collection. Gift of Frederick Layton, L99. Photograph by John R. Glembin. Homer's title comes from a song in Shakespeare's play *Cymbeline*, "Hark! Hark! The Lark at Heaven's Gate Sings," described by the character Cloten as a "wonderful sweet air." The song concludes: "with everything that pretty is / My lady sweet, Arise / arise, arise."

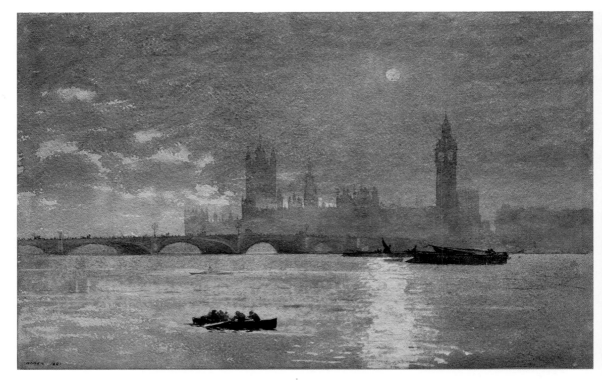

10. Winslow Homer, *The Houses of Parliament*, 1881. Watercolor, 12¾ x 19¾". Hirshhorn Museum and Sculpture Garden, Smithsonian Institution, Washington, D.C. Gift of Joseph H. Hirshhorn, 1966. Photograph by Lee Stalsworth.

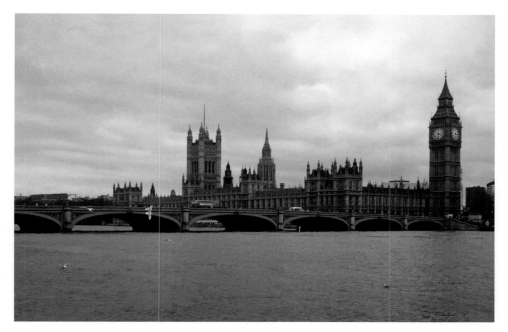

11. *The Houses of Parliament,* London. Photograph, 2008, Cleota Reed.

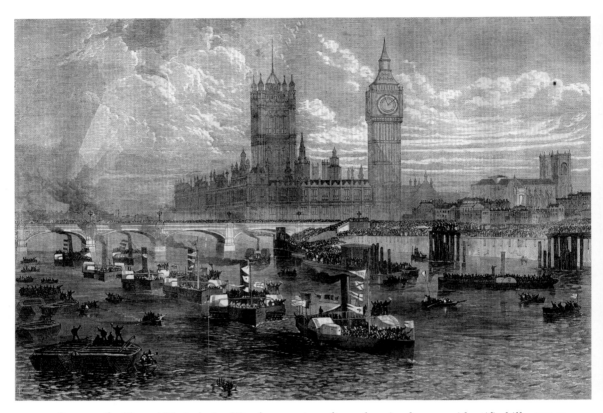

12. *Scene on the River at Westminster.* Wood engraving after a drawing by an unidentified illustrator. *Illustrated London News,* 3 August 1867. Syracuse University Library.

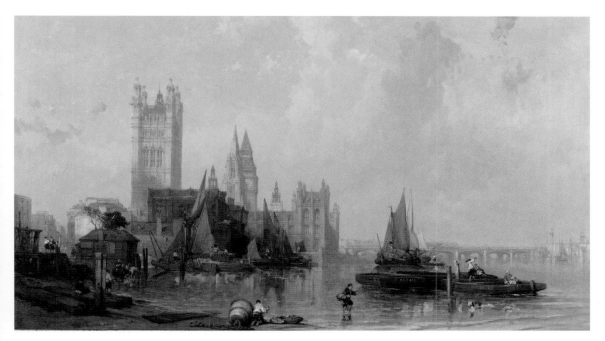

13. David Roberts, *The Houses of Parliament from Millbank,* 1861. Oil on canvas, 35¾ x 20½". © Museum of London.

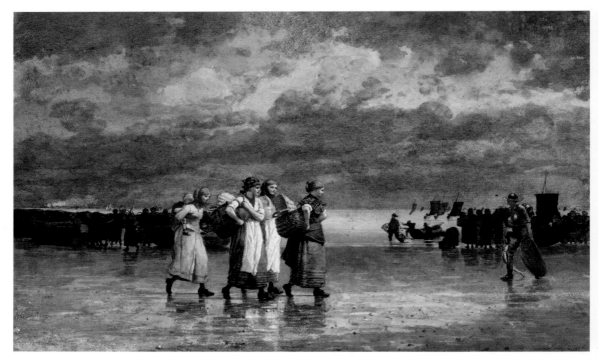

14. Winslow Homer, *Four Fishwives,* 1881. Watercolor, 18 x 28½". Ruth Chandler Williamson Gallery, Scripps College, Claremont, California. Gift of General and Mrs. Edward Clinton Young.

15. Winslow Homer, *An Afterglow*, 1883. Watercolor over graphite, 14⅞ x 21½″. Museum of Fine Arts, Boston. Bequest of William P. Blake in memory of his mother, Mary M. J. Dehon Blake, 1922. Photograph © 2010 Museum of Fine Arts, Boston.

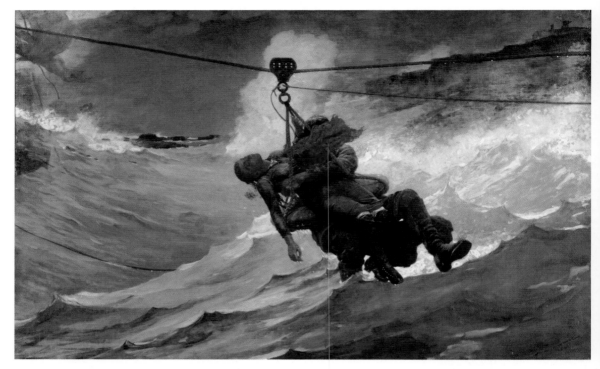

16. Winslow Homer, *The Life Line,* 1884. Oil on canvas, 28¾ x 44⅝". Philadelphia Museum of Art. George W. Elkins Collection, 1924.

5

London, 1881–1882

Art and Artists

Homer's initial three weeks in London beginning at the end of March 1881 introduced him to a city famed for its wet and sooty atmosphere. More than half a century earlier his American predecessor John James Audubon had written home about "infernal smoky London."[1] By the time Homer had arrived in the city, the coal fires of its hugely enlarged population darkened the air even more severely. Nevertheless, as an artist always intrigued by the color of light, Homer may have found interest in the varied appearances of London's frequent midday duskiness. The interplay of smoke and fog, forever shifting in its effects, could change day by day, if not hour by hour. Even on sunny days in cooler months, smoke changed the nature of the light. Henry James would observe of London that "the atmosphere with its magnificent mystifications . . . magnifies distances and minimizes details, confirms the inference of vastness by suggesting that, as the great city makes everything, it makes its own optical laws."[2]

Homer's visit began with more than a week of dry days, but by 12 April intermittent spring showers followed regularly.[3] Precisely where he went and what he did during these first weeks in the city remain a matter of speculation with only a single datable exception. On the morning of 14 April, he visited the British Museum's Department of Prints and Drawings. He may have walked to the museum from Newman Street. At a brisk pace, the journey would have taken less than a quarter of an hour. During these first weeks in London, he may also have painted his view of the Houses of Parliament, though this watercolor may in fact be the product of a return to the city later in the year.

Homer's appearance at the British Museum, first published by Judith Walsh in 2008, is one of great historical significance. On the morning of Thursday 14 April, he arrived at the museum at its opening hour.[4] He viewed drawings on display in the Department of Prints and Drawings' Print Room, which then occupied part of the northwest corner of the building. He arrived at the Print Room alone.[5] The museum's policy for certain of its galleries required that a keeper or keeper's assistant register each visitor by name. If the visitor were accompanied by a companion or guests, the keeper recorded the number of such persons, but not their names. Homer probably also studied the prints and drawings from

that department's collections that were exhibited in the King's Library (now the Enlightenment Gallery) on a group of free-standing, double-sided display screens.[6]

No record survives of the individual works Homer examined. They may well have included Old Master drawings, perhaps some by Michelangelo and Raphael.[7] In any event, the museum's graphic arts collections presented Homer with an unprecedented opportunity to study the work of major draughtsmen from the Renaissance to the recent past. The likelihood that he studied figure drawings in particular and studied them with great care helps immeasurably to account for the advances apparent in his own figure work so soon afterward at Cullercoats. He had always been an autodidact, learning from analytic observation rather than from instruction. No museum or private collection of drawings in the United States could have begun to offer him such riches from the High Renaissance, Baroque, or eighteenth century as could the British Museum.[8] Beyond the prints and drawings on display, he could easily have examined others by applying to the department's Students' Room. No records of visitor applications for individual prints of drawings seem to have survived from this time.

As Walsh has established, Homer arrived at the department's gallery alone as its first visitor on 14 April. He may, however, have arranged to meet someone there. The next visitor to gain admission was Alphonse Legros, the distinguished French-born artist who was a close associate of Whistler.[9] Legros had come to England in the early 1860s at age twenty-five, married there, and became a naturalized British citizen in the year of Homer's visit. He had enjoyed a highly successful career in England as a draughtsman, printmaker, sculptor, and teacher at the South Kensington Museum. At the time of Homer's visit, he was Slade Professor of Art at University College London. He brought five others with him to the Print Room, which suggests that he may have been conducting a tour of the exhibition for students or colleagues. If Legros had invited Homer to attend this session, Homer's arrival in advance of the others required the separate recording of his name. A total of twenty-five persons came to the gallery that day.[10]

There is no reason to assume that Homer's visit to the museum on 14 April was his first or his last. An intriguing possibility for an earlier visit arises from a visitors book entry for the previous week. On Wednesday 6 April, Whistler had appeared at the gallery.[11] The keeper entered his name more fully and with rather more formality than he had for others. Standard usage would have made the entry simply "Mr J. Whistler," but the keeper wrote out "Mr James A. McNeill Whistler," adding, "and friend." He inscribed Whistler's name more boldly than the others, owing, perhaps, to a prior acquaintanceship. Whistler was, of course, an artist whose graphic work was of keen interest to the museum's Prints and Drawings Department. Then again, perhaps this keeper (or, more likely, keeper's assistant) entered the name boldly simply because Whistler had announced himself grandly, as he tended to do. That Whistler's "friend" on 6 April might have been Homer and that Homer found the exhibition interesting enough

to return to the gallery by himself on 14 April are a fascinating prospect, though a purely conjectural one.

An assumption has long existed that the two men never met. Because Whistler's mannered Bohemianism and aesthetical persona stood at some remove from Homer's middle-class propriety and Yankee reserve, it has been easy to suppose that if they had met in London in 1881 or 1882, they would have found little to talk about.[12] Yet they certainly already knew about each other, for news concerning recent work from both artists crossed the Atlantic regularly. It did so in published art reviews and, more important, in the conversational accounts of artists such as Linton who divided their time between New York and London. However different Homer and Whistler's personas may have been, both had become important figures in their shared profession, though each in a different land. Both artists had ample reason to respect the work of the other.

Before Walsh's discovery of Homer's presence in the British Museum, conjecture that he had visited that institution placed him almost without exception not in a graphic arts exhibition, but rather in the museum's sculpture galleries. By the 1970s, an assumption had gained currency to the effect that Homer had almost certainly spent time with the museum's Elgin Marbles (now called the Marbles of the Parthenon). This conjecture, it was argued, best explained his portrayal of some of the Cullercoats fishwives in statuesque poses in a few works.[13] Yet the notion that Homer's Cullercoats fishwives owe as much or more to Hellenic art as they do to his usual practice of recording what he saw in the world around him has always seemed less than fully persuasive.

It is true that the fishwives' distinctive working attire offers some slight resemblances to the drapery of classical sculpture, but the naturalism of nearly all of Homer's fishwives and their costumes is at some remove from that of the idealized figures of the Parthenon figures.[14] The latter figures are not, in any event, of uniform likeness. The quietly seated female goddesses in the great frieze, for example, differ greatly in character from the more dramatically animated freestanding figures of the east pediment. Homer posed only a very few of his Cullercoats fishwives for dramatic effect, and they, such as the figure in his watercolor *Inside the Bar* (1883, Metropolitan Museum of Art) offer little if any correspondence to figures from the Parthenon.

An alternative source for the quasi-sculptural solidity and even heaviness of some of Homer's Cullercoats women rests in his reportorial instincts. These fishwives, accustomed to hard manual labor and to moving and acting in ways bolder and more outgoing than the demure women he had painted in America, presented him with opportunities to enlarge his mastery in the drawing of three-dimensional figures. The deep folds and broken contours of the working attire of the women who posed for him (for a fee) gave him repeated opportunities to draw from the round. If the collections of the British Museum can claim some degree of credit for the effectiveness with which Homer drew and painted these women and their costumes, the credit seems at least as likely to rest

with the figure work in its graphic arts collections as with the great Hellenic remains in its sculpture collections.

Homer, of course, already knew much about sculpture as a fine art. He had seen a great deal of it in Paris. In America, he had at least a nodding acquaintance with the cast collections at the National Academy. More significant, the growing number of public monuments in New York by such able artists as John Quincy Adams Ward attracted much attention from artists in all mediums. At the National Academy and elsewhere, sculptors were among his acquaintances. In 1876, he sat for a bust portrait modeled by William O'Donovan.[15]

While in the British Museum, Homer may indeed have found his way to the Parthenon Marbles, though they were not then quite so central a part of the museum experience as they became in the twentieth century. Some guidebooks to London in the 1880s made little special mention of them in their passing attention to the museum.[16] Homer and other visitors of the 1880s would have seen the marbles displayed in the Elgin Room, a long, corridor-like space (fig. 3). The frieze lined the walls on both sides of this rather constricted gallery. It included pieces recently modeled and cast to conjecturally "complete" certain of the fragments. The Parthenon's pedimental sculptures rested on tall pedestals, standing in a line directly in front of the frieze. It was an installation more crowded and less well illuminated than the much grander environment that the sculptures have enjoyed since the opening of the museum's Duveen Gallery in 1962. Even so, the marbles offered visitors of Homer's time the aura of Hellenic perfection in the art of sculpture.[17]

Yet Homer may not have seen the Parthenon sculptures at all. During his April visit to London, the British Museum was in the midst of a reorganization of its galleries. It had transferred its vast natural-history collections to an imposing new facility—the British Museum (Natural History) in South Kensington. Later renamed the Natural History Museum, this terra-cotta-clad building (designed by Alfred Waterhouse) opened its doors to the public on Easter Monday, 18 April, while Homer was still in London.[18] In the process of moving collections within its Bloomsbury building, the museum from time to time temporarily closed access to some of its galleries.

A further concern about the notion that the Parthenon marbles in some way inspired Homer's renderings of the Cullercoats women arises from the fact that he had rarely demonstrated an interest in three-dimensional works as aids to his thinking as an artist. On arrival in London, he was still very much a planar artist, one who relished the two-dimensional surfaces of paper and canvas. Throughout his career, the defining line had counted for more than had intimations of volume. This balance shifted during his time in England, and exposure to much great sculpture may have played a part in the change, but so also, it is fair to assume, did his study of drawings by major masters of illusionism—masters of the art of making a planar surface appear to be three dimensional. His Cullercoats women are typically more three dimensional in appearance than, say, his croquet players of the

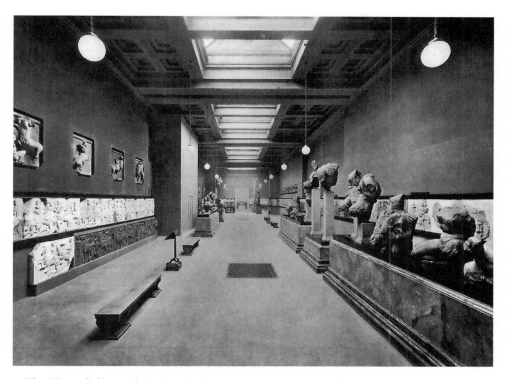

3. The Elgin Gallery of the British Museum in the nineteenth century between 1868 and 1885. Photograph, British Museum Archives, London. Courtesy of British Museum Images. © The Trustees of the British Museum.

late 1860s or most of his tailored young women of the 1870s, but the defining line, sometimes outline, still played a part.

It seems likely that if Homer had been inspired by classically draped figures during his March 1881 visit to London, they would have been drawn and painted examples rather than works of sculpture. He would have had little difficulty in finding such drawings and paintings, for they were plentiful (though not in the galleries of the British Museum). They came not from antiquity, but from the studios of Lawrence Alma-Tadema, Edward Burne-Jones, Evelyn De Morgan, Frederic Leighton, Albert Moore, Edward Poynter, and others. Indeed, the painting and drawing of idealized draped female figures of a vaguely classical type—all products of the Aesthetic Movement—had become almost a cottage industry in the London Homer knew.[19] Aesthetic classicism had made less headway among artists and collectors in New York, but in London it flourished in countless studios and galleries. During Homer's April stay in the city, the Graphic Gallery on the Strand, for instance, displayed in its exhibition Types of Female Beauty works of this sort by Leighton, Alma-Tadema, James Jacques Tissot, and "other British and French Artists."[20]

The vogue in London for idealized female figures in drapery of a generalized clas-
sical sort may now seem at first glance to have offered little of interest to a realist artist
such as Homer. Yet a quiet dialogue between the real and the ideal had always existed
in his depictions of women. We can see this concurrence in his watercolor of two young
fishwives seated, *Mending the Nets* (1882, National Gallery of Art, Washington, D.C.), and
in his etched version of the subject (1888), informed by a rethinking of the background
and other details, *Mending the Tears* (plate 8). The setting and activities are ordinary, of the
moment, and the stuff of nineteenth-century realism, but Homer has idealized the figures
somewhat in the spirit of Leighton and Alma-Tadema.

This slightly awkward balance between the real and the ideal became even more strik-
ing in the oil painting Homer submitted to the Royal Academy's summer exhibition in
1882, *Hark! The Lark* (plate 9), for this realist work was informed to a degree by frieze-
like qualities that nod toward classicism but in a wholly naturalistic setting. The vertical
rhythms of the skirts, aprons, arms, and baskets, all in a single plane, flow across the can-
vas almost as in a sculptural composition. The fresh, youthful faces, distracted from their
labors by the rising of a lark, invest the painting with the necessary element of beauty to
move it toward the goals of aestheticism. The lark is unseen, and its song unheard, but any
viewer's memory of its appearance or song in flight would contribute to an understanding
of beauty made more rewarding when unexpected. So, too, does the screenlike expanse of
yellow morning sky, similar in its effect to the flat backgrounds of many British Aesthetic
Movement paintings, mark Homer's interest in unexpected visual pleasure. The subject,
of course, speaks of the entrancing power of beauty. The ascending lark's song, cascading
down from above, interrupts the women's toil to bring them a moment of pleasure.

It is hardly surprising that British reviewers took no note of Homer's attempt to elevate
a far from aesthetic subject, momentarily distracted working women, to a more aesthetic
level. The important British painters of the movement, all determined idealists, would
have found little of value in such an attempt to intertwine a workaday subject with ele-
ments of pure beauty. There was no escaping the fact that Homer's subject remained the
real one of the fishwives' world. But his aim here was not to imitate the hallmarks of Brit-
ish aestheticism, but rather to borrow certain elements of effect and to use them to bring a
new vitality to his essential naturalism. His attempt was ambitious and interesting, and it
confirms his determination while in England to remake himself as an artist.

His confidence in what he had accomplished in *Hark! The Lark* led him to recast it. He
repeated the figures, now on a small scale and with a different background, in one of his
finest English watercolors, *A Voice from the Cliffs* (1883, private collection). He then adapted
that work, using the same title but further altering the background, for one of his finest
etchings of the mid-1880s.[21] There was something distinctly democratic and American in
his belief that in this image of contemporary workingwomen, he had attained a modern
quality of beauty. At another level, his painting joins those of J. F. Millet, Gustave Courbet,

Thomas Eakins, and others of his era—more often French and American than British—in finding nobility in labor.

Two decades later his confidence in *Hark! The Lark* remained intact. Writing to a dealer, he characterized this work as "the most important picture I ever painted, and the very best one."[22] He doubtless added this dollop of hyperbole to strengthen his dealer's hand with prospective buyers. At the same time, he must have recalled the hours and days of the painting's creation, for in this work more than in any other he cut his ties to the past. Nothing he had painted in America resembled *Hark! The Lark*. With it, he began to transform himself from a distinctively American artist (with all of that term's implications of provinciality) to an artist who was at last engaged, however idiosyncratically, with one of the mainstreams of European art.

Long after Homer's return to the United States, the painting could still claim importance, at least to American eyes, purely for its aesthetic qualities. In 1914, the classicizing American painter and critic Kenyon Cox praised it at a little length in ways that Homer would probably have found acceptable. In discussing both this oil and the Cullercoats paintings more generally, he wrote that Homer's visit to England had awakened "in him a sense of human beauty and, particularly, of the beauty of womanhood. . . . Not from art but from life he learned the meaning of classic breadth and serenity, and his idea of figure drawing was transformed and enlarged."[23] In 1944, Lloyd Goodrich observed that the painting was "larger, more highly finished—one of his most consciously poetic themes."[24] Both comments made clear Homer's transcendence of purely realist observation.

Walsh has argued quite reasonably that this reform probably began with Homer's presence in London's National Gallery. She suggests that he almost certainly arrived in London meaning to study, among other things, watercolors and oils by J. M. W. Turner. He could have done so best in the new Turner Rooms at the National Gallery. As Walsh has pointed out, despite Turner's international fame, few of his works had reached American shores in the years preceding Homer's journey to England.[25]

As a leading American watercolorist who had steadily enlarged his mastery of the medium, Homer had every reason to study closely Turner's work in the medium. He would have been interested as well in contemporary British work in transparent watercolor, some of which had consolidated Turner's innovations into mainstream practice. It is reasonable to suppose that throughout his year and a half in England, he visited more than once the National Gallery's Turner Rooms and the watercolor galleries housed beneath them. He almost certainly also visited exhibitions at the Society of Painters in Watercolors in its rooms on Pall Mall East, a short stroll from the National Gallery. These exhibitions of new work in the medium presented levels of proficiency that made most American practitioners seem weak (Homer, John La Farge, and very few others excepted). The society's Ninety-fifth Exhibition opened on 6 April, by which time Homer was well settled in London. Exhibitions of new work by watercolor artists who were not members of the

society occurred in other venues. It would not be surprising to find that during his time in England Homer exhibited one or more of his new watercolors in London.

In visiting exhibitions, however, he can hardly have limited himself to work in watercolor, for he was still, even in England, a painter in oils. Listings of dealers' gallery shows appeared each day on the front page of the *Times.* The Grafton Gallery, just off Old Bond Street, was home to a memorial exhibition of work by the American painter William Morris Hunt, who had died in the autumn of 1879. Homer had been acquainted with Hunt, perhaps initially through La Farge. Long associated with Boston, Hunt had been an early champion of the work of Millet and the Barbizon School.

The Fine Art Society in Old Bond Street presented an extensive exhibition of works by the still active Pre-Raphaelite painter John Everett Millais. In another of its rooms, the society had hung a contrasting show of pastels from Venice by Whistler. In early March, about a month before Homer's arrival in London, Whistler's portrait of Thomas Carlyle had gone on view at the gallery of H. Graves & Co. on Pall Mall. The painting had drawn much interest, for Carlyle had died only a few weeks earlier. It is this painting about which Homer would later remark so positively to Beatty.[26] The showing at the Graves gallery had closed before Homer reached London, but he may have gained access to the portrait nonetheless, perhaps through its maker. The Grosvenor Gallery offered an exhibition of drawings by contemporary British artists.

The Doré Gallery on New Bond Street offered a broad range of the artist's paintings. After the success of *London a Pilgrimage* in 1872, Doré had returned to the less arduous task of illustrating literary classics, while still hoping for critical recognition as a painter. He and Homer had nothing in common as painters, though much in common, despite differences in style, as designers of woodblock illustrations. Curiosity alone may have taken Homer to the gallery.

More than curiosity would have brought him to another site, one scarcely more than a ten-minute walk from the British Museum: Sir John Soane's Museum. Homer would have heard from Linton and other well-traveled colleagues in New York of this extraordinary house. It had been Sir John's home and had been preserved as a museum after his death in 1837 according to his instructions. Its architecture, decoration, collections, and much more presented visual rewards of many kinds, especially for sophisticated eyes. A. J. Hare exaggerated a bit when he wrote in his *Walks in London,* "Few people know of it, and fewer visit it, which is much to be regretted. . . . Though the overcrowded and labyrinthine house leaves an impression of a feverish dream, it contains, together with much rubbish, several most interesting pictures."[27] Hare's comment aside, the "rubbish"—artifacts of many kinds from many ages and cultures—was as much admired in Hare's time as it continues to be in the twenty-first century.

The question naturally arises whether Homer visited exhibitions in London on his own or in the company of others. Might he have visited an exhibition and then perhaps

lunched at the Arts Club with some noted figure in London's art world? Could he have taken tea with Legros at the Refreshment Rooms of the South Kensington Museum? How likely is it that he attended a concert with a British colleague who, like himself, was a devotee of opera and orchestral music?[28] Or did he remain always a solitary sojourner in London, standing apart from other artists, as he would soon do in America?

He seems to have made no effort to forewarn anyone in London, except perhaps the Rimers, of his impending arrival. Although it was known in New York that he had embarked for England, none of his acquaintance in London would have been aware of his lodgings or plans unless he had alerted them about these things in advance. He may of course have chosen to avoid social engagements to maximize time available for work.

One person who, if he had known of Homer's presence in the city, would very likely have been inclined to contact him was the artist George Henry Boughton. Born in England but raised in America, Boughton was an expatriate painter and (honorary) member of the Tile Club.[29] The two men had apparently known each other briefly in New York late in 1859 before Boughton left America to study in Paris. In 1862, he settled in London rather than returning to the United States. The three years (1862–65) during which he maintained a studio on Newman Street saw him achieve sufficient success as a painter and illustrator to enable him to move with his wife to a more fashionable neighborhood, Notting Hill. In making this move, he became part of a trend in the 1870s and 1880s that encouraged several established artists to move to the new streets of this rapidly developing part of West London, close to Kensington Gardens.[30]

Here in the late 1860s Boughton transformed the interior of his home, a terrace house he had named "Grove Lodge," into a much admired example of interior decoration inspired by the Aesthetic Movement.[31] Despite his long absence from New York, but in part owing to his several paintings of Puritan New England and Knickerbocker New York, he had been elected to the National Academy of Design in 1871. Indeed, he always identified himself as an American artist, even after 1879, when he became an associate of the Royal Academy. (In 1896, he would advance to the rank of academician.) Homer had undoubtedly heard of him now and then through his National Academy and Tile Club connections.

Boughton knew and entertained many of London's leading painters and writers. He differed from most of them in his keen interest in also entertaining visiting American artists and authors. To gain a rather grander facility for this hospitality and a larger studio as well, in the mid-1870s he commissioned the architect Richard Norman Shaw to design a house and studio on Campden Hill, close to Notting Hill in Kensington.[32] He named this imposingly handsome structure "West House" in honor of Benjamin West, whom he believed to have been his earliest predecessor as an American artist elected to the Royal Academy.[33] At West House, he presided over countless dinner parties, gathering around his table with regularity not only such artist-friends as Whistler, Leighton, Alma-Tadema, and Poynter, but also such literary figures as W. S. Gilbert, Robert Browning, Henry James,

James Russell Lowell, and Thomas Bailey Aldrich. Soon after Abbey arrived in London from America in 1879, Boughton had introduced him over postprandial drinks to Gilbert and "Jimmy" Whistler.[34]

By 1881, both Boughton and Whistler were certain to have heard admiring accounts of Homer's recent work from Abbey, Parsons, Parton, and other artists with active American connections. Whatever critical carping may have greeted Homer's work from time to time, no one had doubted that he ranked among the most interesting and, in his way, accomplished painters in New York. Nothing, however, has yet come to light to suggest that Homer broke bread with Boughton or enjoyed his claret at West House in the company of celebrated members of London's community of artists. But it seems unlikely that the visiting American's presence in London went entirely unnoticed by his old acquaintances. If his presence in England had somehow escaped notice in spring 1881, then the inclusion of *Hark! The Lark* in the Royal Academy's summer exhibition of 1882 must have made him a topic of some interest within the American expatriate community.

Yet Homer's reputation as the most "American" of American artists of his era may have cast a shadow on the social dynamic of Boughton's circle. Nearly all the expatriate Americans in this group—even Abbey—had pointedly separated themselves from a society they perceived to be, compared to London's, provincial, unrefined, and unfeeling in relation to the fine arts. One thinks of Homer's inelegantly direct paintings of farmers, woodsmen, and children, his avoidance of urban subjects, and the rough execution of his early paintings—compared at least to the meticulous refinement and high finish of the artists in Boughton's circle. Homer's work, coupled with his well-known laconic social reserve, may have left Boughton hesitant to make him the center of a convivial evening.

Whatever Homer's social schedule may have been during his April weeks in London, he almost certainly spent most of his time preparing himself for the act of painting. He did it as he had always done it, by looking at how others had resolved specific problems in art making. For every increase in skill that appeared in his work so soon after he arrived in Cullercoats—greater mastery in three-dimensional design, stronger figure drawing, more varied uses of light, enlarged watercolor technique—the way had been suggested by works from a host of other masters, past and present, accessible in London collections and exhibitions. Busy as this preparation kept him during these initial weeks in London, he may nonetheless have found time to paint his view of the Houses of Parliament.

6

London, 1881

The Houses of Parliament

At some point after Homer put finishing touches to his only painting of a London subject, the watercolor *The Houses of Parliament* (plate 10), he signed it simply "Homer" at lower left, placing the year "1881" after his name. Although he spent nine months of that year in England, most chroniclers of the artist's career have described this watercolor as a product of the first weeks after his arrival in late March.[1] This presumption is a risky one, however, for he may have painted the work later in the year. New exhibitions, new acquaintances, and perhaps the presence of friends or relatives visiting from America are likely to have drawn him back to the metropolis from Cullercoats from time to time before the year drew to a close.[2]

The question of why he selected the Houses of Parliament as a subject has no easy answer, but conjectural possibilities abound. He may have painted the work as a kind of pictorial memoir, a record of where he had been and what he had seen in London—the building had few rivals as an icon of the city. When he sent the work to his Boston dealer for exhibition early in 1882, this act announced that Homer was abroad to those who did not already know.[3] After the watercolor failed to sell, Homer presented it to Charles and Martha. Perhaps he meant it to serve as a souvenir of a visit they had made to the city (if indeed these seasoned travelers had already been to London). The couple may possibly have journeyed to London to visit Homer, perhaps in the summer or autumn of 1881 (though no evidence exists of any such trip).

An even stronger case can be made that he painted the work expecting to submit it to a watercolor exhibition in England in 1881. He might reasonably have expected it to attract attention as a uniquely London subject treated in an original way in a traditional British medium by an American painter. But no record has yet appeared to establish its presence in any British showing. A further possibility suggests that as part of his effort to enlarge his powers, he chose the subject simply to investigate problems inherent in the depiction of a complex work of architecture in relation to a body of water. It was a challenging task that many British painters in watercolor had met with distinction since the eighteenth century.[4] Homer would have needed great confidence to involve himself in this British tradition on

its home ground. Whatever his motive, there is no doubt that he had found in the subject an ensemble of structure, water, and sky enhanced by atmospheric conditions that struck him as exceptionally pictorial.

Since the mid–twentieth century, the painting has become a familiar image within Homer's oeuvre.[5] Its owner since 1966, the Smithsonian Institution's Hirshhorn Museum and Sculpture Garden, has periodically exhibited the work and lent it to grace loan exhibitions of Homer's work at other venues. Reproductions appear in several Homer catalogues and monographs.

The image seems a familiar one even to persons unacquainted with Homer's work. Beginning in the middle of the twentieth century, countless magazines, travel leaflets, calendars, and other mass-circulation publications have repeatedly reproduced color photographs of the Houses of Parliament (formally the Palace of Westminster) taken from an angle of vision that comes close to duplicating Homer's. During the same post-1950 decades, tourists and others have snapped a prodigious number of photos of the subject that correspond generally to what Homer saw and painted (plate 11). Indeed, since the midpoint of the twentieth century, it has been an easy matter to promenade along a broad public walkway on the Lambeth (Surrey) side of the Thames between the Westminster and Charing Cross (Hungerford) bridges—the latter now flanked by the Golden Jubilee pedestrian bridges—to find a viewpoint that comes close to matching Homer's.

Throughout Homer's time in England, however, that viewpoint existed in an environment wholly different from the one known since the 1950s. In 1881, he painted from a location in an unappealing industrial precinct that was unwelcoming to casual visitors. Passing boats allowed a fleeting view of the grand building from an angle similar but not identical to Homer's, a view altered from his in perspective owing to differences in elevation and closeness of approach. Difficulties of access to the wharves that lined the Lambeth industrial riverside meant that few if any fine artists prior to Homer had painted the subject from his location.[6] His painting site merits close attention, but only after a consideration of his treatment of his subject.

Writers about Homer's sole London watercolor have admired his evocation of mood and his command of technique in achieving that mood.[7] The subject itself has provoked little comment beyond the observation that it was somehow odd that a painter who had avoided urban scenes in America should tackle one in London.[8] It needs to be said, however, that Homer's *Houses of Parliament* is an urban subject only in the narrow sense that the structures he depicts stand within a city. The painting says almost nothing about the character of city life. In this respect, what can be seen of the lightly populated line of pedestrians crossing Westminster Bridge counts for little. The painting conveys none of the sense of metropolitan life found in urban subjects by such British and French artists of the era as Frith, Manet, and Renoir, who incorporated in their paintings some combination of crowds of figures, peoples of diverse types, interactions among social classes,

activities of a particularly urban character, open spaces tightly confined or channeled by built structures, and intimations of city noises. Homer gives no hint of how crowded and cosmopolitan a city London had become by late Victorian times. There is nothing here of Doré's London.

Even the city's great river appears in a rare quiet moment. Homer causes the Thames's typically busy water traffic to shrink to a pair of men rowing a small, loaded boat. They provide the pictorial weight needed to counterbalance the upward thrust of the distant towers. On the river beyond these working oarsmen, a faintly rendered solitary sculler makes a turn in his racing shell. Barges anchored in midstream hug the water, their masts and sails folded. This is the Thames as it might appear on a Sunday in the 1880s, in a rare moment when river traffic was at its quietest (though Homer very likely made it quieter still). He has, in any event, ensured that nothing on the water acts as a significant distraction from his main subject—the buildings, the bridge, the flowing river, and the fog-infused light that acts on them.

Rather than a cityscape, this watercolor has better claim to be a landscape, though an unconventional one. Great blue-gray bands of river and sky occupy most of the sheet, each with its own tonality and sense of movement. The built structures in the middle ground—a bridge and a sequence of buildings—separate the expanses of air and water. The gentle, almost imperceptible, rise and fall of Westminster Bridge, supported by the graceful arches of its seven spans, forms a horizontal axis. Above it, rises the blocklike sequence of buildings whose towers, spires, and pinnacles stab into the sky. Soot-laden moist air—the twentieth century would call it smog—obscures the afternoon sun while lending it a reddish tone. The fog elsewhere appears as a grayish light touched with pinks and blues. It envelops the buildings and robs their details of clarity.

The colors of the fog were not necessarily Homer's invention. Writers in Victorian and Edwardian London—indeed, even into the 1950s—commented on the varying colors of London's fogs.[9] Homer's soot-darkened air has sometimes left viewers of this watercolor with a fleeting impression that it is a nocturne. What we see is instead daytime duskiness, a condition of light common enough in Victorian London. In this respect, Homer's rendering of the afternoon sun's reflection on the river's surface seems almost too bright, though welcome.[10]

The range of structures behind the bridge consists chiefly but not exclusively of the Houses of Parliament. That building's three major towers as seen in the painting are, from the left, the massive Victoria Tower, the Central Tower (sometimes called St. Stephen's Tower), and the tallest, the Clock Tower, home of the great bell Big Ben. Immediately to the right of the Clock Tower and at a distance beyond it, and thus rendered in a fainter tone, is one (or a conflation of both) of the pinnacled towers of nearby Westminster Abbey. A crevasse in the line of buildings then brings the viewer to Bridge Street. The tightly grouped buildings to the right of the street stand on a site occupied since 2001 by Portcullis House,

an office and conference facility serving the Houses of Parliament. At the time of Homer's visit, smaller buildings on this site stood adjacent to the underground railway's Westminster Bridge Station. (The station's name became simply "Westminster" in 1907. At the end of the twentieth century, it was rebuilt and much enlarged, with Piranesi-like depths).

Both the Gothicized Houses of Parliament and its adjacent bridge were relatively new structures when Homer painted them, despite their historic appearances.[11] Construction on the building had begun in 1840, six years after the destruction by fire of the earlier complex of palace buildings. (Turner had painted that conflagration from several points on both sides of the river.) Designed by Charles Barry and A. W. N. Pugin, the new complex achieved its striking silhouette with the completion first of the Victoria Tower in 1858 at the south end and then, at the north in 1860, the soaring Clock Tower. Henry James described the complex as "the great pinnacled and fretted talking-house on the edge of the river."[12] The new Westminster Bridge shed its scaffolding in 1862.[13] The ensemble of building and bridge that then reached completion had existed for nineteen years before Homer painted it.

The new bridge replaced a mid-eighteenth-century predecessor. Barry had served as consultant to the new bridge's architect and engineer, Thomas Page, to ensure that the design would harmonize with the new building. The Tudor Gothic lamp standards, restored in the twenty-first century, were part of this effort to make the bridge seem almost an outgrowth of the building. In his watercolor, Homer made more of the bridge than most painters had done; his depiction is one of notable accuracy. It suggests that he made detailed studies and preliminary drawings, though none are now known to exist.[14]

Before examining Homer's painting site, it is best to establish the direction of his view, for that view has sometimes been described inaccurately.[15] As the River Thames snakes its way through London from west to east, it shifts direction from time to time, running from south to north or north to south before resuming its eastward course. The Houses of Parliament stand at the western edge of a section of the river that flows from south to north. The view in Homer's watercolor is from the northeast facing upstream toward the southwest. The river is at or near high tide. The sun is in the west; the building is backlit.

Homer presumably scouted about the riversides before selecting this vantage point on the Lambeth side, north of Westminster Bridge (map 2). In choosing the site, he seems to have followed no other artist's example. Compendious surveys of nineteenth-century and early-twentieth-century paintings of the Houses of Parliament as viewed from the Thames identify no work in oil or watercolor earlier than Homer's that precisely duplicates his angle of vision (though, of course, some may exist). The very few artists who drew or painted the subject from the north (facing upstream) prior to Homer did so using one of three locations: from midstream on boats anchored in the Thames between the two bridges; from the broad foreshore of mudflats that appeared along the Lambeth side at low tide; or from high on a built structure at water's edge on the Lambeth side. Their views differ markedly from Homer's in elevation and perspective.[16]

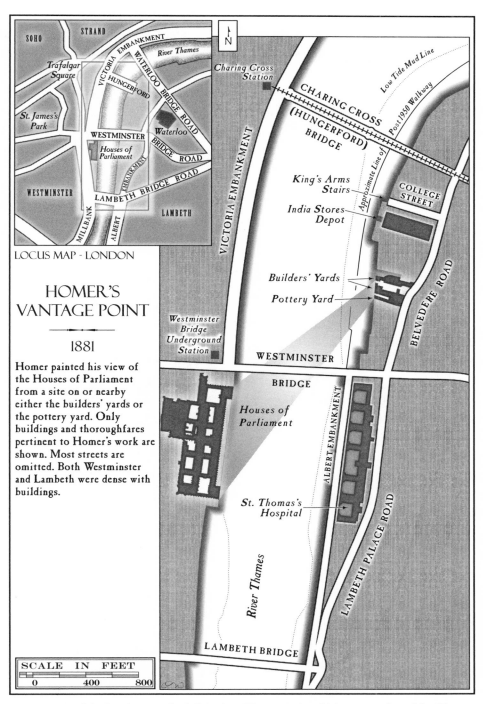

LOCUS MAP - LONDON

SOHO
STRAND
Trafalgar Square
VICTORIA EMBANKMENT
River Thames
WATERLOO BRIDGE ROAD
HUNGERFORD
St. James's Park
WESTMINSTER
Waterloo
BRIDGE ROAD
Houses of Parliament
EMBANKMENT
WESTMINSTER
LAMBETH BRIDGE ROAD
MILLBANK
ALBERT
LAMBETH

HOMER'S VANTAGE POINT

—————●————

1881

Homer painted his view of the Houses of Parliament from a site on or nearby either the builders' yards or the pottery yard. Only buildings and thoroughfares pertinent to Homer's work are shown. Most streets are omitted. Both Westminster and Lambeth were dense with buildings.

N

Charing Cross Station

Low Tide Mud Line

Post 1950 Walkway

CHARING CROSS (HUNGERFORD) BRIDGE

VICTORIA EMBANKMENT

King's Arms Stairs

India Stores Depot

Approximate Line of

COLLEGE STREET

Builders' Yards

Pottery Yard

BELVEDERE ROAD

Westminster Bridge Underground Station

WESTMINSTER

BRIDGE

Houses of Parliament

ALBERT EMBANKMENT

St. Thomas's Hospital

LAMBETH PALACE ROAD

River Thames

LAMBETH BRIDGE

SCALE IN FEET

0 400 800

Map 2. Map of the locality in which Winslow Homer painted his watercolor of the Houses of Parliament in 1881. Lucie Wellner, cartographer.

The Works of Art Collection of the Palace of Westminster holds a few such views.[17] One is a wood-engraved image published in the *Illustrated London News* for 3 August 1867 titled *Scene on the River at Westminster* (plate 12). It depicts the celebratory procession of flag-bedecked side-wheel steamboats transporting the Belgium Rifle Volunteers downstream to a waiting ship that would carry them home. To attain an elevated view, the unidentified artist may have perched atop the India Military Stores Depot, which at three substantial stories stood as the tallest building between the two bridges on the Lambeth side. His working station was in any event closer to Charing Cross Bridge than to Homer's location and presented a different angle of vision. The illustrator's arrangement of the key landmarks—the Houses of Parliament, Westminster Bridge, and Westminster Abbey—is at best approximate. Westminster Abbey, for instance, seems to have wandered away from proximity to the Houses of Parliament. Though faulty in topography, the illustration remains an agreeable example of popular pictorial journalism.

A work that comes closer to Homer's angle of vision is James Francis Danby's luminous oil painting *View of Westminster Bridge and the Houses of Parliament with a Hay Barge* of 1859 (Works of Art Collection, Palace of Westminster). Presumably painted from sketches and studies made in a boat anchored in the river, Danby's work pays homage to the old bridge, soon to be replaced. Except for the Clock Tower, he greatly diminishes the presence of the Houses of Parliament by enveloping it within a Claude-like radiance of light from a setting sun. The great building, not yet quite complete at the time and lacking the old bridge's sentimental associations, had yet to become an iconic image of resonant meanings.

Few other depictions from the north are known to exist, none corresponding to Homer's angle of vision. But between the completion of the Clock Tower in 1860 and Homer's arrival in 1881, several artists painted the Houses of Parliament from vantage points clustered well south of Westminster Bridge. They worked chiefly from both ends of Lambeth Bridge and from the bridge itself. The views from the south could be striking, with the Victoria Tower claiming a commanding presence in any composition. Westminster Bridge became a lesser distant detail in the prospect, though one of reassuring familiarity. Seen from the south, the bridge lay just beyond the new building and thus did not obstruct a clear view of the lower part of the building's river facade. In Homer's painting, the bridge masks that part of the structure, though to no ill effect.

Several of the artists who painted from the south worked from locations near the meeting of two much-traveled streets, Horseferry and Millbank, at the western end of Lambeth Bridge. Here groups of small boats docked at the riverside offered material for picturesque foregrounds, as did larger boats anchored nearby, sometimes with raised sails. In season, overhanging foliage enhanced the setting. Viewed from the south, the building became part of an ensemble more complex than that offered from the north. Among the most imposing of the views painted from the south were those by David Roberts. His handsome

oil *The Houses of Parliament from Millbank* of 1861 (plate 13) exemplifies the merits of the southern vantage points.

The configuration of the towers as seen from the south struck some observers as more felicitous than the configuration from any other direction. A few found the prospect from the south to be the building's only redeeming feature. In his *Walks in London*, Hare offered the opinion that the Houses of Parliament possessed an "exterior which is so wanting in bold lines and characteristic features that no one would think of comparing it for beauty with the halls of Brussels, Ypres, or Louvain, though its towers group well at a distance."[18]

The artists who worked from the south had no reason to move north along the river. They found little if any pictorial interest in the broadside view of the Houses of Parliament as encountered on a stroll along the Albert Embankment from Lambeth Bridge to Westminster Bridge. Along the embankment stood the seven linked pavilions of St. Thomas Hospital, built in an Italianate style in the late 1860s to provide a visually interesting across-the-water neighbor to the Houses of Parliament. In the view from the hospital, Barry's expanse of riverside wall seemed excessively long and almost flat. Monet would occasionally paint the subject from the riverside terrace at St. Thomas Hospital, cloaking the building's details in an atmosphere of colored mists and fogs, but he found much greater interest in the view from the balcony of his upper-story room at the Savoy Hotel, with Charing Cross Bridge in the foreground.[19] From this vantage point high on the north bank, the towers form an ensemble of complementary elements of a sort altogether lacking in the view from St. Thomas Hospital.

North of Westminster Bridge on the Lambeth side of the river, the view of the building quickly became more interesting. The paucity of artists who exploited it surely reflected their reluctance to spend time within the crowded industrial neighborhood that lined that foreshore. It was not a pretty bankside. A nearly unbroken line of wharves, docks, cranes, smokestacks, warehouses, and walled storage yards ran along the river's edge from bridge to bridge. Without an embankment or river wall to contain it, the Thames at high tide lapped against the wharves' pilings. Low tide exposed an extensive muddy foreshore in front of the wharves.[20] This waterfront was a heavier-duty, less ramshackle, less picturesque kind of industrial waterfront than those that had attracted Whistler at Wapping and Rotherhithe in the early 1860s when he etched his Thames Set.

From the Port of London, barges brought to these wharves timber, stone, iron, clay, cement, and grain. The sequence of riverfront operations from north to south began by Charing Cross Bridge with a lime- and cement-production yard containing a working lime kiln. Then came a sawmill with a lumberyard.[21] At that point, the narrow College Street slipped in between high walls to reach King's Arms Stairs. This small, centuries-old public landing place offered the only Lambeth-side open access to the river between the two bridges. If Homer came to the stairs, by boat or along College Street, he would

have found himself too distant and set at too oblique an angle to have a satisfactory prospect of his subject.

Immediately south of the stairs stood Suffrance Wharf and its warehouse. Alongside it were two wharves serving the three-storied India Military Stores Depot, whose roof may have been the site from which the artist for the *Illustrated London News* drew side-wheelers loaded with Belgian Rifle Volunteers. Beside the depot were another sawmill and timberyard and then a stoneyard and another timberyard complete with sawmill.

Next along the line came the wharves that offered Homer his view. The first of these wharves served a pair of builders' yards and a pottery yard with an industrial kiln, used probably for the manufacture of chimney pots or other heavy ceramic products. Close by was another wharf for the unloading of stone and timber. It seems most likely that Homer painted his view from a point on either the wharves for this pottery yard or the adjacent wharves of its neighbor, which served two sets of builders: the Lucas Bothers and Holland and Hannay.[22] Homer's chosen view cut across these wharves. To his left, the rest of this riverside consisted of another builders' yard, another lime and cement yard, an iron foundry, and a steam-powered flour mill.

Homer probably painted on a Sunday or holiday. On other days, dust and smoke would have filled the air not only from the sawing, firing, grinding, cutting, and milling operations, but also from the coal-fired steam cranes that stood at water's edge. Barges, wherries, and lighters would have passed and docked nearby. Any artist would have found the near-constant movement and noise along the riverside distracting. If Homer painted on a Sunday, when all was quiet, he probably arrived by boat, perhaps delivered by a waterman rowing a Thames wherry. On a Sunday, there would have been no access from the land side. Walls enclosed the yard behind each wharf.[23]

Weather was a crucial consideration for any artist working in watercolors on an open wharf. Meteorological records for Lambeth for 1 to 11 April indicate no significant rainfall. From 12 to 14 April about 0.13 inches fell each day, with less on most following days.[24] Homer's Sundays in London during that month were 3, 10, and 17 April. The first of these Sundays was dry, but at that early point in his visit he may not have been ready to paint. The second was also a dry day. The third was Easter Sunday. Work may have ceased on Good Friday. Monday, 18 April, was also a holiday. If Homer painted his *Houses of Parliament* in April 1881, then the Easter weekend, despite an occasional shower, may have offered him the best opportunities to spend extended time at his site. There is, of course, no way of knowing how much on-site time he required and how much work ensued in his studio. The precision of his rendering of the bridge may owe much to both preliminary studies and later off-site stages of production.

What arrangements might he have made to paint on the wharves? Whether he scheduled the use of the site in advance, paid a willing watchman on a holiday when the wharf was quiet, or set up a visit in some other way are speculative possibilities. It is fair to

assume that he had no access to photographs or other images of the building and bridge taken from this site—if indeed any such existed.

No panoramic photographic record of the line of wharves as they existed between the bridges in 1881 has yet come to light.[25] But a distant view of this industrial riverside with its forest of cranes appeared in the *Illustrated London News* for 28 January 1860 as a small detail in a panoramic view from the Victoria Tower (fig. 4). Even at such a small scale, the distant precinct presents itself as a conspicuously unappealing place.

It remained so until the early decades of the twentieth century. Then, in advance of construction of the first, river-facing parts of London County Hall, the London County Council cleared the southernmost half of this part of the riverside of its old structures. The wharves that had provided Homer with his view of his subject disappeared to make room for the new building and its forecourt. The forecourt and a river wall were built on the mudflats to continue the line of the Albert Embankment's wall. Homer's painting site probably lies buried somewhere between County Hall's northwest pavilion and the north end of the building's central colonnade.[26]

The wharves, cranes, mills, kilns, foundries, sheds, and warehouses that remained along the river north of County Hall suffered bomb damage in World War II. The London

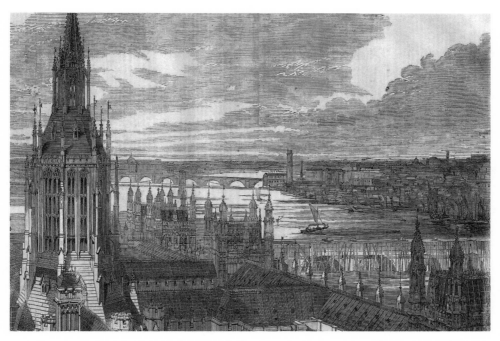

4. A distant view of the Lambeth riverside lined with cranes as seen from the roofs of the Houses of Parliament, 1860. Detail of a wood engraving after a drawing by an unidentified illustrator. *Illustrated London News*, 28 January 1860. Syracuse University Library.

County Council swept away what was left in 1949–50 to make room for the 1951 Festival of Britain's Dome of Discovery and Upstream Pavilions. Only then did the council extend the river wall it had built in front of County Hall all the way to Charing Cross Bridge. Running through spaces once occupied by wharves and walled yards, this new river walk connected the historic Albert Embankment to the new walkways of the South Bank.[27] It then became possible for persons to promenade along the edge of the Thames from just south of Lambeth Palace to Waterloo Bridge. (Later clearances to the east extended the walkway much farther, well past Tower Bridge.) Since 1977, the Jubilee Gardens have occupied much of the space just northeast of Homer's painting site. Erected in 2000, the London Eye has ever since loomed over the area.

Although the point from which Homer painted his *Houses of Parliament* lies buried, his approximate line of vision can be reclaimed from a location on the river walk at which the configuration of the great towers with respect to each other and to the bridge's arches matches most clearly what can be seen in his painting. Despite his penchant in other works for recomposing what he found in a landscape, Homer altered little in his *Houses of Parliament*.

What might explain this uncharacteristic though impressive precision in the rendering of his subject? One possibility is the chance that having examined paintings by Turner and others that set grand buildings adjacent to bodies of water, he undertook a study of the problems inherent in the subject. He had surely seen and may have studied Turner's large oil *Dido Building Carthage* (1815) at the National Gallery. This oil was one of the paintings that Turner, as a condition of his gift to the nation, required the museum to have always on view and to place always adjacent to Claude's much earlier and much admired *Seaport with the Departure of the Queen of Sheba* (1648). In each of these paintings, the artist had contrasted the static forms of buildings with the restlessly moving surfaces of an adjacent body of water. In both, light in its many guises reflects differently from each of several surfaces and suffuses the air with color.

As Homer would have been the first to point out, his watercolor merits no place in the history of the grand tradition of ideal landscape from the seventeenth century into the nineteenth. It offers no figures in historical attire, no buildings in classical style, and no carefully composed and detailed natural setting in which a historical event pregnant with meaning occurs. Nonetheless, he accomplished one of the things vital to the success of many of the older masterworks in the tradition—the establishment of a complex dialogue between solids and fluids within a unifying envelope of color and light. The Turner and Claude paintings present grandly elaborated contrasts between buildings and bodies of water; a sense of history hangs over each, supplied more by their titles than by depicted activity. Homer's work is far simpler. Its sense of history comes solely from the building's Gothic style. All the rest—barges, oarsmen, figures crossing the bridge—are products of realist observation. Yet Homer accomplished something here that he had never before attempted, and he did so in a distinctly British medium.

This watercolor's quiet but pulsing energy, so evident in the moving water and clouds, in the passing boat, and in the taut line of the bridge, almost makes the viewer overlook the quality of the light. Dusky, shifting, sometimes hiding, tremulous in reflection, this light is among the most variously alive of any Homer had thus far painted. It proved to be a transient interest, however. Once away from London, he would find and engage elsewhere in England a different range of problems in the making of art: those concerning the human figure. For these, he would need other kinds of light.

7

New York and Maine, 1882–1890

The New Painter

Even before Homer returned to New York on 24 November 1882, he had begun to place a selection of his new paintings before the eyes of collectors and other artists.[1] He had sent watercolors from England to his dealers in Boston and New York late in 1881, and, probably following his directions, they had placed one or two of these works, varying the selection for each venue, in at least four different exhibitions. These showings occurred between January and April 1882—that is, during New York's art season.[2] Soon after his return to Manhattan in November of that year, he arranged for a similar introduction of a second group of his English watercolors during the early months of 1883, now in slightly greater quantity. Four went into the American Watercolor Society's annual exhibition in late January and brought much praise. In the following month, the watercolors on show at the Century Association ensured that they would be seen by artists and others who had not viewed them elsewhere. As Beatty later noted, Homer had a great deal of business sense.

By the end of the 1883 season, a critical consensus had begun to take shape in New York that Homer was now indeed in many respects a "new" artist and a profoundly impressive one.[3] That autumn Mariana Griswold Van Rensselaer, perhaps the most perspicacious American critic of Homer's time, reviewed what she had seen of the Cullercoats watercolors. She did so with an eloquent display of feeling guided by intellect. In the 1870s, she had held serious reservations about Homer's work, although never doubting his talents and promise. She had been bothered by what she saw as an awkward freedom of brushwork, a purposeful lack of finish, and an apparent withholding of feeling. Even so, she had acknowledged and admired his originality. Now, reviewing his Cullercoats work in an essay for the November number of *The Century*, she proclaimed him a master at last worthy of high praise. She began by stressing his singular place within the recent history of American painting: "He cannot be classed with those who won their position and gained their chief honors before the War of the Rebellion; nor is he identified with the later generation which has so rapidly grown in numbers and influence since the appearance of a few clever Munich and Paris students on the Academy walls in 1877. And not

only in time, but in the character of his work, he stands apart from both these well-known groups."[4] The first of these two groups would have included such painters of the Hudson River School as Frederic Church and Albert Bierstadt; the second, William Merritt Chase and Frank Duveneck.

After a review of his earlier years, she characterized his individuality in terms that have been echoed by critics and viewers ever since.

> For a noteworthy point about Mr. Homer's work, one that proves its inherent originality of mood and strength of utterance, is that it always makes itself felt, no matter amid what surroundings. Every passer-by marks it at once, and is apt to give it an unusually decided verdict in his mind, whether of approval or dispraise. No one can be blind to it in the first place or indifferent in the second, as one may be to the things by which it is encompassed on the average exhibition wall—things probably more "pretty" or more "charming," possibly more polished, but in almost every case much weaker, more conventional, less original, and at the same time much less truthful.[5]

She then began an extensive discussion of his recently exhibited work from England with words that Homer must have welcomed as a rare instance of a critic understanding what he had done:

> At the watercolor exhibition of 1883, Mr. Homer again surprised us with drawings of a new kind and possessing novel claims to praise. They were pictures of English fisherwomen, set, as usual with him, in landscape surroundings of much importance, and were, I think, by far the finest works he had yet shown in any medium. They were lacking in but one quality we had prized in his earlier work—in the distinctively American accent hitherto so prominent. . . . It is proof of his true artistic instinct and insight, and his freedom from conventionality of thought or method, that Mr. Homer, who had so clearly understood and expressed the American type during so many years of working, could now free himself so entirely from its memory as to make these English girls as distinctly, as typically English as any which have ever come from a British hand. . . . [The pictures] seem to me not only, as I have said, the most complete and beautiful things he has yet produced, but among the most interesting American art has created. They are, to begin with, *pictures* in the truest sense, and not mere studies or sketches, like most of his earlier aquarelles.[6]

From Van Rensselaer onward, commentators have left no doubt that Homer's Cullercoats watercolors represented a crucial turning point in his development.[7] If Houghton Farm had been his laboratory for testing the merits of transparent watercolor against those of gouache, Cullercoats represented the place where he put his growing skills in the former medium more fully to work than ever before. Most accounts of his time in the village have emphasized its advantages to this task. Even so, it makes sense to review that setting

and the work it produced, for these watercolors were New York's introduction to an artist who was indeed in many respects "new".

Cullercoats faces the sea immediately north of the town of Tynemouth.[8] Homer painted in the village itself, around its bay, on nearby ledges, and up and down the coast. With his watercolor kit, he traveled as far as Scarborough, Flamborough Head, and Bridlington, more than fifty miles to the south. Without his kit, he acquainted himself with the prosperous city of Newcastle, close by Cullercoats. In August 1881, four months after his arrival in the village, he exhibited new works in the annual exhibition of the recently founded Newcastle-upon-Tyne Art Association. It seems likely that the closeness of Cullercoats/Tynemouth to the prosperous and rapidly developing city of Newcastle played a part in his choice of a place to settle.[9]

At some point, he purchased in a Newcastle bookshop a French–English dictionary,[10] which suggests that he contemplated a trip to Paris during his time in the Northeast. Among the several possible motives for such a journey, two are among the strongest. He would most certainly have arranged to meet Charles and Mattie in the French capital if they had gone there on a winter holiday—they had previously visited the city. Beyond that, his familiarity with London collections would have encouraged him to look again at Parisian museum and gallery offerings fifteen years after his earlier visit, now with eyes sharpened by his time in London.[11] But although the dark Northumberland winter offered few occasions for painting, he remained in Cullercoats for at least part of that season during 1881–82.[12] He may have returned to New York briefly in the early months of 1882.[13] A trip to London at any point in this cold season seems probable.

Whatever his winter travels may have been, it seems clear enough that he had settled happily into the fishing village. In even his earliest Cullercoats watercolors, his depiction of human relationships as distinctly communal suggests that he had bonded with the women who would serve as his models in this community of sea-oriented working families. It suggests that he found in the village a more amiable life than he had known in recent years in New York.

The question of why he chose to settle in a place so remote from London continues to puzzle biographers. But remoteness is a relative matter. Fast trains sped between London and Newcastle in half a day. Homer was a veteran of long-distance rail travel in America. As to his choice of seaside locale, there is every reason to take seriously the reasons for choosing Cullercoats that he gave to Alan Adamson, a young friend in the village. Adamson remembered Homer as having said that on the recommendation of a fellow passenger on his Atlantic crossing, he came to Cullercoats for its "atmosphere and color."[14] By "color," Homer would certainly have meant the color of light in this northern latitude, a light grayer, less intense, and more subtle than the light he had known in New England and New York and a cleaner, clearer light than was to be seen in London.[15]

By "atmosphere," he may have meant not only the air, but also the ambience of the village's fisherfolk society, simpler in many ways than the society he had known in New York and London. He remarked to Adamson that as a painter he had tired of the sameness of the appearance among American places, activities, and attire.[16] Whether intended or not, his comment amounted to an announcement that he was about to abandon the painting of American life in the manner that had characterized his career to date. In the oil medium, he would in fact now cease to paint American genre subjects as he had previously.[17]

Another advantage of locating himself in a village apart from a large city was the likelihood that it would free him from the demands and expectations of the art world as he had known it in New York and observed it in London. Village life gave him time without major distractions to put to work what he had learned in London. The small seasonal art colony at Cullercoats counted for little in this respect. Its members were minor figures in British art. Homer would have considered paintings by even the more prominent of them *retardataire*, lesser work in all respects than his own.[18] He apparently spent scarcely any time with the colony's members beyond a few courtesy calls.[19] For congeniality, he turned to the local fishing community.

After painting numerous smaller works, he at some point in the summer of 1881 produced his large, highly finished *Four Fishwives* (plate 14). This work's scale alone placed it in the distinctly British "exhibition watercolor" category. In it, he revealed a new and impressive ability to paint figures in motion naturalistically. By comparison, his oil of a decade earlier, *Snap-the-Whip* (1873, Metropolitan Museum of Art) and its widely distributed reproduction as a wood engraving in *Harper's Weekly* (plate 2), must have seemed in retrospect to New York critics in 1883 an ambitious but not altogether successful attempt to manage the daunting challenges of deploying moving figures. The earlier image's enduring popularity surely owed as much to its evocation of the pleasures of childhood as to Homer's figure drawing or (in his oil versions) to his handling in paint of its volumetric motion.

In his *Four Fishwives*, the rendering of the women's movement shows a greater and more confident command of the problems involved. The kinetic naturalism of the figures' free forward motion gains in interest through the contrasting action of their arms as they tighten straps, hold baskets, and carry a toddler. The coordinated actions of each of the figures' skeletal and muscular parts rings true as never before in his work. His figure paintings for a decade and a half prior to his arrival in London had held visual interest of several kinds, but never this semblance of vital life.

This watercolor also made clear Homer's advances in the handling of recessive space. He had always been a master of two-dimensional design. From early in his career as an illustrator for the pictorial press, his work had stood out from the dross of other graphic artists especially in this respect. But his was a strength of planar design, and it had served his early paintings well enough. Complex design within recessive space was rarely a

significant or successful aspect of his compositions. In his paintings, color as an instrument of design had remained little used. He had continued to depend on a linear construction of space. Beginning in Cullercoats, however, his work in three-dimensional design began to reflect academy-sanctioned techniques, though always with an effect wholly his own. The source of this change, like that of others, almost certainly came from his study of masterworks in London collections.

His *Four Fishwives* offered early evidence of his new capabilities in the handling of recessive space. Pictorial tension asserts itself as the four figures stride along an axis perpendicular to a recession of land, water, air, and sky. This space proceeds stage by stage through modulations of tone that leave no spot on the sheet lacking in interest and that carry the viewer's eye over the wet sands to the sea and on into the clouds. But the women's eyes look elsewhere to a place unseen by the viewer, and they stride toward it.

The solitary fisherman at right, less completely composed and detailed than the women so as not to detract from them, acts as a point of transition. He pulls the viewer's attention from the women to himself and then sends it farther back to the crowded band of figures at water's edge. These distant figures form a partial backdrop for the women, a screen open wide at center to expose the quiet water of low tide. The view through the opening acts as a reminder that the sea, despite its remoteness and even when quiescent, remained the main player in the drama of life in the fishing village.

The figures of the four fishwives overlap, conveying a sense of familiarity, community, and shared effort. In depicting them as he has, Homer seemed also to record his good feeling for them. Each woman differs from the others in subtle ways—stance, attire, posture, burden. Their common activity unifies them as a group.

In the later decades of the twentieth century, commentators sometimes interpreted Homer's several dozen depictions of Cullercoats fishwives as a visitation on his part to the traditional subject category of peasant life. This subject was an aspect of romanticism much exploited in European art during the second half of the nineteenth century as the ever more urban art audiences of a complex industrialized society found interest in evocations of the seemingly simpler life of peasants. But the women who posed for Homer at Cullercoats would have objected vociferously to any characterization of themselves as members of a peasant society. Neither illiterate nor bound to generations-old ways of life, they were instead members of a small local fishing industry scarcely a century old and soon to disappear (put out of business by the large steam-powered trawlers that Homer sometimes painted on the horizon off Cullercoats Bay).

Homer presented his fishwives as individuals more than as stereotypes. In the 1883 watercolor *An Afterglow* (plate 15), three young fishwives in two cobles lean toward each other over the gunwales to converse. Their freshness of expression and casualness of posture is at a far remove from conventional painted images of peasants. This watercolor speaks of a realist artist at work, of the observation and recording not of a culture different

from his own, but of members of a community of which he was a part. He emphasized the friendships of these women as fellow workers. He made clear their relaxed independence as members of a community socially distinct from the tonier Tynemouth and the industrial Newcastle classes.

Although Homer individualized these women, he left their men as stock figures. Indeed, the male figures he painted at Cullercoats come much closer to the idea of the peasant in art than do his women. They are closer still to the idea of the faceless worker in industrial society. In his *Returning Fishing Boats* (1881, Fogg Art Museum, Harvard University), Homer presents one fishwife in a coble resting her arm for balance on the shoulder of another in a naturally companionable way, but he gives only back views of the two men in the boat, both dressed in oilskins that obscure any individuality.[20]

On Sundays and for non-work-related events, the fishwives shed their working garb to don prettier attire. Photographs show stylish print blouses, fashionable earrings, and other accessories popular among working-class women nationwide.[21] With their husbands, the fishwives of Cullercoats operated what amounted to labor-intensive small businesses. Some fishermen owned their cobles; their wives and daughters sold the catch, often delivering it on foot to shops and houses along routes radiating from the village, reaching even as far as Newcastle. That task done, they returned to bait hooks, mend nets, and otherwise prepare their husbands' next sailing. The work was hard for all involved and dangerous for the men, and it brought modest earnings at best. Unlike peasant society, the Cullercoats fishing community depended for its welfare entirely on its own labors rather than on the whims and obligations of a controlling higher social class.

Yet the question arises whether Homer might in his portrayals have implied that these women were peasants, perhaps to meet a market demand. His Cullercoats paintings could be seen as works motivated by the late romantic fascination with survivals of presumably simpler lives. But to assume that he sought to fit the Cullercoats fishwives into the peasantry molds created elsewhere in Europe in the decades before his visit by such painters as Millet, Jules Breton, or Jozef Israels flies in the face of all that is known about his resistance to following the manner of other artists. This is not to say that he ignored their work or might not have learned from it in minor ways, consciously or unconsciously, perhaps by the memory of something seen in a painting by, say, Millet. But his sensibilities ensured that his work would not be *like* that of the others in concept or appearance, and it was not.

Far from seeming to be a passing novelty in Homer's development, these English watercolors soon held a place of special respect in the years that followed.

In 1911, Homer's biographer William Howe Downes found in *A Voice from the Cliffs* (1883), private collection), Homer's watercolor variant of his *Hark! The Lark*, that

[a]striking feature of this compact group of figures is the repetition of lines in the arms of the girls as they hold their baskets. This gives a swing of movement to the group and

is highly effective and rhythmical, without monotony. The heads are the prettiest female heads painted by Homer up to this time, though they are probably all painted from the same model, which is a detail of no great importance. The [quality of the] drawing has an unusually potent element of charm, and the first and last impression is of the extraordinary beauty of the composition.[22]

In emphasizing beauty, Downes as well as Cox meant something more than mere optical appearance. Cox's mention of the "beauty of womanhood" in Homer's *Hark! The Lark* surely encompassed character and behavior as well as aesthetic pleasure. Both authors had observed the strikingly womanly ways in which Homer's fishwives act in relation to one another and to their children. They talk, touch, work together, smile, and hold children in ways that Homer had shown earlier only in his paintings of African American women in Virginia in the mid-1870s. There, as in Cullercoats, he had painted a society and class not his own, finding in it a warming life among women that had seemed to elude him at home. It is absent from his early croquet scenes of the late 1860s, his farm girls of the early 1870s, and his elegantly attired young women later in the decade. The stillness and self-preoccupation that distinguished nearly all of these earlier female figures may, of course, have been products of his use of posed professional models. Though he paid the Cullercoats women for posing, he painted them most often extemporaneously, outside the formalities of studio sessions. They were, in any event, neighbors with whom he chatted on the street.

This congeniality between artist and subject disappeared when he returned to New York. Only in a single painting, his warm-hearted *Cloud Shadows* of 1890 (Spencer Museum of Art, University of Kansas), executed at Prout's Neck, did a female figure as fresh and bright as many of his Cullercoats women make a return appearance. He painted this work, as with his fishwives, from a neighbor rather than a professional model. But he had few paintable female neighbors at Prout's. When he left Cullercoats, he left behind an important part of his engagement with community life.

Among the things he took back to America was a deepened interest in the power of storms. He had set nearly all his paintings of the 1860s and most of the 1870s in fair weather. He had introduced an oncoming storm as a significant component of a subject perhaps first in 1878 in his watercolor *Shepherdess Tending Sheep* (Brooklyn Museum of Art), one of the most carefully and thoughtfully composed works among the many from his time at Houghton Farm. In Cullercoats, living at the edge of the tempest-prone North Sea, he began to take the impact of storms on the community as a subject. In his *Watching the Tempest* (1881, Harvard Art Museum), fisherfolk who are gathered for protection behind beached cobles near the village's Watch House anxiously look out on the storm-tossed sea for boats yet to return. In Maine, his new paintings would eliminate this human element and shift the subject to the more universal and elemental one of a storm's contest with a battered rock-bound coast.

∞

WHAT VAN RENSSELAER and others in New York had recognized as "new" in Homer was based on the work in watercolors he had completed in England. It amounted to only the first stage in a greater transformation. The second stage began after his return to New York and centered on new work in oils. Like his recent watercolors, the works of this stage seem to a large extent to be products of what he had learned in London museums and galleries as well of what he had observed of the North Sea.

In early spring of 1884, more than a year after his return to New York, Homer put into the National Academy's annual exhibition his first significant post-England oil, *The Life Line* (plate 16). A prominent collector bought it at a preview for twenty-five hundred dollars, a sum by far the greatest Homer had yet received for a single work.[23] He lost no time in showing the buyer's check to his mother, who lay mortally ill in Brooklyn. The press and public alike greeted the work with acclaim.

The Life Line depicts a coastguardsman in a breeches-buoy carrying an unconscious or semiconscious woman to shore from a ship that has run aground. Homer had apparently observed at close quarters a demonstration of this rescue gear and its method of use on a beach in New Jersey in 1883. Earlier, however, in 1881, and from a greater distance, he had watched and recorded an actual rescue of this type in Tynemouth.[24] The level of energy and dramatic intensity in *The Life Line* had no precedent in his work.

On 5 April, the critic for the *New York Times* described the painting as "the most striking picture in the exhibition" and offered some interesting insights:

> Mr. Winslow Homer by no means exhausted his quiver at the Water-colors [the American Watercolor Society's annual exhibition], but reserved for the Academy a large-sized arrow. . . . [The painting depicts] that part of a shipwreck in which the tragedy is taking a happy turn. The background is composed of two great gray rollers, between which a sailor and a young woman are passing, suspended to a life-rope. . . . The hiding of his features [by the woman's wind-blown scarf] concentrates the attention very cleverly on his comrade, who has fainted or is numb with fright. She has nothing on but her shoes, stockings, and dress, while the skirt of the latter has been so torn that her legs are more or less shown above the knees. . . . Mr. Homer has sprung this figure on us unexpectedly. As is usual, his is the charm of the unexpected. Who, beholding the undrawn, boneless, muscle-less women he used to paint only a few years ago would look to him for such strength in modeling? . . . He has done a very unusual thing of uniting clearness of conception and good composition with a sensuousness, a feeling for physical beauty in the woman's form, which is nonetheless admirable because, true as it is, it will not shock the most decorous.[25]

Most other reviews were no less positive. Several mentioned the great waves, which in their scale and suggestions of power and motion were indeed unlike any that Homer had

earlier painted in America. They did, however, have something in common with paintings of rough seas by British and Continental painters whose work he had seen in London. Turner's *Calais Pier* of 1802–1803, for instance, part of the Turner Bequest on view at the National Gallery, offered a compelling example. Homer had observed active seas of this sort from beaches in America and at Cullercoats, but only from close study and an understanding of how such seas were created on canvas in masterworks of the past in London had he learned how to paint them with conviction.

Though painted from models, the suspension in midair of *The Life Line's* entwined figures was necessarily a product of Homer's imagination. The woman carried by the coastguardsman has none of the hallmarks of Homer's Cullercoats fishwives. Dependent for her very existence on the man in the breeches-buoy, this figure has (at least in her present circumstances) none of the fishwives' life-enhancing energy. Echoes of the Cullercoats women's stateliness and vigor would reappear only occasionally in Homer's later works. This insensible woman and two others in his oil *Undertow* (1886, Sterling and Francine Clark Art Institute, Williamstown, Massachusetts), also begun in 1883 but not exhibited until 1887, are among the last of Homer's carefully studied female figures. With the critical, financial, and popular success of *The Life Line* in New York, he had at last achieved the "greatness" that his mother had forecast. He was now, at least for the present, financially comfortable.[26]

He now would push ahead farther, still using as a foundation what he had learned abroad but aided also by the site of his studio, for by late June 1884 he had settled himself by the edge of the sea at Prout's Neck.[27]

There on occasion he used local farmers and fishermen as models, but before leaving New York, he once again used professional models. His strongly drawn, well-modeled coastguardsman in *The Life Line* had been a new departure that deeply impressed critics, and so did the two lifeguards in his *Undertow* (1886, Sterling and Francine Clark Art Institute, Williamstown, Massachusetts) when it was later exhibited. Viewers of this depiction of two manly life savers rescuing a pair of young women probably assumed that the four figures were in rough surf on an American beach. But the male figures in the oils Homer began after settling at Prout's could not easily be identified specifically as Americans, nor did he place them in obviously American settings. He suppressed the national flavor that had been so important to his earlier reputation. His new subjects might as well have been from Canada or northern Europe if they were not from some location well out to sea. Their circumstances were in a sense timeless. He would continue to record in watercolor with local detail subjects that piqued his interest in Canada, the Caribbean, Florida, and the Adirondacks—places outside the geographic mainstream of American art—but his oils would with few exceptions now include no specific details of location. When he recorded the rock-bound coastline close to his studio, the image conveyed meanings that were universal rather than local. Published commentaries on his edge-of-the-sea marines and the

titles of a few of these works tend to identify them as from Prout's Neck, but the paintings themselves depict a generic, rock-bound, northerly coastal landscape of a type scattered throughout the planet.

To exploit *The Life Line*'s success, Homer lost no time while in New York in making and issuing an etching of it. Here, too, he may have had in mind the British practice of producing etched reproductive images of paintings. Settled at Prout's, he etched a further seven subjects, reproducing images from both his new oils and his English watercolors.[28] He may also have been encouraged by the new and flourishing American vogue for etchings that had been aroused by the Etching Revival in Europe. Because that vogue called for original subjects rather than reproductions, however, his etchings remained outside the revival's mainstream.[29] The extent to which they sold in the 1880s remains a puzzle.

As a painter in oils, he now worked at a pace slower than that of his pre-England years. In the mid-1880s, he created a quartet of oils with male figures that varied the central theme of both *The Life Line* and *Undertow*: an encounter of one or more persons with a threatening sea. In these new paintings, Homer portrayed the sea explicitly or implicitly as a force in the natural world of more significance than any human protagonist. These oils of the mid-1880s deeply impressed critics and fellow artists. Any thought that *The Life Line* might have been an aberration vanished with the arrival of *The Herring Net* (1885, Art Institute of Chicago), *The Fog Warning* (1885, Museum of Fine Arts, Boston), *Lost on the Grand Banks* (1885, private collection), and *Eight Bells* (1886, Addison Gallery of Art, Andover Academy, Andover, Massachusetts).

None of these paintings sold rapidly, and none, when a buyer at last appeared, earned anything close to the figure that the first of the sequence had brought. Nonetheless, they solidified the deeper level of respect from critics that *The Life Line* had earned. Rather than being considered only a promising artist, as Homer had so often been described for nearly twenty years, he now and with some suddenness ranked as an artist of mature accomplishment. With the appearance of *Undertow*, one critic observed that "[a]fter Mr. Homer's intense epic one must wait a little or other paintings of the figure will seem tame."[30]

In a review of *Undertow,* when it at last reached exhibition early in 1887, a critic for the *Boston Daily Evening Transcript* observed that "[Homer's] work is frank, outspoken, penetrating; utterly characteristic, his own; inevitable in fact, the only thing he *can* do. . . . The picture has the absolute truth of fact. . . . This is Ruskin's veritable 'uncompromising realism.'"[31] The reviewer might have added that what Homer could do, other painters could not. His work was sui generis. His realist style was one that in the twentieth century would be described with greater admiration as "objective realism," Homer and Eakins considered its two masters, though different in character.[32]

At about the same time as the *Transcript* review, Augustus Stonehouse in an essay in the *Art Review* observed about this "new" Homer that

[w]hat I want to impress on [my] readers . . . is the fact that in Winslow Homer we have one, and a chief among them, of a band of native painters who are not "eclectic" in any sneering sense, but represent the United States in genius as well as limitations. He is the growth of our imperfect art schools, our tremendous war full of humiliations and mistakes, of the stupidity of our picture buyers, and the encouragement of the few who can see genius under superficial faults. The slowness of his development had its good side, for it has kept him from early success, and made him continue til his fiftieth year to grope after artistic wisdom instead of sinking into the complacency of an early mannerism.[33]

The "groping after artistic wisdom" had, of course, led Homer to London's museums and galleries.

Earlier in his essay, Stonehouse, who was well acquainted with Homer, made an interesting observation about Homer's persona outside the art world when he noted that "in his relations toward mother, father, and brothers his nature is simply charming."[34] Perhaps he offered this comment to soften the impression of cold remoteness that Homer was now presenting within the art community.

Stonehouse was rare among critics in searching Homer's post-1883 work for evidence of influences stemming from his time in Britain. For reasons now lost, in his review he placed Homer "for a year or so" in Wales as well as in England. He observed that in examining Homer's work from his time abroad, he had found "never a trace of certain English and Welsh art influences, such as those emanating from Millais and Burne-Jones."[35] It has required the passage of time in relation to *Hark! The Lark* to find touches of the influence not of Burne-Jones himself, but more generally of the Aesthetic Movement in Great Britain, an influence that Homer felt for a season or two, but that he very largely disguised within the lucidity of his realism. That Homer continued well past the 1880s to "grope after artistic wisdom" elevated his status to heights in the American art world hardly envisioned for him before 1881.

THE THIRD AND CONCLUDING STAGE of Homer's transformation into a "new" artist saw the sea assume an ever greater role as the primary component of his work in oils. Beginning in 1890, the sea increasingly replaced all lesser things to become the sole active player as it assaulted the shore. The first of these pure marines was his *Sunlight on the Coast* (Toledo Museum of Art) painted in 1890. The last was his *Early Morning after a Storm at Sea* (plate 1), the oil that, as noted in chapter 1, caused him such distress in 1903.

In these years between 1890 and 1903, the human figure had no place in most of Homer's new oils. When present, as in his *Winter Coast* (1890, Philadelphia Museum of Art), that figure was sometimes a detail small in scale, freely brushed in, and showing Homer's new comprehension of the human body's volume, weight, and balance. The larger figure in *The*

Gulf Stream (1899, Metropolitan Museum of Art) has none of the refined drawing of *The Life Line* or *Undertow,* and for good reason, for the fisherman whose boat has been hit by a waterspout is meant to seem pummeled and insensible. Elegant draughtsmanship would be of little use and even counterproductive in this case. Prominent though the figure is, he remains a supporting actor in a drama in which the sea itself is the leading player, as the painting's title asserts.

The figureless oils of these years, such as *Cannon Rock* (1895, Metropolitan Museum of Art) and *Eastern Point* (1900, Sterling and Francine Clark Art Institute, Williamstown, Massachusetts), became the most original of Homer's late works, freeing him altogether from his longstanding reputation as a figure painter. They required his audiences to think of him and his work in new terms, and the terms began to echo those of the sublime often used in appreciations of Turner. But his audience also found in these new works a reflection of a Darwinian comprehension of the natural world. The boldness of technique that made these oil paintings so visually stunning would in time bring him favor even in the mid-twentieth-century world of painterly abstraction. By this time, however, few viewers had any reason to think that the catalyst that had released the energies seen in his late works was his experience in London's museums and galleries.

8

Prout's Neck, 1905–1910

Edging Toward the Pantheon

By 1905, burdened by bouts of ill health, Homer no longer worked in watercolor and only rarely painted in oils. Even so, the strikingly original concepts of the few paintings that came from his studio around this time, including *Kissing the Moon* (1904, Addison Gallery of American Art, Phillips Academy, Andover, Massachusetts) and *Right and Left* (1909, National Gallery of Art, Washington, D.C.), attested to the resilient vitality of his creative impulse. In the watercolor medium, his last campaign of painting had been in Florida in the winter of 1904–1905. Earlier groups from Florida and the Caribbean and even earlier ones between 1889 and 1902 from the Adirondacks and Quebec had already established him securely as the major master of the medium in America. Indeed, to the extent that his late watercolors might be known in Europe, he could count himself a master of international rank. His oils had begun to appear in exhibitions overseas, in Paris, Venice, and elsewhere.

Even in his ill-humored last years, he must occasionally have savored the growing body of honors that confirmed his stature as an important painter. His friend John Beatty recalled as much. He remembered that in 1907 when he made his second and last visit to Prout's, his host had on one occasion reached onto a table in his studio room to pull four gold medals from an accumulation of other awards. He used them without comment to hold down the corners of an etching.[1] Beatty understood that although Homer said nothing about them, these medals-as-weights possessed much more than utilitarian value for the painter, confirming as they did his late-achieved eminence.

From all evidence, of this quartet of medals Homer valued most highly the one awarded at the Paris Exposition of 1900 for a group of oils that included his *Summer Night* (1890, Musée D'Orsay, Paris). During his last illness, he reputedly carried the Paris medal in a pocket of his nightclothes. More than any other award, it had marked his attainment of a place at the highest levels of American-European fine art culture.[2] When his *Summer Night* joined Whistler's portrait of his mother in the collections of the Musée du Luxembourg, this pair of paintings ranked as the most distinguished works in Paris by American artists of their generation. Because Whistler was an American painter only by the most

arbitrary of definitions, Homer's painting effectively stood alone in Paris as a distinctly American achievement of its time.[3]

Among the most notable of the honors that he received in these late years was his election in 1905 to the American Academy of Arts and Letters. At the academy's founding in 1898, more than two dozen American painters and sculptors—all men—had made up the initial class of artists. They included such well-established figures as the sculptor Augustus Saint-Gaudens and the painters Chase and La Farge, as well as a few others whose reputations have since faded beyond hope of restoration. The most obvious omission was Homer. Perhaps he had been approached about his willingness to accept election and declined in advance of a formal offer. Half-a-dozen years later someone may have pressed him to reconsider. One wonders whether Saint-Gaudens, always a champion of Homer and his work, might have done so. Perhaps La Farge, with whom Homer on his visits to New York still discussed matters of art, urged his friend to join him in membership. Homer's brother Charles might have persuaded him to claim this honor. Whatever the circumstances, by 1905 any doubts the artist may have harbored about the still-young academy's viability were put to rest. The organization had already earned a place of respect among New York's cultural institutions. In 1905, Homer accepted election.

In the same year, the academy elected John Singer Sargent. As with Whistler, whose career had been entirely in Europe, the claim that Sargent was an American painter was to some degree problematic. He had been born in Florence, the child of expatriate Americans, and did not set foot in the United States until 1887, when he was in his thirties. By then, he had already established himself as an artist with great success, first in Paris and then in London. Unlike Whistler, who had found no reason to return to America after leaving it as a young man before he had become a painter and who disdained much of what he remembered about American culture, Sargent found American society agreeable. That society returned the compliment. He visited the United States annually, building an especially close relationship with Boston. From that city came commissions for portraits and major mural projects. Sargent's rise to celebrity status in America had been as rapid as Homer's had been measured.

Neither Homer nor Sargent attended the academy's installation ceremony in 1905. Sargent wrote from London gracefully accepting the honor of election and regretting his inability to attend the festive events. Homer may have communicated his regrets less formally.[4] If they had attended, the two artists would have made an odd pair in conversation—the urbane, cosmopolitan, socially engaging painter visiting from London and the reserved, laconic, business-like artist living on a point of land facing the sea on the coast of Maine. Nevertheless, they held a few things in common. Both had quite separately known London in the 1880s, though in different ways. Each had become a leading painter in watercolors within the Anglo-American world. In England, Sargent, through his friends Abbey and James, had very likely heard much about Homer's work.[5] On visits to Boston in

the late 1880s and 1890s, he had undoubtedly learned even more and had almost certainly seen some of Homer's paintings.

The two men held a few acquaintances in common, not least Abbey, who was already a member of the academy and who in 1905, like Sargent, was busy with a mural commission for the Boston Public Library. Among the American artists whom Sargent had once expressed an interest in meeting was Thomas Eakins, though the interest was apparently never realized. Because Homer knew Eakins, at least slightly, this connection, too, could have offered a basis for a chat if Sargent and Homer had met at the academy's installation festivities.[6] Alas, they did not.

In 1908, Homer suffered a stroke. He recuperated sufficiently within a few weeks to travel to the North Woods Club in the Adirondacks. Later in the year he managed to paint strongly in oils, beginning and completing his *Right and Left.* Second thoughts enabled him in 1909 to finish *Cape Trinity, Saguenay River* (private collection), a work begun in 1904. His last oil, *Driftwood* (Museum of Fine Arts, Boston) followed later in 1909.

In June 1910, he managed to return to the North Woods Club in late June and stayed into early July. Once he was back in Maine, his health worsened. On 29 September, with his brothers by his side, he died in his cottage. In the days, weeks, and months that followed, newspapers and art journals across the country spoke of him with unreserved respect as a major American artist of his era. They tended to describe him as a great painter of the sea. Less mention was made of him as a painter of American life.

Colleagues from earlier decades paid homage. In 1910, even before Homer's death, the artist Elihu Vedder, a good friend in New York in the 1860s and a presence at the Century Association when he occasionally returned from his expatriate life in Italy, had referred to Homer in his autobiography as "that best of American painters."[7] A few years later, when a journalist asked Eakins, himself a painter of great accomplishment, whom he believed to have been the greatest American artist of his era, Eakins responded simply, "Winslow Homer."[8]

Some of the most insightful tributes went out in personal letters. One such came from Abbey. If they had not managed to meet in London, then the two men might not have seen each other since the late 1870s. Nonetheless, Abbey remembered Homer vividly from their days thirty years earlier in the Harper's art room and at meetings of the Tile Club. Memories of those years flooded back when, soon after learning of Homer's death, Abbey wrote from London to the American muralist and decorative artist Edwin Blashfield. "They keep dropping off—our old friends. Since I was in America, dozens of them. I think Homer a great loss. I began to admire him when I saw his things in *Our Young Folks* and *Harper's Weekly*—ages ago. I wonder if you remember a drawing in *Harper's Weekly* of a Sharpshooter in a pine tree and a double page of a campfire with a soldier dancing a breakdown."[9]

Less than a year later Abbey himself was dying. His last letter, dictated to his wife, Mary, at their home in London, responded to a letter just arrived from James Kelly, his

colleague of the 1870s at Harper's. Kelly was now a sculptor specializing in Civil War memorials. Both artists remembered Homer from their meetings at Harper's and, in Abbey's case, at Tile Club sessions. Abbey had not been in touch with Kelly since the late 1870s. He wrote,

> I cannot tell you how deeply I appreciate your writing me after all these years, and especially what you say about our early days together—those early days when everything seemed possible, and when one's work is the most devouringly interesting thing there is in life. . . . So many of my old friends have died during these last few years that I look forward with very great dread to a visit home. . . . You had such good ideas in your early, warlike moods that I hope that some of those subjects that used to be suggested by Walt Whitman have been carried out by you [in sculpture] in some sort of scale. I remember how much Winslow Homer used to help you [and] I wish that sometime some of us who knew so much more about him than ignoramuses do who have written about him, could write down something that would really do him justice, for he was a very great and single-minded man. Why don't you do it?[10]

With Abbey's death, London lost the only artist of major repute in England who had known Homer well at some point in his career. He had followed Homer's work with interest, though mostly from a distance. He might have found reason one day to recall in print, if only in a general way, the older artist's relationship to England and perhaps even to London in particular. That relationship would not have been easy to summarize from a British viewpoint. Homer had painted only a single London subject—his *Houses of Parliament*—and, so far as is known, had exhibited only a single English subject in a London exhibition: *Hark! The Lark*.[11] He had left no lasting mark on England.[12]

But England had left its mark on Homer. It had done so in ways both immediately evident on his return to New York and apparent later as the foundation of all that was new in his subjects and style. England had altered his identity as a painter. He had become less an American artist as defined by his subjects and more an artist who looked beyond cultures and boundaries to take as his subject a timeless natural world. He would always be classified as an American artist—there was no alternative—but after London and Cullercoats he was a very different American artist than he had been before his year and a half in these places. It was surely in recognition of both identities—an artist who had recorded American life with remarkable insights and an artist who had then transcended the topical and cultural limitations of his earlier genre subjects—that the Academy of Arts and Letters found a place for him within its august ranks.

In the years that followed this recognition and despite his eminence and prosperity, he remained discontented. By 1905, he was all too aware that his career was coming to an end. It is tempting to find some sense of late-life gloom even as early as 1903 in that most troublesome painting of his last decade, his *Early Morning after a Storm at Sea* (plate 1). The great

storm of the title is unseen, as were indeed the gales of feeling, creative and otherwise, that Homer's reserve and formal appearance had long managed to mask. In the painting, an elegantly formed breaking wave of diminished energy rolls in from distant origins. The early light delicately illuminates this evidence of beauty born of chaos. The wave's arrival stirs the waters of the foreground, though with less agitation than in the artist's earlier coastal scenes. A breaker hits the headland beyond, a survivor of the artist's instinct in his marine paintings of the 1890s to make such thunderous impacts of sea against shore his main subject. But the mood of the foreground in *Early Morning* is different. It speaks more of spent force, of aftermaths, of things that have happened than of things to come.

In this work, Homer invested the tops of his rollers with a filigree-like delicacy rare in his marines. Throughout the coursing flow of the foreground water and in the thinning cloud cover, colors glow dimly through his many grays. The horizontal bands of quiet sea and sky work together with the gentle rush of the surf to create as elegiac a work as any Homer would paint.

The sense of elegy was probably not consciously personal, of course, for in 1902, when Homer had all but completed the painting, he remained in apparent good health. But in this work he seems to have taken a bow as a painter of the unending contest between wave and rock, motion and stillness. He may well have understood that *Early Morning* would be the last of his "pure" marines, for he was then ready to move on to something new.

The few oils yet to come from his brush were indeed new in concept. In *Kissing the Moon, Right and Left,* and even *Driftwood,* human activity reclaims the center of interest, now in new and original ways. The sea, although still powerful and ever threatening, assumes a secondary role. In these late works, Homer headed in a fresh direction, but it was now late in the day rather than early in the morning, and soon nothing more would be felt from distant storms.

<div align="center">⸎</div>

AS HOMER'S EMINENCE as a painter became steadily more secure in the decade before his death and his appearances in New York ever rarer, his reputation began to assume an almost Olympian character. Distance in miles and manner contributed to this sense of near-otherworldly authority, but so also did a growing comprehension that the watercolors and oils of his years at Prout's stood as a body of American art superior in many ways to anything produced by others in the United States during his lifetime.

A year after Homer's death William Howe Downes's earnest, spacious, richly illustrated, and handsomely produced biography, *The Life and Work of Winslow Homer*, further enhanced the artist's reputation. No other American painter had been honored with such a publication. Although Downes wrote without assistance from Homer, he managed to establish a generally accurate and coherent narrative of the artist's career. In setting out the sequence of Homer's travels, however, he made no mention of London. Nor would London

find a place in the several biographical sketches and monographs by others that followed throughout the next half-century. Nonetheless, in all these publications an essential truth was clear: Homer's emergence as an artist of major achievements had begun with a year and a half in England.

Now, a century after his death, when it has at last become clear that this crucial English episode began not in a Northumberland fishing village but in a very great city of art, we can see more clearly Homer's sequence of steps as he set out to make an "important" artist of himself. We can see how in London he began his self-transformation as an artist.

Notes
Bibliography
Index

Notes

1. Homer undoubtedly traveled to London in late spring to deliver at least one painting in advance of the opening of the Royal Academy's summer exhibition in 1882. Alan Adamson, "The Homer That I Knew," in *Winslow Homer in England,* by Tony Harrison (Ocean Park, Me.: Hornby Editions, 2004), 35. It seems highly likely that this trip was one of a few return visits to the city. He would have had reason, for instance, to attend the academy's 1881 summer exhibition as a kind of preparatory reconnaissance even though he submitted nothing to it.

2. No comprehensive collection of Homer letters has yet been published. Judging from letters already in print, such a volume would be unrevealing of all but a narrow range of the artist's thoughts. It would nevertheless be of use to establish chronologies and details of his activities while traveling. Throughout most of his life, he seems to have kept few letters that he had answered or acted upon. Until the 1880s, many of the persons to whom he wrote, including members of his family, apparently made little effort to preserve his correspondence. Those of his letters that have reached publication show scarcely any instinct for discursiveness. Neither in person nor on paper was he inclined to be chatty. Most of his letters are brief and businesslike, though a few to his family and those to Helena de Kay exhibit a more personal flavor. For the de Kay letters, see Sarah Burns, "The Courtship of Winslow Homer," *The Magazine Antiques* 161 (Feb. 2002): 69–75.

3. In *Winslow Homer in England,* Harrison's comprehensive account of Homer's work in and around Cullercoats and along the coast to the north and south is especially useful in its identifications of the localities of individual works. It appeared before Harrison turned his attention to locating Homer in London. See also Judith Walsh, "More Skillful, More Refined, More Delicate: London," in *Watercolors by Winslow Homer: The Color of Light,* exhibition catalogue by Martha Tedeschi and Kristi Dahm, with contributions by Judith Walsh and Karen Huang, 75–106 (Chicago: Art Institute of Chicago, 2008).

4. Walsh.

5. Lloyd Goodrich, *Winslow Homer* (New York: Macmillan, 1944).

6. Helen Cooper, *Winslow Homer Watercolors,* exhibition catalogue (New Haven, Conn.: Yale Univ. Press, 1986); Nicolai Cikovsky Jr. and Franklin Kelly, with contributions by Judith Walsh and Charles Brock, *Winslow Homer,* exhibition catalogue (New Haven, Conn.: Yale Univ. Press, 1995).

7. Cikovsky and Kelly, 414–18.

8. Lloyd Goodrich and Abigail Booth Gerdts, *Record of the Works of Winslow Homer,* vol. 1: *1846–1866* (New York: Spanierman Gallery, 2005), 41–55. Goodrich had begun compiling information for the catalogue in the 1930s and advanced the project as time became available from his duties as curator and then director at the Whitney Museum of American Art. He was ably assisted in the task by his wife, Edith Havens Goodrich, who had also trained as an artist. Gerdts worked with Goodrich in the years before his death in 1987, augmenting and editing the original entries and adding new ones as well as a chronology and commentaries.

1. PROUT'S NECK, 1903: THE PAINTER IN HIS PRIME

1. One of these newspaper squibs, "The Strange Hermitage of Winslow Homer on the Maine Coast," written to some degree tongue in cheek and published in the *Boston Herald* in December 1884, reads: "Here, since his quarters have been fitted to bear the strain, the artist passes summer and winter, in profound and guarded solitude, seeing no company, speaking to any of the natives only on business or necessity, and absolutely tabooing all curious visitors and sightseers." Quoted, apparently from an undated clipping, in Cikovsky and Kelly, 397. The piece smacks of a report by a journalist rebuffed in seeking an interview.

2. *The Wreck* became the second of Homer's oil paintings to enter a major museum collection. The purchase of *The Fox Hunt* in 1894 by the Pennsylvania Academy of the Fine Arts had been the first.

3. In 1897, Homer's fellow American jurors for this exhibition included John La Farge, who had remained his good friend since the 1860s, as well as Cecilia Beaux, Frank Benson, William Merritt Chase, Frank Duveneck, Will Low, and Edmund Tarbell. Beatty persuaded Homer once more, in 1901, to serve on the exhibition's jury. See Goodrich, *Winslow Homer,* 167–68, 206. See also David G. Wilkins, "Winslow Homer at the Carnegie Institute," *Carnegie Magazine* 55 (Jan. 1981): 5–20. No museum director did more than Beatty to champion Homer during his lifetime as a major painter of the era.

4. John W. Beatty, "Recollections of an Intimate Friendship," in Goodrich, *Winslow Homer,* 206–26.

5. Ibid., 211.

6. In the company of artisans and other skilled workers, Homer became an interested and better-natured person. On his travels, he also occasionally found kinship with professionals in medicine, accounting, and other fields requiring precision in observation and objectivity in reportage. There was nothing of the Bohemian in his makeup as an artist to separate him from middle-class propriety. Beginning around 1905, however, his declining health gradually spread his disagreeableness more widely.

7. Beatty, 217, 218, 220.

8. Beatty's summation of Homer's personal qualities has a slightly defensive tone, as though he sought to soften his host's late-life reputation for austerity and remoteness.

9. At his hotel, Beatty made notes of what Homer had said and done during the day and later used these notes to draft a memoir of his visit. Some years after Beatty's death, Lloyd Goodrich brought the memoir to publication as an appendix to his seminal study *Winslow Homer.*

10. Quoted in Beatty, 213. Homer's reference to Ruskin probably pertains to that critic's denigration in print of Whistler's *Nocturne in Black and Gold: The Falling Rocket* (1874, Detroit Institute of Arts) and the artist's subsequent legal suit for damages.

11. Quoted in Beatty, 210. By the time of Beatty's visit in 1903, Homer had completed all but a handful of these paintings.

12. These objective criteria may have been lacking in a few cases in which Homer's subjective estimate of a painting qualified it as "important." In these cases, he undoubtedly pressed his dealers to redouble their efforts to sell a work for a fee that would confirm his own high estimate of it.

13. For Homer's relationship with his brother Charles, see Sarah Burns, "'To Make You Proud of Your Brother': Fishing and the Fraternal Bond in Winslow Homer's Art," in *Winslow Homer: Artist and Angler,* by Patricia Junker, with Sarah Burns, 13–31 (New York: Thames and Hudson, 2003).

14. Goodrich, *Winslow Homer,* 51.

15. Homer had always taught himself and resisted instruction from others. His biographers have mentioned his mother as a formative influence—she was an able amateur watercolorist—but her sway was surely one of encouragement more than instruction beyond basic elements of design and the elementary handling of the watercolor medium. His work in no way resembles hers. He learned best and most extensively through the

observation and study of what other artists had done and how they had done it, adapting what he had learned from their work to his own more highly individualistic uses. He was an analytic observer, but he had no interest in closely emulating the work of others. His marked sense of personal independence, much commented upon by his contemporaries and evident throughout his life's work, prohibited such imitation.

16. Though no records of the amounts in his accounts in 1903 are known, they were probably not hugely less than in 1910, when in a letter to a banker cousin he enclosed a check for six thousand dollars to open a new account and mentioned in passing accounts in two other banks amounting to twelve thousand dollars. Goodrich, *Winslow Homer,* 199. He may well have maintained accounts in banks beyond these three.

17. Quoted in ibid., 177.

18. Ibid., 178.

2. NEW YORK, 1876–1880: THE DISCONTENTED ARTIST

1. For an introduction to Homer and the New Woman, see Sarah Burns, "Winslow Homer's Ambiguously New Woman," in *Off the Pedestal: New Women in the Art of Homer, Chase, and Sargent,* edited by Holly Pine Connor, 53–90 (Newark, N.J.: Newark Museum, 2006).

2. *New-York Daily Tribune,* 25 Nov. 1876. Homer's comments appear in the column "A Ramble among the Studios."

3. For Homer's "American-ness," see Nicolai Cikovsky Jr., "Winslow Homer's National Style," in *American Icons: Transatlantic Perspectives on Eighteenth- and Nineteenth-Century American Art,* edited by Thomas W. Gaehtgens and Heinz Ickstadt, 247–65 (Santa Monica, Calif.: Getty Center for the History of Art and Humanities, 1992). See also the chapter "Being Big: Winslow Homer and the American Business Spirit," in Sarah Burns, *Inventing the Modern Artist: Art and Culture in Gilded Age America,* 187–217 (New Haven, Conn.: Yale Univ. Press, 1996).

4. James was in Italy when Homer arrived in London sixteen years after *The Galaxy* review. Though James returned to Bolton Street soon afterward, there is no reason to suppose that the two men met in England.

5. Henry James, "On Some Pictures Lately Exhibited," *The Galaxy* 20 (July 1875): 89–97, emphasis in original.

6. The term was first used by Goodrich in *Winslow Homer,* 53, and has been reiterated by others, though usually without Goodrich's balanced context. He wrote: "The most perceptive criticism, though in some ways the most devastating, was written by the young Henry James, with an eye trained in European art and a pen subtler than any professional critic's."

7. Henry James, "The Real Thing," first published in the magazine *Black and White* (London), 16 Apr. 1892, then published in book form as *The Real Thing* (London: Macmillan, 1893).

8. Henry James, "The Story of a Masterpiece," originally published in *The Galaxy* (Jan.–Feb. 1868); republished in *Eight Uncollected Tales of Henry James,* edited by Edna Kenton (New Brunswick, N.J.: Rutgers Univ. Press, 1950), 111, emphasis in original.

9. Homer's illustrations were for Marion Harland's serialized novel *Beechdale.* The first two illustrations appeared in *The Galaxy* for May 1868. He continued to contribute drawings to the magazine through the number for January 1870. David Tatham, *Winslow Homer and the Illustrated Book* (Syracuse, N.Y.: Syracuse Univ. Press, 1992), 297–99.

10. Once settled in London, James contributed regularly to *The Galaxy* until a year before its demise in 1878. For the history of the magazine, see Frank Luther Mott, *A History of American Magazines: 1865–1885* (Cambridge, Mass.: Harvard Univ. Press, 1938), 369.

11. The time had not yet arrived for American critics to engage seriously in the more rigorous practice of descriptive or analytic criticism with its objective scrutiny of how a painting was made and how it "worked."

12. For a summary of Kelly's recollection of a visit by Homer to the art room, see David Tatham, *Winslow Homer and the Pictorial Press* (Syracuse, N.Y.: Syracuse Univ. Press, 2003), 3–8.

13. Four of these 1877 paintings were of young women: *Backgammon* (Fine Arts Museums of San Francisco); *Blackboard* (National Gallery of Art, Washington, D.C.); *Book* (now titled *The New Novel*, D'Amour Museum of Fine Arts, Springfield Museums, Springfield, Massachusetts); and *Lemon* (now titled *Woman Peeling a Lemon*, Sterling and Francine Clark Art Institute, Williamstown, Massachusetts). The unity of the four subjects contrasted sharply with the variety among the fourteen watercolors he had shown the previous year, 1876, some of which depicted African American figures.

14. Quoted in E. V. Lucas, *Edwin Austin Abbey: Royal Academician*, 2 vols. (London: Methuen, 1921), 1:40.

15. For the Tile Club, an all-male, essentially social group devoted to tobacco, beer, excursions to picturesque places, and painting on blank ceramic tiles, see Ronald G. Pisano, *The Tile Club and the Aesthetic Movement in America* (New York: Harry N. Abrams, 1999).

16. For Houghton Farm, see David Tatham, "Winslow Homer and Houghton Farm," in *Winslow Homer's Empire State: Houghton Farm and Beyond*, exhibition catalogue, edited by David Lake Prince and David Tatham, 25–46 (Syracuse, N.Y.: Syracuse Univ. Art Galleries, 2009). See also Linda Ayres, "Lawson Valentine, Houghton Farm, and Winslow Homer," in *Winslow Homer in the 1870s: Selections from the Valentine-Pulsifer Collection*, edited by John Wilmerding, 18–26 (Princeton, N.J.: Art Museum, Princeton Univ., 1990).

17. The costumes have been described as "rococo," "Bo-Peep," "à la Watteau," and "of the stage." Homer had dressed a model in his adaptation of historical attire a year earlier, in 1877. In *Shepherdesses Resting*, the two figures converse, seemingly unaware that a third shepherdess on a hilltop beyond calls to tell them that her flock of sheep is on its way to them. See Tatham, "Winslow Homer and Houghton Farm."

18. Goodrich, *Winslow Homer*, 73–74.

19. Concerning the first two of these notions, it is best to remember that such affairs of the heart that Homer may have had apparently occurred in the early 1870s. It is improbable that any sense of dejection resulting from one or more failed courtships would have persisted to the end of the decade and then sent him abroad. For his only known blighted romance, see Burns, "The Courtship of Winslow Homer." The notion that he went to England to "dry out" comes from my conversations in the mid- and late 1960s with two elder Bostonians, one at the Boston Athenaeum and the other at the Essex Institute. Each claimed an understanding derived from persons who, in one case, had as a child known Homer in his last years and, in the other, had many years earlier been acquainted with an art dealer who had handled works by Homer well after the artist's death. Though Homer— like many, perhaps most, American artists of his generation—imbibed generously, nothing survives to document him as a drinker of marked immoderation, nor is there any reason to suppose that he (or anyone) might have thought England to be a place particularly conducive to "drying out." Concerning Homer and critics, there is no evidence, despite what has been suggested occasionally in public lectures since the 1970s, that reviewers singled him out for unrelievedly harsh reviews. In any season, the mix of positive and negative comments by critics nearly always treated him with respect even when expressing impatience.

3. NEW YORK AND LONDON, 1880–1881: LONDON ENVISIONED AND FOUND

1. Harrison, 17.

2. For Anglomania in relation to artists journeying to London in the years surrounding Homer's visit, see Marc Simpson, "Windows on the Past: Edwin Austin Abbey and Francis Davis Millet in England," *American Art Journal* 22, no. 3 (1990): 64–89.

3. Gordon Hendricks, *The Life and Work of Winslow Homer* (New York: Abrams, 1979), 29. Goodrich, *Homer*, 4. While in England and perhaps also in Paris, the senior Homer promoted the political aspirations of his

countryman John Fremont, already renowned in America as an explorer of the western frontier and now a rising figure in the new Republican Party.

4. Alfred Waud drew illustrations for the *Pictorial* under both his own name and the pseudonym "A. Hill." Tatham, *Winslow Homer and the Pictorial Press*, 38–39. Boston business directories locate Homer and the Wauds at 24½ Winter Street. For an illustration of the building, see Tatham, *Winslow Homer and the Pictorial Press*, 12.

5. The wood engravers Homer knew were by no means all British trained. Among those who worked at the *Pictorial* was Charles Damoreau, a Frenchman who was part of the extensive immigration of graphic artists and artisans to the United States following the social and political unrest that gripped the Continent in 1848. Damoreau engraved several of Homer's drawings and probably coached Homer on matters of composition and tone pertinent especially to wood engraving.

6. Linton devotes most of his autobiography *Threescore and Ten Years: 1820–1890* (New York: Charles Scribner's Sons, 1894) to his early career and relatively little to his years in America. His rambling reminiscences to some degree support Thomas Carlyle's opinion of him (p. 110) as an "extremely windy creature." In 1882, while Homer was in England, Linton's *History of Wood Engraving in America* (Boston: Estes and Lauriat) reached publication. Homer would already have seen much of the text in 1880, when it was serialized in issues 5 through 12 of the *American Art Review*.

7. For example, Homer's *March Against the Indians in Connecticut* in William Cullen Bryant and Sydney H. Gay, *A Popular History of the United States* (New York: Scribner, Armstrong, 1876), 1:460.

8. Not all of London supported the building of the sewer system, for its construction demolished parts of heavily populated neighborhoods and destroyed historic landmarks. For a perceptive cultural history of the project, see Charlotte Allen, *Cleansing the City* (Athens: Ohio Univ. Press, 2009).

9. *Indicator Map of London and Visitors Guide* (London: C. Smith & Son, 1881), published "for the American Exchange in Europe/449 Strand . . . [and] 102 Broadway, New York, U.S.A." The front wrapper of the bound-in visitors guide pages offers information about "public buildings, theatres, and places of amusement in London and the environs, with a complete list of railway stations." Another pocket-size guidebook, in this case emphasizing text over map, was *Collins' Illustrated Guide to London and Neighborhood*, new ed. (London: William Collins, 1882).

10. A present-day photograph of the well-restored American Exchange building appears in Harrison, 15.

11. Augustus J. C. Hare, *Walks in London*, 2 vols. (New York: George Routledge and Sons, 1878), from an unpaginated prefatory paragraph in the front matter.

12. Blanchard Jerrold and Gustave Doré, *London A Pilgrimage* (London: Grant, 1872).

13. For a concise and insightful account of Doré and his work, with particular attention to his relationship with London, see Samuel F. Clapp, "Doré in London," in *The Image of London: Views by Travellers and Emigres 1550–1920*, exhibition catalogue by Malcolm Warner (London: Trefoil, 1987), 164–66.

14. Doré's illustrations followed suit. Doré was by no means the first illustrator to portray the squalor of the poor in London. Wood-engraved depictions of the city's underclass had appeared now and again in magazines and books. See, for example, "Dwelling of the Poor in Bethnal Green," *Illustrated London News*, 24 Oct. 1863. These pictures, however, were nearly always the work of graphic artists of limited talents who apparently harbored little sympathy for the poor; their illustrations can hardly have aroused strong responses from their viewers.

15. The novelty—and notoriety—of Doré's illustrations for the book rested in the nature of his attention to the poor. More so than in his renderings of the upper classes, in his pictures of the poor he centered attention on individuals within groups or crowds of figures. Jerrold's rambling text with its many allusions keeps a polite distance from a real engagement with the ubiquity of poverty in this wealthiest of cities, but Doré's depictions of

the conditions of the poor and other unfortunates remain riveting. His images of destitute families, prisoners, the homeless, and the downtrodden of many kinds were always documentary in spirit if not precisely so in fact. They were unmotivated by and unallied to any organized movement for social reform.

16. *Harper's Weekly*, 6 Apr. 1872, 266. What the American audience saw in the course of a year was less splendid than this announcement promised. The *Weekly* reset Jerrold's text in a small font (in England the book had a large and elegant typeface). The Harper firm printed the illustrations from electrotypes on newsprint, thereby compromising their sharpness (the type is crisper on the book's heavier stock). It crowded each chapter's text and illustrations into a rearrangement made to fit the *Weekly*'s format (in the book, as a reader turns the pages, the sequential appearance of the illustrations produces a more powerful effect).

17. The Harper firm also shied away from producing a similar volume about New York, but there was, of course, no equivalent of Doré in America. Nor was New York in the 1870s so visually rewarding a city as the much larger and far more historic London. Nevertheless, it is easy to wonder whether three illustrations by Homer in the *Weekly* in February, March, and April 1874, all dealing with New York's underclass, might have been Harper's soundings for an unrealized project. In these pictures, Homer drew a crowded jailhouse, an opium den, and a home for battered women. Wholly different from anything he had previously contributed to any magazine or would do again, and different as well from anything by Doré, these three images stand as a reminder of Homer's versatility as well as of his capacity for reinvention, even when he worked as an illustrator. See Tatham, *Homer Winslow and the Pictorial Press*, 191–94.

18. *Making Hay* is reproduced in Philip C. Beam, *Winslow Homer's Magazine Illustrations* (New York: Harper and Row, 1979), 215. Homer adapted the image from a variant of an 1872 oil painting, *Waiting for an Answer* (Peabody Collection, Maryland State Archives).

19. The illustrations in *That Good Old Time* are reproduced in Tatham, *Winslow Homer and the Illustrated Book*, 195–201. The title-page portrait of Gordon appears only in the book's first printing.

20. I am grateful to the late Tony Harrison for calling this book to my attention.

21. I thank Dr. Steven Lozazow for calling this use of the illustration *The Boat Race* to my attention.

22. At the time of Homer's visit, rates for lodgings (bedroom plus sitting room) in Marylebone ranged from thirty to sixty shillings a week according to location. Accommodations in the less fashionable Newman Street quarter of the parish would have been at the lower part of this range, or approximately a pound and a half per week. *Collins' Guide to London and Neighborhood* (London: William Collins, Sons, 1882), 153. Homer would have paid an additional fee for use of studio space.

23. Henry, Hennessey, and Parsons are recorded at these addresses in Ann Cox-Johnson, *Handlist of Painters, Sculptors, and Architects Associated with St Marylebone, 1760–1960* (London: Borough of St. Marylebone Public Libraries Committee, 1963).

24. Lucas, *Edwin Austin Abbey*, 1:59.

25. Ibid., 1:69.

26. Ibid., 1:71.

27. Cox-Johnson.

28. Lucas, *Edwin Austin Abbey*, 1:71. This historical observation, presumably found by Lucas in one of Abbey's letters to his home in America, may have been passed on to Homer by Abbey. The Rimers probably told their American artist lodgers something similar on their arrival at No. 80 Newman.

29. The station's architectural detailing in the Doric order, culminating in its colossal Doric arch, may have caught his attention, for American rail terminals offered nothing so grand. Despite public outcry, the station was demolished in 1961–62 to make way for a modern facility of little significant architectural distinction.

30. Though now very largely forgotten, William Rimer, a painter of portraits as well as of genre and historical subjects, had exhibited at the Royal Academy from 1846 into the 1870s. Louisa Serena Rimer, who painted

flowers and a variety of other subjects, seems to have possessed a more distinctive artistic persona. That certain of her works still hold interest is suggested by the fact that her striking depiction of a pair of owls and their chicks (*Owls,* 1863) sold at an international auction close to a century and a half after its creation. She exhibited at the Royal Academy from 1856 to at least 1874. For most of her life, she resided on Newman Street, moving through the years to at least three addresses, the last of them No. 80. See Cox-Johnson.

31. National Archives of the United Kingdom, 1881, English Census Record, Record Group 11/133, ED2, Folio 53, p. 35. The census records provided in association with the National Archives are available through the Internet at http://www.Ancestry.co.uk.

32. Homer had found some years earlier that his surname—an uncommon one of Huguenot origin—was to an annoying degree susceptible to misspelling. Scribes sometimes misread and recorded the *m* as an *rn* (thus *Horner*) or, as happened London in the 1881 census, read the *m* as an *sm* (thus *Hosmer*). An instance of the former misreading of Homer's name appears in the listing of American artists who exhibited in 1866–67 at the Exposition Universelle in Paris; he was recorded there as "Horner, W." Frank Leslie, "Report of the Fine Arts," in *Paris Universal Exposition, 1867: Report of the United States Commissioners* (Washington, D.C.: U.S. Government Printing Office, 1868), 38. Both the "Horner" and "Hosmer" misspellings had occurred on occasions well before Homer arrived in London and had annoyed him. In an undated note, probably a submission of information for an exhibition label in the late 1860s, he specified with some firmness that his name be given as "Winslow Homer / not Horner or Hosmer or Homer Winslow." Goodrich and Gerdts, 3:11.

4. LONDON, 1881: THE NEIGHBORHOOD

1. Few artists from the Continent seem to have resided on Newman Street. They probably gravitated to neighborhoods where speakers of their languages were more plentiful.

2. *List of Streets and Places within the Administrative County of London* (London: London County Council, 1929), 121.

3. Altered and enlarged in the 1820s, the hospital gained a medical school wing to its west side in the 1830s and further enlargements later in the nineteenth century. The hospital was rebuilt on a much larger scale on the same site early in the twentieth century. Hilary St. George Saunders, *The Middlesex Hospital 1745–1948* (London: Max Parrish, 1949).

4. The hospital had been established "partly in compassion, partly, perhaps, in fear of the seething filth and contagion of working class London, and partly in the anxiety of medical men to come to grips with the most glaring problems of disease." John Summerson, *Eighteenth Century London* (London: Penguin Books, 1962), 119.

5. The worlds of art and medicine had by then coexisted cheek by jowl for more than a century, nodding to each other now and again as commissions arose from the medical side for a painted portrait or a sculptural memorial and from the art makers' side as the ill and dying among them arrived at the hospital's door. There was apparently little exchange otherwise between artists and physicians, in part because the latter tended to reside elsewhere in London. Nevertheless, the hospital's presence helped to sustain the respectability of the neighborhood to the end of the nineteenth century. The hospital building, much enlarged on its original site in the twentieth century, was demolished in 2008.

6. Summerson, 119.

7. The development of the street is discussed briefly in Kit Wedd, *Artists' London* (London: Merrell, 2001), 68–71.

8. For these and other architects as well as for most painters and sculptors resident on the street before the 1870s mentioned in this chapter, see Cox-Johnson, ii. Cox-Johnson's many later publications concerning the history of London art and architecture have appeared under her married name, Ann Saunders.

9. Ibid.

10. Ibid., i–ii.

11. For a plan of West's house, an engraving showing his gallery, and a painting by the artist of his garden, see Wedd, 63–65.

12. See Dorinda Evans, *Benjamin West and His American Students* (Washington, D.C.: National Portrait Gallery, 1980). Other artists of less note claimed to have been West's students, among them Abraham G. D. Tuthill. For Tuthill, see David Tatham, "Abraham Tuthill at Mrs. Trollope's Bazaar," in *The Documented Image: Visions in Art History*, edited by Gabriel Weisberg and Laurinda Dixon, 1–12 (Syracuse, N.Y.: Syracuse Univ. Press, 1987).

13. Leslie had been born in London of American parents but raised and educated in Philadelphia. Remaining in England, he enjoyed a highly successful career.

14. Cox-Johnson, i–ii.

15. Ibid.

16. Charles Dickens, *Bleak House* (London, 1853; new ed., New York: W. W. Norton, 1977), 170. The visit to Newman Street occurs in chapter 14.

17. Newman Passage, a pedestrian alleyway connection to Rathbone Street, ends at the Newman Arms public house. That the filmmaker Michael Powell used the passage as the setting leading to the murder of a prostitute to begin his film *Peeping Tom* (1959) may be taken as evidence of the neighborhood's continuing decline in the second half of the twentieth century. In the early twenty-first century, a walk through the passage evokes something of the scale and character of the neighborhood as it was known to both West and Homer. The facades of Nos. 27 and 33 Newman, near the passage, retain much of the scale and character of the buildings that originally lined both sides of the street.

18. Edward Walford, *Old and New London: A Narrative of Its History, Its People, and Its Places* (London: Cassell, 1878), 4:467.

19. William Makepeace Thackeray has sometimes been claimed as a product of the Leigh/Heatherley school owing in part to the prominence of a private academy of art seemingly modeled on it in his novel *The Newcombes* (1854; new ed., 2 vols., New York: Limited Editions Club, 1954). At the time when Thackeray was likely to have been a student, however, Leigh had not yet opened his school. Thackeray may have visited Leigh's school in the 1850s to gain literary color while writing *The Newcombes*.

20. Cox-Johnson, listing.

21. On the east side, No. 14 Newman, formerly West's house and spacious gallery, had for some years served as a venue for lectures and meetings. It now held the name "Cambridge Hall." No. 17, which a century earlier had been the residence and studio of the sculptor John Bacon, now served Burke & Co., commercial sculptors, near-solitary survivors of a practice that had once filled the street with marble dust. Others on Newman included a stained-glass maker, an engraver, an art dealer, an artist's mount maker, a repairer of tapestries, picture restorers, art pottery repairers, interior decorators, decorative painters, a draper, and a modeler, as well as milliners, music publishers, and a teacher of singing. *Post Office Directory for 1881, Street and Commercial* (London: Kelly, 1881).

22. Ibid. Those identified as "Artist" were located at No. 22 (J. Hough); No. 65 (J. Arnott and George Wilson); No. 68 (Edwin Turner); No. 74 (R. W. Warwick); No. 76 (Earl George and Thomas Stowers); No. 77 (A. DeLeeuw); and No. 80 (William Rimer). At No. 60, Phillipe Emile was identified as "Sculptor."

23. Walter Besant, *London in the Nineteenth Century* (London: A. & C. Black, 1909), 401. The "compartment" was probably a screened bar parlor or a club room.

24. Tatham, *Winslow Homer and the Illustrated Book*, 10–12.

25. The name refers to the practice in eighteenth-century London of using upright blue posts to identify a sedan chair rank. The pub may occupy the site and perpetuate the name of such a place, perhaps a tavern,

to which eighteenth-century residents of the street dispatched a runner to summon a pair of chairmen with a sedan chair. A tradition holds that the corners of the sixteenth-century royal hunting ground that occupied the quarter since then known as Soho were marked with blue posts, but these posts of course preceded the appearance of sedan chairs.

26. *Collins' Standard Map of London with Illustrated Guide* (London: Edward Stanford, n.d. [c. 1882]). In addition to giving the hours and frequency of operation, the section "Public Conveyances" (unpaginated) notes that fares range from one pence to six pence, presumably according to distance.

27. Inquiries made in 2007 and 2008 to the office of the principal at Heatherley's School of Art brought no evidence that archives survive from its years on Newman Street.

28. Pamela Taylor, "Langham Place and Fitzrovia 1870," essay printed on the verso of the map *Langham Place and Fitzrovia 1870*, in *Old Ordnance Survey Maps, London Large Scale Series*, Godfrey ed., sheet 7.52 (Leadgate, U.K.: Alan Godfrey Maps, 2005).

29. E. V. Lucas, *London Afresh* (Philadelphia: J. B. Lippincott, 1937), 126.

30. David Piper, *The Companion Guide to London* (London: Collins, 1963; 7th ed., 1992), 226–27.

31. For a sense of the area's decline in the late 1940s, see Paul Willetts, *North Soho 999* (Stockport, U.K.: Dewi Lewis, 2007).

32. For a detailed record of bomb damage on and near Newman Street, see Ann Saunders, ed., *The London County Council Bomb Damage Maps, 1939–1945* (London: London Topographical Society and London Metropolitan Archives, 2005), map 61.

33. Even so, in 1909 Walter Besant in his posthumously published *London in the Nineteenth Century*, 402, refers to all of the eastern edge of Marylebone as "Fitzroy Square District."

34. Nathaniel Hawthorne, *Our Old Home: A Series of English Sketches* (Boston, 1863; new ed., Boston: Houghton Mifflin, 1902), 256.

5. LONDON, 1881–1882: ART AND ARTISTS

1. Quoted in Richard Rhodes, *John James Audubon: The Making of an American* (New York: Alfred A. Knopf, 2004), 389.

2. Henry James, *Essays in London and Elsewhere* (New York: Harper and Brothers, 1893), 14.

3. Climatological Returns for Brixton (Lambeth), April 1881, National Meteorological Archives, Exeter, U.K. I thank Joan Self of the archives staff for retrieving these records from storage.

4. British Museum, Department of Prints and Drawings, visitors book for Thursday, 14 Apr. 1881; Walsh.

5. British Museum, Department of Prints and Drawings, visitors book, 14 Apr. 1881.

6. A photograph of the screens around 1868 appears in Antony Griffiths, ed., *Landmarks in Print Collecting* (London: British Museum and Museum of Fine Arts, Houston, 1986), 117.

7. Judith Walsh discusses some of these possibilities in her essay "More Skillful," 81–84.

8. Fifteen years earlier, during his time in Paris, Homer seems not to have sought out (or to have profited from them if he had) Old Master drawings in museum collections.

9. Walsh, 85.

10. The visitors book entries for the day, all in the keeper's hand, are: *Morning:* Mr. W. Homer; Mr. A. Legros and friends (six total); Mr. G. F. Chesher; Miss Mary W. Minshall; Mr. H. F. Fleiss; Mr. John Butler; Mr. Law; Mr. E. Edward Gefflowski; Mr. Carruthers; Mr. F. J. Deprey; Mr. R. Lesley; Mr. W. G. Allen; Mr. Sherborn; Dr. Percy; *Afternoon:* Madame Modjeska and Friends (three total); Mr. F. Robertson; Mr. Moore. Helena Modjeska was a distinguished actress of international renown.

11. British Museum, Department of Prints and Drawings, visitors book for Wednesday, 6 Apr. 1881.

12. Whistler's manner offended even some in the art world. Janet Ashbee—who with her husband, the architect and designer Charles Robert Ashbee, knew, liked, and worked with many eccentric figures—described Whistler late in the century as "that horrid, curled, perfumed creature." As recalled by her daughter, Felicity Ashbee, in "Dandy in Decline: Whistler's Last Home," *Country Life* (22 Nov. 1984): 1360–61.

13. Very few of Homer's several dozen watercolor depictions of standing fishwives qualify as "statuesque" in the sense of an artfully posed figured treated with illusionistic emphasis on modeling in three dimensions. His *Inside the Bar, Cullercoats* (1883, Metropolitan Museum of Art), painted in watercolors in New York from studies made in Cullercoats in 1881, is a rare instance of such sculptural qualities. Nearly all of the watercolors he painted in Cullercoats depend on naturalistic observation more than on attempts to emulate another medium or manner besides his own. In oils, however, such as *Hark! The Lark, The Coming Away of the Gale* (1883, extensively repainted by Homer in 1891 and retitled *The Gale*, Worcester Art Museum, Massachusetts), and *Sailors Take Warning* (c. 1882, extensively altered and repainted by Homer in 1907 and retitled *Early Evening*, Freer Gallery of Art, Smithsonian Institution, Washington, D.C.), Homer seems to have made a greater effort to incorporate and transform outside influences.

14. For an example of Homer's treatment of fishwives' costumes as drapery, see his 1882 drawing *Fishergirl with Net* (Sterling and Francine Clark Art Institute), illustrated in Harrison, 84.

15. The plaster cast is in the collections of the Pennsylvania Academy of the Fine Arts. Bronze castings are in the collections of the Brooklyn Museum of Art and the Metropolitan Museum of Art.

16. For example, the 1882 edition of *Collins' Illustrated Guide to London*, 45. This brief entry includes "the Elgin and Phigalian Marbles" without special distinction among the museum's "extensive series of galleries and saloons." It groups the marbles with Roman sculptures and sepulchral antiquities, Sir. T. Lawrence's collection of casts, British antiquities, and several other holdings.

17. For a brief history of the marbles, including photographs showing the display of the Parthenon sculptures in the British Museum's Elgin Room, see B. F. Cook, *The Elgin Marbles*, 2d ed. (London: British Museum Press, 1997), 89–90. The marbles occupied this gallery between 1869 and 1939. The Duveen Gallery, constructed in the late 1930s but damaged by bombing during World War II, was rebuilt when resources became available in postwar London. During the war, the Parthenon sculptures were stored deep within an underground tramway in Bloomsbury.

18. The opening of the British Museum's new Natural History building, in itself a major public event, had the happy result of bringing even more visitors to its neighbor on Cromwell Road, the South Kensington Museum (which was later renamed the Victoria and Albert Museum when much enlarged). The latter already renowned museum of the decorative arts recorded more than 120,000 visitations—-an unprecedented number—-for the month of April 1881. Homer may have been included in the count. The museum frequently displayed watercolors from its collections.

19. The decoration of the three Refreshment Rooms in the South Kensington Museum (now the Victoria and Albert Museum) became the work of three figures prominent in London's world of art and design: William Morris (aided by Philip Webb and Edward Burne-Jones), James Gamble, and Edward Poynter. Poynter designed the ceramic tiles interior of the Grill Room with allegorical female figures representing the seasons and the months. These draped figures had more to do with the vogue for aestheticized young women among British fine artists than with traditional images of the months and seasons. Pointer's students copied his designs onto the tiles in ceramic colors. The room remains a key piece of evidence for the aesthetic taste of its time. For the revival of these figures a century later in Madrid, see Cleota Reed, "The Golden Fountain and the Grill Room: The Evolution of a Design in Tile," *Glazed Expressions* (a publication of the Tiles and Architectural Ceramics Society, United Kingdom) 63 (spring 2009): 11–15. The Refreshment Rooms, often described as the earliest of their kind in any museum, were restored in the years surrounding the millennium celebrations of 2000.

20. *Times* (London), 28 Mar. 1881, 1. The exhibition ran throughout Homer's initial weeks in London.

21. For reproductions of the etching and its source watercolor on facing pages, making clear the very great differences in the backgrounds Homer provided for his fishwives, see Lloyd Goodrich, *The Graphic Art of Winslow Homer* (New York: Museum of Graphic Art, 1968), plates 99 and 100.

22. Quoted in Goodrich, *Winslow Homer,* 80–81.

23. Kenyon Cox, *Winslow Homer* (New York: privately printed, 1914), 12–13.

24. Goodrich, *Winslow Homer,* 80.

25. Walsh, 83.

26. Beatty, 213.

27. Hare, 87.

28. A devotee of music in performance, Homer held Beethoven's symphonies, Wagner's operas, and Handel's oratorios in high regard. He mentioned Beethoven's symphonies in a letter to Helena de Kay (Burns, "The Courtship of Winslow Homer"). In a letter to his sister-in-law Mattie, he said that "Die Meistersinger" by Wagner was about as good as any old master. In another letter, he reported having sung "Hail the Conquering Hero Comes," from Handel's oratorio *Judas Maccabeus,* in his Prout's Neck studio (Hendricks, 206). The concerts available to him in London in April 1881 included the Bach Choir performing Handel's *Alexander's Feast* at St. James' Hall, an elaborately neo-Gothic concert facility tucked into the corner of Piccadilly and the Regent Street Quadrant. In the same hall on another evening, the Philharmonic Society offered Berlioz's *Romeo and Juliet,* Beethoven's First Piano Concerto, and the overtures to both Mozart's *Marriage of Figaro* and Wagner's *Tannhäuser.* (If the Berlioz was performed in its entirety, this program was full indeed.) At the grander Royal Albert Hall facing Kensington Gardens, Arthur Sullivan conducted his new oratorio—or Sacred Musical Drama, as he preferred to call it—*The Martyr of Antioch.* W. S. Gilbert had adapted his libretto from a poem by H. H. Millman. Gilbert and Sullivan's newest comic opera *Patience* was also then in rehearsal, set to open on 23 April.

29. Boughton had been born at Norwich in England in 1834. As a child, he moved to the United States with his parents, settling near Albany. He studied in France and elsewhere in Europe in 1853–54, returning to New York City in 1855. He may have met Homer at the Art Room of the Harper's firm on one of the occasions when Homer went to New York from Boston to draw illustrations on woodblocks for the *Weekly.*

30. Abbey and Parsons were among the artists who settled in Notting Hill. Part of this neighborhood's appeal was its closeness to Kensington Gardens and the leafy passages leading nearly without break through Hyde Park, Green Park, and St. James Park to Westminster, the Thames, and the Victoria Embankment. Henry James made much of this connection of parks and gardens in his essay "London" (in James, *Essays in London,* 16). James's move in 1886 from busy Bolton Street to the quieter DeVere Gardens off Kensington Road and near Kensington Gardens put him closer to several of his artist friends.

31. For a description of the interior, see Moncure Daniel Conway, *Travels in South Kensington* (London: Trübner, 1882), 178–82.

32. The house is described and illustrated in *The Survey of London,* vol. 37: *Northern Kensington* (London: Athlone Press, Univ. of London, for the Greater London Council, 1973), 82–83, plate 79.

33. Ibid., 182.

34. Lucas, *Edwin Austin Abbey,* 1:78–79. Drawing on Abbey's letters, Lucas cites several mentions in them of Boughton's dinner guests.

6. LONDON, 1881: THE HOUSES OF PARLIAMENT

1. Nicolai Cikovsky Jr., for instance, has suggested that "Homer passed through London, remaining only long enough to paint a beautiful watercolor of the Houses of Parliament" (*Winslow Homer* [New York: Abrams,

1990], 80). This supposition was not unreasonable in light of Homer's rapid production of watercolors soon afterward in Cullercoats. In Cullercoats, however, he presumably encountered fewer distractions than those met on a first visit to London.

2. If Homer returned to London between June and August to view the Royal Academy's summer exhibition, he not only would have gained a general sense of what to expect when he submitted his own work to the academy the following summer, but also would have had an opportunity to visit exhibitions in museums and galleries installed since he had left the city in April.

3. The dealer J. Eastman Chase's exhibition of the group of watercolors Homer had sent from England received a review in the *New York Times,* 20 February 1882, which noted of *The Houses of Parliament,* "the sepulchral gray of this watercolor is not conducive to its popularity, but it has all Mr. Homer's originality."

4. Venice, of course, provided innumerable opportunities to paint this kind of subject. James Holland's *Ospedale Civile, Venice* (1858, Victoria and Albert Museum, London) offers a strong example. For a reproduction in color, see Graham Reynolds, *English Watercolors,* new ed. (New York: New Amsterdam Books, 1988), 94.

5. Owned by Joseph Hirshhorn between 1957 and 1966, *The Houses of Parliament* has been part of the permanent collection of the Smithsonian Museum's Hirshhorn Museum and Sculpture Garden in Washington, D.C., since the museum's founding.

6. One indication of painters' avoidance of this site is found in the exhibition catalogue *Monet's London: Artists' Reflections on the Thames, 1859–1914* (St. Petersburg, Fla.: Museum of Fine Arts, 2005), which reproduces more than forty pre-1882 painted, drawn, and photographed views of the House of Parliament from a variety of points on the Thames. None other than Homer's is a view from the Lambeth side between the Charing Cross and Westminster bridges.

7. Among them, Helen Cooper, *Winslow Homer Watercolors,* exhibition catalogue (Washington, D.C.: National Gallery of Art, 1986), 80–82; and Cikovsky and Kelly, 200.

8. Although Homer had not painted outdoor urban subjects in America, he had drawn several between 1857 and 1868 for publication as wood-engraved illustrations in *Ballou's Pictorial Drawing-Room Companion* and *Harper's Weekly.* For reproductions of his work for the weeklies, see Barbara Gelman, ed., *The Wood Engravings of Winslow Homer* (New York: Bounty Books, 1969); Tatham, *Winslow Homer and the Pictorial Press;* and Beam.

9. T. S. Eliot reported brown fog; Paul Verlaine, pink and yellow; Valery Larbaud, blue; Max Hershman, gray; Oscar Wilde, yellow. See J. C., "N. B.," *Times Literary Supplement,* 2 May 2008. See also Peter Ackroyd, *London: The Biography* (London: Chatto and Windus, 2000), 427–28, for mention of fogs colored black, bottle green, yellow, lurid brown, gray, orange, and chocolate.

10. J. C., "N. B."

11. For a concise and enlightening account of the design and construction of both the building and the bridge, see Simon Bradley and Nicholas Pevsner, *London 6: Westminster,* the Buildings of England, vol. 6 (New Haven, Conn.: Yale Univ. Press, 2003), 212–18, 273.

12. James, *Essays in London,* 21.

13. The passing of the old bridge with the completion of the new is the subject of Whistler's *The Last of Old Westminster* (1862, Museum of Fine Arts, Boston).

14. The rumor that a cache of drawings of London and Essex countryside subjects by Homer exists in a private collection in England has eluded my tracing.

15. In her pioneering and still valuable study of Homer's career as a painter in watercolors, Helen Cooper errs in describing the view as one "taken from Westminster Bridge looking north toward Lambeth Bridge." The view in fact is from the Lambeth bank looking to the southwest, with Westminster Bridge in sight. Lambeth Bridge is not visible in the painting. Cooper describes the painting as a "conventional tourist view," but the view was not in fact known to tourists when Homer was in London or for some years afterward (Cooper, 80).

16. See *Monet's London.*

17. I thank Claire Brenard of the Curator's Office for information relating to pertinent works in the Palace of Westminster collections.

18. Hare, 1:377.

19. The balconies were removed from the hotel early in the twentieth century.

20. For details of this part of the riverside and surrounding areas at the time of Homer's visit, see the maps *London Sheet 76 Waterloo & Southwark 1872* and *London Sheet 76 Waterloo & Southwark 1894* in *Old Ordnance Survey Maps.* The first of these sheets gives more detail concerning the wharves. That so little had changed along the dockside during the twenty-two years spanned by these two sheets makes it clear that nearly everything shown in the 1872 map was still in place when Homer arrived to paint in 1881.

21. The names of the proprietors of some of the docks and wharves appear in *The Post Office Directory for 1881, Street and Commercial* (London: Kelly, 1881), 178.

22. Ibid.

23. On workdays, a gate at the far end of each yard opened onto Belvedere Road, which roughly paralleled the river (and which in the twenty-first century remains a busy thoroughfare). Wagons and carts carried lumber, cut stone, cast iron, chimney pots, and other goods from the yards to sites in London.

24. Climatological Returns for Brixton (Lambeth), April 1881, National Meteorological Archive, Exeter, U.K. The rainfall measurement was made at Brixton, the meteorological service's closest point to Homer's Lambeth riverside painting location.

25. The Wooley Collection in the Lambeth Archives of Minet Library, London, contains highly interesting late-nineteenth-century photographs of houses and pubs along and near Belvedere Road, but none showing the crane-lined riverside. I thank Len Reilly for calling the collection to my attention.

26. For the construction of County Hall, see Bridget Cherry and Nicholas Pevsner, *London 2: South,* the Buildings of England, vol. 2 (London: Penguin Books, 1983; new printing with minor revisions, 1994), 355–56.

27. Ibid., 345–46.

7. NEW YORK AND MAINE, 1882–1890: THE NEW PAINTER

1. Homer at first resided in an apartment near Washington Square with Samuel T. Preston, a cousin of his sister-in-law Mattie. Photographs of the apartment with Homer's paintings on its walls are reproduced in Hendricks, 169. Homer made arrangements in New York for studio space, but not in the Tenth Street Studio Building, where he had spent most of the 1870s. Perhaps that facility was fully occupied, or, more likely, he already had in mind, however tentatively, a central role in his family's emerging plan to develop Prout's Neck as a summer residence community. He may have envisioned himself spending summers in Maine while wintering in New York.

2. In January, the American Watercolor Society's annual exhibition included two Cullercoats watercolors; in February, his Boston dealer showed another two, including *The Houses of Parliament;* in March, the Brooklyn Art Association showed one; in April, a watercolor and drawing were shown in Boston. Cikovsky and Kelly, 409.

3. Ibid.

4. Mrs. Schuyler Van Rennselaer, "An American Artist in England," *Century Magazine* (Nov. 1883), 13.

5. Ibid., 14–15.

6. Ibid., 17.

7. For Cullercoats, see Harrison. Much of value about Homer in Cullercoats can be found in the chapter "London and Cullercoats" in Cooper, 80–91.

8. Tynemouth had a long history as a favored place of resort for the gentry and others. Homer and his dealers undoubtedly specified Tynemouth in the titles of many of the watercolors he had painted at Cullercoats or elsewhere along the coast to suit a market-oriented understanding that although the name of the town was nationally recognized, that of the fishing village was not. Beyond that, it was common practice throughout England to identify a village by linking it to a larger neighboring community. Letters addressed to Homer very likely followed the form "Cullercoats, Tynemouth." It is possible that Homer probably also chose the use of Tynemouth in titles to avoid any possible linking of him with the Cullercoats art colony.

9. I thank Peter Hornby for pointing out the several advantages that Newcastle held for Homer, not least its wealth and its relative "newness" as a city.

10. David Tatham, "Winslow Homer's Library," *American Art Journal* 9, no. 1 (May 1977), 96–97. The book was F. E. Feller, *A New English and French Pocket Dictionary*, vol. 1: *English–French* (London: DuLau, 1879). This volume is part of the Homer Family Collection, Bowdoin College Library, Brunswick, Me.

11. If Homer went to Paris, he would have traveled via London, where boat trains left for Dover (or another port) to transfer passengers to a channel steamer, thence to a French train. On such a trip, he could have arranged his time to spend days in London before or after Paris.

12. Winslow Homer to William Cochrane, 21 Dec. (no year). The content of the letter, written from Cullercoats to a patron in Gosforth, Newcastle-upon-Tyne, makes it clear enough that the year was 1881. Homer left England well before December 1882. See Harrison, 39.

13. Goodrich, *Winslow Homer*, 76. Publications on Homer since Goodrich have speculated about the likelihood of a brief return to New York, but without arriving at a consensus. If Homer made a return, his purpose may have been related to family matters, for he had already sent a group of watercolors for exhibition at a dealer's gallery.

14. Quoted in Adamson, 36. It is possible, of course, that the passenger on the *Parthia* had recommended the fashionable town of Tynemouth, Cullercoats's larger and more attractive neighbor, and that only after examining both places did Homer choose the quieter place—the fishing village. Then, too, Homer may have known about Cullercoats well before hearing it praised mid-Atlantic. The village's art colony received occasional notice in the art press. Beyond that, the marine painter Mauritz de Haas, Homer's colleague at the Tenth Street Studio Building and his fellow contributor of illustrations to *That Good Old Time: Our Fresh and Salt Tutors*, had visited Tynemouth a few years earlier. While there, de Haas in all likelihood sought out its ocean-fronting suburb and may have sung its praises to Homer. See Hendricks, 150.

15. For a linking of Homer's travels with his interest in the color of light in various geographic locations, see Jana Colacino, "Winslow Homer's Watercolors and the Color Theories of M. E. Chevreul," M.A. thesis, Syracuse Univ., 1994.

16. Adamson, 36.

17. Nothing in the figures Homer painted soon after his return to the United States—including those in *The Life Line, Undertow, Eight Bells, The Herring Net,* and *The Fog Warning*—identify them specifically as American, though they have always been assumed to be such owing to their maker's nationality. These figures' activities, circumstances, and to some degree attire could be found in other marine-oriented societies of the North Atlantic.

18. For an introduction to the colony, see Laura Newton, with Abigail B. Gerdts, *Cullercoats: A North-East Colony of Artists* (Newcastle-upon-Tyne, U.K.: Laing Art Gallery, 2003).

19. Ibid., 20–21.

20. Illustrated, with its source drawing, in Harrison, 119.

21. See, for example, the frontispiece in Newton, a studio photograph of around 1900 titled *Fisher Folk*. The poses and facial expressions as well as the popular attire and accessories distinguish these four women from

mid- to late-nineteenth-century stereotypical images of peasants. A photograph of Maggie Storey, reputedly Homer's favorite model, taken during or soon after his time in the village, displays the same characteristic attire. See Harrison, 26.

22. William Howe Downes, *Life and Work of Winslow Homer* (Boston: Houghton Mifflin, 1911), 102.

23. Goodrich, *Winslow Homer,* 87.

24. Harrison, 45–62.

25. *New York Times,* 5 Apr. 1884, 4.

26. Homer was also about to settle at Prout's Neck, where he and his brothers would soon develop their extensive seaside holdings into a select summer community. In so doing, they to some extent followed the example of their mother's brother, Arthur Benson of Brooklyn, who had developed a residential community at Montauk Point on Long Island. For Benson's closeness to Homer, see Patricia Junker, "Pictures for Anglers," in *Winslow Homer: Artist and Angler,* exhibition catalogue by Patricia Junker, with Sarah Burns (Fort Worth, Tex.: Amon Carter Museum, 2002), 40, 66–68.

27. On 24 June 1884, Homer had sent a note to his sister-in-law Martha Homer, saying that "the studio will be quite wonderful, will have it finished in about a week" (quoted in Earle G. Shettleworth Jr. and William David Barry, "'Brother Artists': John Calvin Stevens and Winslow Homer," *Bowdoin* 61, no. 4 [fall 1988], 17). At that point, he was probably living temporarily next door in the Ark, overseeing the transformation of a carriage house into his home.

28. Homer undoubtedly saw the reproductive etchings he made between 1884 and 1889 as a welcome source of both income and prestige. See David Tatham, "Winslow Homer and the Etching Revival in America," *Imprint* 33, no. 1 (spring 2008): 2–9. Though Homer claimed to have learned the art and craft of etching from manuals and from one or more etchers and printers in Manhattan, it seems likely that he had examined and found interest in many etchings in London at the British Museum, in the National Gallery, in exhibitions on Bond Street, and in Newcastle and learned something of their making. He probably understood how earlier in the century Turner had counted on reproductive etchings of his work to spread his fame.

29. Ibid.

30. Quoted in Goodrich, *Winslow Homer,* 95.

31. *Boston Daily Evening Transcript,* 21 Jan. 1887.

32. The distinctions between objective realism and romantic realism are set out by E. P. Richardson in his still valuable book *Painting in America* (New York: Crowell, 1956).

33. Augustus Stonehouse, "Winslow Homer," *Art Review* 1, no. 4 (Feb. 1887), 84.

34. Ibid.

35. Ibid.

8. PROUT'S NECK, 1905–1910: EDGING TOWARD THE PANTHEON

1. Goodrich, *Winslow Homer,* 167.

2. Beatty, 212.

3. Whistler, who had become a fine artist first in Paris and then in England, was consistently referred to as an American, for, as was often remarked, his work in Paris had not seemed French, and his work in London did not seem British. Though he never returned to the United States after his early departure, he retained his American citizenship and thus remained an "American artist."

4. I thank Kathy Keinholz, archivist of the American Academy of Arts and Letters, New York, for her report that Sargent wrote from London to express his regret at being unable to attend the ceremony for newly elected members. Nothing survives to suggest that Homer attended the ceremony.

5. Sargent had become a good friend of Abbey during the summer gatherings of artist friends and their families in the mid- and late 1880s at Broadway in Worcestershire and later spent much time with Abbey and his wife at their Gloucestershire residence, Morgan Hall, in Fairford. The Broadway group also included Boughton, Parsons, and the American artist Frank Millet, who had been the first of the artists to come to Broadway. Henry James occasionally visited from London. For the Broadway group, see Henry James, "Our Artists in Europe," *Harper's New Monthly Magazine* 79 (June 1889): 50–66, a highly sympathetic and critically superficial account. For a scholarly historical consideration of this group, see Marc Simpson, "Reconstructing the Golden Age: American Artifacts in Broadway, Worcestershire, 1885–1889." Ph.D. diss., Yale Univ., 1993.

6. Homer had probably met Eakins when both were in Paris in 1867. Eakins was then a student, and Homer a new and already much praised painter of the Civil War. Homer and Eakins certainly spent time together in October 1901 as members of Beatty's jury for the Carnegie Institute's annual international exhibition.

7. Elihu Vedder, *The Digressions of V* (Boston: Houghton Mifflin, 1910), 219. Vedder, Homer, and La Farge had painted together at Newport, Rhode Island, and elsewhere in the 1860s. Though Vedder spent most of his long career as an expatriate in Italy, he returned to the United States periodically. Among his great successes as a graphic artist were the full-page illustrations he drew for a deluxe edition of Edward Fitzgerald's free translation of *The Rubaiyat of Omar Khayyam* (Boston: Houghton Mifflin, 1884), when the poem was new to the public. The critical success of this volume led the publisher to issue and reissue smaller trade editions with Vedder's illustrations photomechanically reduced in size. Homer was almost certainly acquainted with the book, and he probably renewed his acquaintanceship with Vedder during the latter's visits to New York and Boston in the 1880s.

8. Quoted in Goodrich, *Winslow Homer*, 139.

9. Lucas, *Edwin Austin Abbey*, 2:466. The *Harper's Weekly* illustrations Abbey mentions are *A Bivouac Fire on the Potomac* (1861) and *The Army of the Potomac: A Sharp-Shooter on Picket Duty* (1862) and are reproduced in Tatham, *Winslow Homer and the Pictorial Press*, 113 and 122, respectively.

10. Given in Lucas, *Edwin Austin Abbey*, 2:488–89. Kelly's unpublished memoirs, which include descriptions of Homer, are available on microform reels 1876–77 in the Archives of American Art, Smithsonian Institution, Washington, D.C.

11. In 1878, one of Homer's American subjects, *The Cotton Pickers* (1876, Los Angeles County Museum of Art), a depiction of two African American women in a cotton field, had been shown in the Royal Academy's annual exhibition. It was owned by a British collector with interests in the cotton industry. Homer had nothing to do with this showing of his painting in London.

12. There is some irony in the fact that the museums of the city in which Homer remade himself as an artist with such stunning results hold no painting from any point in his career. Not until 2006, when the Dulwich Picture Gallery mounted the Terra Foundation–organized loan exhibition Winslow Homer: Poet of the Sea did a representative career-spanning selection of his paintings become available for viewing and study in the United Kingdom. American travelers who cross the Atlantic in search of Homer's paintings will find *A Summer Night* (1890) in the Musée D'Orsay, Paris, and several oils and watercolors in the Museo Thyssen-Bornemisza in Madrid, but none in London.

Bibliography

Ackroyd, Peter. *London: The Biography.* London: Chatto and Windus, 2000.

Adamson, Alan. "The Winslow Homer That I Knew." In *Winslow Homer in England,* by Tony Harrison, 33–40. Ocean Park, Me.: Hornby Editions, 2004.

Allen, Charlotte. *Cleansing the City.* Athens: Ohio Univ. Press, 2009.

Ashbee, Felicity. "Dandy in Decline: Whistler's Last Home." *Country Life* (22 Nov. 1984): 1360–61.

Ayres, Linda. "Lawson Valentine, Houghton Farm, and Winslow Homer." In *Winslow Homer in the 1870s: Selections from the Valentine-Pulsifer Collection,* edited by John Wilmerding, 18–26. Princeton, N.J.: Art Museum, Princeton Univ., 1990.

Beam, Philip C. *Winslow Homer's Magazine Illustrations.* New York: Harper and Row, 1979.

Beatty, John W. "Recollections of an Intimate Friendship." In *Winslow Homer,* by Lloyd Goodrich, 206–26. New York: Macmillan, 1944.

Besant, Walter. *London in the Nineteenth Century.* London: A. & C. Black, 1909.

Bradley, Simon, and Nicholas Pevsner. *London 6: Westminster.* The Buildings of England, vol. 6. New Haven, Conn.: Yale Univ. Press, 2003.

Bryant, William Cullen, and Sydney R. Gay. *A Popular History of the United States.* Vol. 1. New York: Scribner, Armstrong, 1876.

Burns, Sarah. "The Courtship of Winslow Homer." *The Magazine Antiques* 161 (Feb. 2002): 69–75.

———. *Inventing the Modern Artist: Art and Culture in Gilded Age America.* New Haven, Conn.: Yale Univ. Press, 1996.

———. "'To Make You Proud of Your Brother': Fishing and the Fraternal Bond in Winslow Homer's Art." In *Winslow Homer: Artist and Angler,* exhibition catalogue by Patricia Junker, with Sarah Burns, 13–31. New York: Thames and Hudson, 2003.

———. "Winslow Homer's Ambiguously New Women." In *Off the Pedestal: New Women in the Art of Homer, Chase, and Sargent,* edited by Holly Pine Connor, 53–90. Newark, N.J.: Newark Museum, 2006.

Cherry, Bridget, and Nicholas Pevsner. *London 2: South.* The Buildings of England, vol. 2. London: Penguin Books, 1983; new printing with minor revisions, 1994.

Cikovsky, Nicolai, Jr. *Winslow Homer.* New York: Abrams, 1990.

———. "Winslow Homer's National Style." In *American Icons: Transatlantic Perspectives on Eighteenth- and Nineteenth-Century Art,* edited by Thomas W. Gaehtgens and Hans Ichstadt, 247–65. Santa Monica, Calif.: Getty Center for the History of Art and Humanities, 1992.

Cikovsky, Nicolai, Jr., and Franklin Kelly, with contributions by Judith Walsh and Charles Brock. *Winslow Homer.* Exhibition catalogue. New Haven, Conn.: Yale Univ. Press, 1995.

Clapp, Samuel F. "Doré in London." In *The Image of London: Views by Travellers and Emigres 1550–1920,* exhibition catalogue by Malcolm Warner, 164–70. London: Trefoil, 1987.

Colacino, Jana. "Winslow Homer and the Color Theories of M. E. Chevreul." M.A. thesis, Syracuse Univ., 1994.

Collins' Guide to London and Neighborhood. London: William Collins, Sons, 1882.

Collins' Illustrated Guide to London and Neighborhood. New ed. London: William Collins, 1882.

Collins' Standard Map of London with Illustrated Guide. London: Edward Stanford, n.d. [c. 1882].

Conway, Moncure Daniel. *Travels in South Kensington.* London: Trübner, 1882.

Cook, B. F. *The Elgin Marbles.* 2d ed. London: British Museum Press, 1997.

Cooper, Helen. *Winslow Homer Watercolors.* Exhibition catalogue. New Haven, Conn.: Yale Univ. Press, 1986.

Cox, Kenyon. *Winslow Homer.* New York: privately printed, 1914.

Cox-Johnson, Ann. *Handlist of Painters, Sculptors, and Architects Associated with the Borough of St Marylebone, 1760–1960.* London: Borough of St. Marylebone Public Libraries Committee, 1963.

Dickens, Charles. *Bleak House.* London, 1853. New ed. New York: W. W. Norton, 1977.

Downes, William Howe. *Life and Works of Winslow Homer.* Boston: Houghton Mifflin, 1911.

Evans, Dorinda. *Benjamin West and His American Students.* Washington, D.C.: National Portrait Gallery, 1980.

Feller, F. E. *A New English and French Pocket Dictionary.* Vol. 1: *English–French.* London: DuLau, 1879.

Fitzgerald, Edward, trans. *The Rubaiyat of Omar Khayyam.* Boston: Houghton Mifflin, 1884.

Gelman, Barbara. *The Wood Engravings of Winslow Homer.* New York: Bounty Books, 1969.

Goodrich, Lloyd. *The Graphic Art of Winslow Homer.* New York: Museum of Graphic Art, 1968.

———. *Winslow Homer.* New York: Macmillan, 1944.

Goodrich, Lloyd, and Abigail Booth Gerdts. *Record of the Works of Winslow Homer.* Vol. 1: *1856–1866;* and vol. 3: *1877–1881.* New York: Spanierman Gallery, 2005 and 2008.

Griffiths, Antony, ed. *Landmarks in Print Collecting.* London and Houston: British Museum and Museum of Fine Arts, 1986.

Hare, Augustus J. C. *Walks in London.* 2 vols. New York: George Routledge and Sons, 1878.

Harrison, Tony. *Winslow Homer in England.* Ocean Park, Me.: Hornby Editions, 2004.

Hawthorne, Nathaniel. *Our Old Home: A Series of English Sketches.* Boston, 1863. New ed., Boston: Houghton Mifflin, 1902.

Hendricks, Gordon. *The Life and Work of Winslow Homer.* New York: Abrams, 1979.

Indicator Map of London and Visitors Guide. London: C. Smith & Son. 1881.

James, Henry. *Essays in London and Elsewhere.* New York: Harper and Brothers, 1893.

———. "On Some Pictures Lately Exhibited." *The Galaxy* 20 (July 1875): 89–97.

———. "Our Artists in Europe." *Harper's New Monthly Magazine* 79 (June 1889): 50–66.

———. "The Real Thing." *Black and White* (London), 16 Apr. 1892. Published in book form as *The Real Thing.* London: Macmillan, 1893.

————. "The Story of a Masterpiece." *The Galaxy* (Jan.–Feb. 1868). Republished in *Eight Uncollected Tales of Henry James,* edited by Edna Kenton, 91–122. New Brunswick, N.J.: Rutgers Univ. Press, 1950.

Jerrold, Blanchard, and Gustave Doré. *London A Pilgrimage.* London: Grant, 1872.

Junker, Patricia. "Pictures for Anglers." In *Winslow Homer: Artist and Angler,* exhibition catalogue by Patricia Junker, with Sarah Burns, 33–69. Fort Worth, Tex.: Amon Carter Museum, 2002.

Leslie, Frank. "Report of the Fine Arts." In *Paris Universal Exposition: Reports of the United States Commissioners,* n.p. Washington, D.C.: U.S. Government Printing Office, 1868.

Linton, William James. *History of Wood Engraving in America.* Boston: Estes and Lauriat, 1882.

————. *Threescore and Ten Years: 1820–1890.* New York: Charles Scribner's Sons, 1894.

List of Street and Places within the Administrative County of London. London: London County Council, 1929.

London County Council Bomb Damage Maps, 1939–1945. London: London Topographical Society and London Metropolitan Archives, 2005.

Lucas, E. V. *Edwin Austin Abbey: Royal Academician.* 2 vols. London: Methuen, 1921.

————. *London Afresh.* Philadelphia: J. B. Lippincott, 1937.

Mayhew, Henry. *London Labour and the London Poor.* 3 vols. London: Woodfall, 1851.

Monet's London: Artists' Reflections on the Thames, 1859–1914. Exhibition catalogue. St. Petersburg, Fla.: Museum of Fine Arts, 2005.

Mott, Frank Luther. *A History of American Magazines: 1865–1885.* Cambridge, Mass.: Harvard Univ. Press, 1938.

Newton, Laura, with Abigail B. Gerdts. *Cullercoats: A North-East Colony of Artists.* Newcastle-upon-Tyne, U.K.: Laing Art Gallery, 2003.

Old Ordnance Survey Maps, London Large Scale Series. Godfrey ed. Leadgate, U.K.: Alan Godfrey Maps, 2005.

Piper, David. *The Companion Guide to London.* London: Collins, 1963; 7th ed., 1992.

Pisano, Ronald. *The Tile Club and the Aesthetic Movement in America.* New York: Harry N. Abrams, 1999.

Post Office Directory for 1881, Street and Commercial. London: Kelly, 1881.

Reed, Cleota. "The Golden Fountain and the Grill Room: The Evolution of a Design in Tile." *Glazed Expressions* (a publication of the Tiles and Architectural Ceramics Society, United Kingdom) 63 (spring 2009): 11–15.

Reynolds, Graham. *English Watercolors.* New ed. New York: New Amsterdam Books, 1988.

Rhodes, Richard. *John James Audubon: The Making of an American.* New York: Alfred A. Knopf, 2004.

Richardson, E. P. *Painting in America.* New York: Crowell, 1956.

Saunders, Ann, ed. *The London County Council Bomb Damage Maps, 1939–1945.* London: London Topographical Society and London Metropolitan Archives, 2005.

Saunders, Hilary St. George. *The Middlesex Hospital 1745–1948.* London: Max Parrish, 1949.

Shettleworth, Earle, Jr., and William David Barry. "'Brother Artists': John Calvin Stevens and Winslow Homer." *Bowdoin* 61, no. 4 (fall 1988): 17.

Simpson, Marc. "Reconstructing the Golden Age: American Artifacts in Broadway, Worcestershire, 1885–1889." Ph.D. diss., Yale Univ., 1993.

————. "Windows on the Past: Edwin Austin Abbey and Francis Davis Millet in England." *American Art Journal* 22, no. 3 (1990): 64–89.

Stonehouse, Augustus. "Winslow Homer." *Art Review* 1, no. 4 (Feb. 1887): 84–86.

Summerson, John. *Eighteenth-Century London.* London: Penguin Books, 1962.

The Survey of London. Vol. 37: *Northern Kensington.* London: Athlone Press, Univ. of London, for the Greater London Council, 1973.

Tatham, David. "Abraham Tuthill at Mrs. Trollope's Bazaar." In *The Documented Image: Visions in Art History,* edited by Gabriel Weisberg and Laurinda Dixon, 1–12. Syracuse, N.Y.: Syracuse Univ. Press, 1987.

————. "Winslow Homer and the Etching Revival in America." *Imprint* 33, no. 1 (spring 2008): 2–9.

————. "Winslow Homer and Houghton Farm." In *Winslow Homer's Empire State: Houghton Farm and Beyond,* exhibition catalogue, edited by David Lake Prince and David Tatham, 25–46. Syracuse, N.Y.: Syracuse Univ. Art Galleries, 2009.

————. *Winslow Homer and the Illustrated Book.* Syracuse, N.Y.: Syracuse Univ. Press, 1992.

————. *Winslow Homer and the Pictorial Press.* Syracuse, N.Y.: Syracuse Univ. Press, 2003.

————. "Winslow Homer's Library." *American Art Journal* 9, no. 1 (May 1977): 92–98.

Taylor, Pamela. "Langham Place and Fitzrovia 1870," essay printed on the verso of the map *Langham Place and Fitzrovia 1870.* In *Old Ordnance Survey Maps, London Large Scale Series,* Godfrey ed., sheet 7.52. Leadgate, U.K.: Alan Godfrey Maps, 2005.

Thackeray, William Makepeace. *The Newcombes.* London, 1854. New ed., 2 vols. New York: Limited Editions Club, 1954.

Van Rensselaer, Mrs. Schuyler. "An American Artist in England." *Century Magazine* (Nov. 1883): 13–21.

Vedder, Elihu. *The Digressions of V.* Boston: Houghton Mifflin, 1910.

Walford, Edward. *Old and New London: A Narrative of Its History, Its People, and Its Places.* Vol. 4. London: Cassell, 1878.

Walsh, Judith. "More Skillful, More Refined, More Delicate: London." In *Watercolors by Winslow Homer: The Color of Light,* exhibition catalogue by Martha Tedeschi and Kristi Dahm, with contributions by Judith Walsh and Karen Huang, 75–106. Chicago: Art Institute of Chicago, 2008.

Wedd, Kit. *Artists' London.* London: Merrill, 2001.

Wilkins, David G. "Winslow Homer at the Carnegie Institute." *Carnegie Magazine* 55 (Jan. 1981): 5–20.

Willetts, Paul. *North Soho 999.* Stockport, U.K.: Dewi Lewis, 2007.

Index

Abbey, Edwin Austin, 14–15, 26–27, 40, 66, 92–93, 114n5

Adamson, Alan, 80–81

Aesthetic Movement, 10, 15, 26, 61–65

Albert Embankment, 73, 75–76

Aldrich, Thomas Bailey, 66

Allston, Washington, 33

Alma-Tadema, Lawrence, 26, 35, 61, 62, 65

American Academy of Arts and Letters, 91–92

American Exchange, 21

American Watercolor Society, 14, 78

Andrew, John, 19

Anglomania, 18

Arts and Crafts Movement, 10

Arts Club, 65

Ashbee, Charles Robert, 108n12

Ashbee, Felicity, 108n12

Ashbee, Janet, 108n12

Audubon, John James, 57

Bacon, Francis, 38

Bacon, John, 31

Ballou's Pictorial Drawing-Room Companion, 18

Banks, Thomas, 31

Barry, Charles, 31, 70

Barry, James, 32

Beatty, John, 3, 7, 80, 100n3

Beaux, Cecilia, 100n3

Benson, Arthur, 8, 113n26

Benson, Frank, 100n3

Bierstadt, Albert, 79

Blashfield, Edwin, 92

Blue Posts public house, 36–37, 106–7n25

Boston Athenaeum, 33

Boughton, George Henry, 65–66, 114n5

Breton, Jules, 83

British Isles Census, 1881. *See* Census of 1881, England

British Museum, xvii, 34, 58; Department of Prints and Drawings, xvii, 57–61; Duveen Gallery, 60; Elgin Gallery, 59; Homer visits, 57–61; natural history collections, 60, 108n18; Parthenon sculptures, 59–61. *See also* Natural History Museum

Brown, Ford Madox, 34

Browning, Robert, 65

Burne-Jones, Edward Coley, 26, 35, 36, 61, 88, 108n19

Camden Town painters, 38

Campden Hill, 65

Carlyle, Thomas, 64

Carnegie Institute, 3

Census of 1881, England, 28

Centennial Exposition at Philadelphia, 10

Century Association (Club), 19, 78

Chambers, William, 31, 35

Charing Cross Bridge, 68

Chase, William Merritt, 14, 79, 91, 100n3

Chelsea, 35

Church, Frederic, 12, 79

Claude (Lorrain), 72; *Departure of the Queen of Sheba*, 76

Coldstream, William, 38

Cole, Thomas, 12

College Street, Lambeth, 73

Constable, John, 32

Copley, John Singleton, 32

Cotman, John Sell, 32

County Hall. *See* London County Hall

Courbet, Gustave, 26, 62

Cox, Kenyon, 63, 84

Cox-Johnson, Ann, 32

Criticism, modes of art, 13

Cullercoats, xv, 6, 58, 66; art colony, 81; fishwives, 59, 60, 62, 82–83; relation to Tynemouth, 80, 112n8

Cumberland Club, 2

Cushman, Mrs. Alexander, 8

Damoreau, Charles, 103n5

Danby, James Francis, 72

De Haas, Mauritz F. H., 24–25

De Kay, Helena, 99n2

DeMorgan, Evelyn, 61

Devis, Arthur, 32

Dickens, Charles, 22

Doré, Gustave, 20–23, 69

Doré Gallery, 21, 64

Downes, William Howe, 83–84, 94

Dulwich Picture Gallery, xvi, 34

Durand, Asher B., 12

Duveneck, Frank, 14, 79, 100n3

Eakins, Thomas, 63, 92, 114n6

Earl, Ralph, 32

Elgin Marbles, 59–61

Epstein, Jacob, 38

Euston Road School (of artists), 38

Euston Station, 28, 104n29

Festival of Britain, 76

Fildes, Luke, 35

Fine Art Society, 64

Fitzrovia, 38–39

Fitzroy Square, 37

Flaxman, John, 31

Fog (colors of), 57, 69, 73

Franco–Prussian War, 26

Frith, William Powell, 26, 68

Fry, Roger, 38

Fuseli, Henry, 32

Galaxy, The, 11–13

Gamble, James, 108n19

George III, 29

Gilbert, William Schwenk, 65–66

Golden Jubilee Bridges, 68

Gloucester, Massachusetts, 16

Goodrich, Lloyd, xvii, 63

Gordon, Clarence, 24–25

Gore, Spencer, 38

Grafton Gallery, 61, 64

Graphic, 26

Graves Gallery, 64

Greenaway, Kate, 36

Grosvenor Gallery, 64

Grove Lodge, 65

Guidebooks to London, 20

Hamnett, Nina, 38

Hare, Augustus J. C., 20, 64, 73

Harper's Weekly, 14, 22–23, 27, 81

Harrison, Tony, xvi–xix, 28, 99, 104n20

Hawthorne, Nathaniel, 40

Heatherley's School of Fine Art, 36–37

Hennessey, William J., 27

Henry, Edward Lamson, 27

Hill, A. See Waud, Alfred

Hogarth, William, 30, 32

Holland and Hannay (builders), 74

Holland Park, 35

Homer, Arthur, 2

Homer, Charles Savage, Jr., 2, 5, 18, 67, 80

Homer, Charles Savage, Sr., 5, 18

Homer, Henrietta Benson (mother), 85, 100n15

Homer, Martha (Mattie) French, 2, 57, 109n28

Homer, Winslow: American qualities of his early works, 10–11; character, 2–4, 7, 40; criteria for "important" works, 4–5; depiction of River Thames, 69, 77; disaffection from other artists, 2, 88; election to American Academy of Arts and Letters, 91–92; family relations, 1–2, 5, 8, 72, 80; first publication of his work in London, 24–25; Henry James's criticism of his paintings, 11–13, 16; motives for visiting London, 17, 26–27;

name misspelled in London census records, 28, 105n32; Newman Street residence, 21, 28–30, 37, 39–40; reclusiveness, 2, 94; relations with family, 1–2, 5, 8, 72; response to Aesthetic Movement, 10, 15, 45–47; success in watercolors, 5, 80; travels, 1–2; viewpoint for *Houses of Parliament,* 19–20, 68, 73–75; visit to British Museum, 57–61; weather conditions in London, 57, 74

Homer, Winslow (works): *Afterglow,* 82–83, plate 15; *Backgammon,* 15, 102n13; *Blackboard,* 102n13; *Boat Race,* 25; *Breezing Up,* 14; *Cannon Rock,* 89; *Cape Trinity, Saguenay River,* 92; *Cloud Shadows,* 84; *Cotton Pickers,* 114n11; *Driftwood,* 92–94; *Early Morning after a Storm at Sea,* 7, 88, 93, plate 1; *Eastern Point,* 89; *Eight Bells,* 87, 112n17; *Fog Warning,* 87, 112n17; *Four Fishwives,* 81–82, plate 14; *Fox Hunt,* 100n2; *Gale (Coming away of the Gale),* 108n13; *Girl and Daisies,* 16, plate 4; *Gulf Stream,* 89; *Hark! The Lark,* 62–63, 83; *Herring Net,* 87, 112n17; *Houses of Parliament,* xvi, 20, 57, 66–77, 93, plate 10; *Inside the Bar,* 59; *In the Mountains,* 15; *Kissing the Moon,* 70, 90, 94; *The Life Line,* 4, 6, 85–87, 112n17, plate 16; *Lost on the Grand Banks,* 87; *Mending the Nets,* 62; *Mending the Tears,* 62, plate 8; *New Novel (Book),* 102n13; *Prisoners from the Front,* 5, 9, 14, 15, *Returning Fishing Boats,* 83; *Right and Left,* 90–94; *Shepherdesses Resting,* 16, plate 5; *Shepherdess Tending Sheep,* 84; *Snap-the-Whip* (oil painting), 9, 81; *Snap-the-Whip* (wood engraving), 9, 81, plate 2; *Summer Night,* 2, 90–91, 114n12; *Sunlight on the Coast,* 88; *Tent (Summer by the Sea),* 9, plate 3; *Two Guides,* 15; *Undertow,* 86–88, 112n17; *Visit from the Old Mistress,* 15; *Voice from the Cliffs* (etching), 62; *Voice from the Cliffs* (watercolor), 62, 83; *Watching the Tempest,* 84; *Winter Coast,* 88; *Woman Peeling a Lemon (Lemon),* 102n13; *Wreck,* 3, 100n2

Hone, Nathaniel, 32

Horseferry, 72

Houghton Farm, 15, 84

Houses of Parliament (Palace of Westminster), xvi, 37, 69–70

Hungerford Bridge. *See* Charing Cross Bridge

Hunt, William Holman, 34

Hunt, William Morris, 64

Huntington, Daniel, 34

Illustrated London News, 26, 74

Impressionism, 10, 26

India Military Stores Depot, 72–74

Indicator Map of London and Visitor's Guide, 20–21

Israels, Jozef, 83

James, Henry, 11, 91, 101n4, 109n30; aversion to American culture, 12, 66; comment on Houses of Parliament, 70; criticism of Homer's work, 11–13; dinner guest at West House, 65–66; London residences, 11, 109n30; visits to Broadway, Worcestershire, 114n5

James, Henry (works): "On Some Pictures Lately Exhibited," 11–13; "Our Artists in Europe," 114n5; "The Real Thing," 12; "The Story of a Masterpiece," 13

Japonisme, 10

Jerrold, Blanchard, 20–22

John, Augustus, 38

Jubilee Gardens, 76

Kelly, James Edward, 14, 92–93

Kensett, John, 34

Kensington Gardens, 65, 109n28

King, Charles Bird, 32

King's Arms Stairs, 73

Kingston, William H. G., 25

La Farge, John, 48, 63, 64

Lambeth Bridge, 72

Lambeth Palace, 76

Legros, Alphonse, 58, 65

Leicester Square, 32

Leigh, James Matthew, 36

Leighton, Frederic, 26, 35, 61, 62, 65

Leslie, Charles Robert, 33

Leslie, Frank, 19

Lewis, Wyndham, 38

Linton, William J., 19, 59, 64, 103n6

Liverpool, xv, 18

London A Pilgrimage, 21–24

London County Hall, 75

Low, Will, 100n3

Lowell, James Russell, 66

Lucas, Edward Verrall, 39

Lucas Brothers, builders, 74

Manet, Edouard, 26, 68

Marbles of the Parthenon. *See* Elgin Marbles

Mayhew, Henry, 22

Middlesex Hospital, 30

Millais, John Everett, 35, 88

Millbank, 72

Millet, Jean Francois, 62, 64

Monet, Claude, 73

Moore, Albert, 61

Morris, William, 108n19

Morse, Samuel F. B., 33

Musée de Luxembourg, 90

Nash, John, 34

National Academy of Design, 8, 10, 19, 27, 60, 65, 78

National Gallery, 34, 37, 63

Natural History Museum, 60

New American Woman, 9

Newcastle-upon-Tyne, xv, 80

Newcastle-upon-Tyne Art Association, 80

Newman Passage, 34, 36

Newman Street, Marylebone, 28–30

New York University Building, 8

Nollekins, John, 32

"North Soho," 39

North Woods Club, 92

Notting Hill, 65, 109n30

O'Donovan, William, 60

Omega Workshop, 38

Omnibuses, 37

Opie, John, 32

Page, Thomas, 70

Palace of Westminster. *See* Houses of Parliament

Panic of 1873, 9

Paris, xv, 26, 60, 65, 80, 112n11

Parsons, Alfred, 27, 40

Parthia (steamship) Cunard Line, 18, 28

Parton, Ernest, 27

Peale, Charles Willson, 32

Peale, Rembrandt, 32

Piper, David, 39

Portcullis House, 69–70

Post Office Tower, 39

Powell, Michael, 106n17

Poynter, Edward, 61, 65, 108n19

Pratt, Matthew, 32

Preston, Samuel T., 111n1

Prinsep, Valentine, 35

Prout's Neck, 1, 40, 91

Pugin, Augustus W. N., 31, 70

Realism, 10, 87–88

Renoir, Camille, 68

Reynolds, Sir Joshua, 29

Rimer, William and Louisa S., xvi, 28, 40, 65

Roberts, David, 72

Roberts, William, 38

Royal Academy, 29, 31, 36, 37, 62, 65

Ruskin, John, 4, 100n10

Saint-Gaudens, Augustus, 91

Sargent, Henry, 32

Sargent, John Singer, 91–92, 114n5

Sass, Henry, 36

Savoy Hotel, 73

Shaw, Richard Norman, 65

Sickert, Walter, 38

Sir John Soane's Museum, 64

Society of American Artists, 7, 10

Society of Painters in Watercolors, 63

Soho, 30, 36

Somerset House, 31

South Bank, 76

South Kensington Museum, 58, 65, 108n18

St. Giles Parish, 30

Stone, Marcus, 35

Stonehouse, Augustus, 87–88

Stothard, Thomas, 32

St. Thomas Hospital, 73

Stuart, Gilbert, 32

Sully, Thomas, 32

Symbolism, 10

Tarbell, Edmund, 100n3

Tatham, Charles Heathcote, 31

Taylor, Pamela, 38

Telecom Tower. *See* Post Office Tower

Tenth Street Studio Building, 8, 19, 27

Thomas, Dylan, 38

Tile Club, 15, 18, 27, 40, 65, 92, 102n15

Tissot, James Jacques, 61

Trumbull, John, 32

Turner, William M. W., 63, 70; *Calais Pier,* 86; *Dido Building Carthage,* 76

Tuthill, Abraham G. D., 106n12

Tynemouth, 112n8

Underground railways (London), 20, 37

Valentine, Lawson, 15

Van Rensselaer, Mariana (Mrs. Schuyler), 78–79

Vedder, Elihu, 92, 114n7

Victoria and Albert Museum. *See* South Kensington Museum

Victoria Embankment, 19

Vieux Moustache. *See* Gordon, Clarence

Walford, Edward, 35

Walsh, Judith, xvi–xix, 57–59, 63, 99, 107n4

Ward, John Quincy Adams, 60

Waterhouse, Alfred, 87–88

Watts, G. F., 35

Waud, Alfred, 18–19

Waud, William, 18–19

Webb, Philip, 108n19

West, Benjamin, 29–33, 35, 39, 65

West House, Kensington, 65–66

Westminster Abbey, 69–72

Westminster Bridge, 68–70

Wheatley, Francis, 32

Whistler, James A. McNeill, 4, 36, 37, 50, 58–59, 65–66, 113n3

Whistler, James A. McNeill (works): *Arrangement in Grey and Black: The Artist's Mother,* 4, 90; *The Last of Old Westminster,* 110n13; *Nocturne in Blue and Gold: The Falling Rocket,* 100n10; *Thames Set,* 73; *Thomas Carlyle,* 4, 64; *Venice pastels,* 64

Whitman, Walt, 14, 93

Wilson, Richard, 32

"Winslow Hosmer," 28

Winsor and Newton, 35

Wood, Thomas Waterman, 34

Woodville, Richard Caton, 34

Young Sportsman, 25